WOMEN WRITERS
Buried in
VIRGINIA

WOMEN WRITERS
Buried in
VIRGINIA

SHARON PAJKA

THE
History
PRESS

Published by The History Press
Charleston, SC
www.historypress.com

Copyright © 2021 by Sharon Pajka
All rights reserved

Front cover, bottom: Hollywood Cemetery overlooking the James River. *Author's collection.*
Back cover, inset: Portrait of Margaret Prescott Montague. *West Virginia and Regional History Center, WVU.*

First published 2021

Manufactured in the United States

ISBN 9781467150668

Library of Congress Control Number: 2021945864

This book is dedicated to the women writers buried in Virginia cemeteries whom I have not yet discovered.

CONTENTS

Acknowledgements 11

Introduction 13

1. Cleo Virginia Andrews, "V.C. Andrews" (1923–1986) 23
 Olive Branch Cemetery, Portsmouth

2. Jane Briggs Howison Beale (1815–1882) 29
 Fredericksburg Cemetery, Fredericksburg

3. Helen Gordon Beale (1834–1885) 33
 Fredericksburg Cemetery, Fredericksburg

4. Kate Lee Langley Bosher (1865–1932) 37
 Hollywood Cemetery, Richmond

5. Rosa Dixon Bowser (1855–1931) 41
 East End Cemetery, Richmond

6. Estelle Aubrey Brown (1877–1958) 47
 Arlington National Cemetery, Arlington

7. Ella Howard Bryan, "Clinton Dangerfield" (1872–1954) 51
 Woodland Cemetery, Ashland

8. Letitia "Lettie" McCreery Burwell (1831–1905) 56
 Longwood Cemetery, Bedford

9. Nancy Larrick Crosby (1910–2004) 60
 Mount Hebron Cemetery, Winchester

Contents

10. Elizabeth "Lizzie" Petit Cutler (1831–1902) 64
Riverview Cemetery, Richmond

11. Virginia Emeline Butts Davidson (1833–1911) 69
Blandford Cemetery, Petersburg

12. Varina Anne "Winnie" Davis (1864–1898) 73
Hollywood Cemetery, Richmond

13. Varina Anne Banks Howell Davis (1826–1906) 78
Hollywood Cemetery, Richmond

14. Judith L.C. Garnett (1862–1938) 83
Forest Lawn Cemetery and Mausoleum, Henrico

15. Ellen Glasgow (1873–1945) 88
Hollywood Cemetery, Richmond

16. Lizzie Chambers Hall (1874–1965) 93
Old City Cemetery, Lynchburg

17. Constance Fairfax Cary Harrison (1843–1920) 97
Ivy Hill Cemetery, Alexandria

18. Lucy Norvell Harrison (1878–1955) 101
Shockoe Hill Cemetery, Richmond

19. Mary Jane Haw (1835–1927) 106
Hollywood Cemetery, Richmond

20. Mary Anna Morrison Jackson (1831–1915) 110
Oak Grove Cemetery, Lexington

21. Mary Johnston (1870–1936) 114
Hollywood Cemetery, Richmond

22. Cornelia Jane Matthews Jordan (1830–1898) 118
Presbyterian Cemetery, Lynchburg

23. Mary Greenhow Lee (1819–1907) 123
Mount Hebron Cemetery, Winchester

24. Mary Tucker Magill (1830–1899) 127
Mount Hebron Cemetery, Winchester

25. Julia Magruder (1854–1907) 130
Maplewood Cemetery, Charlottesville

CONTENTS

26. Katherine Boyce Tupper Marshall (1882–1978) 135
 Arlington National Cemetery, Arlington

27. Frances McEntee Martin (1906–1998) 139
 Forest Lawn Cemetery, Norfolk

28. Mabel Wood Martin (1888–1956) 143
 Arlington National Cemetery, Arlington

29. Judith Brockenbrough McGuire (1813–1897) 147
 St. John's Episcopal Churchyard, Tappahannock

30. Margaret Prescott Montague (1878–1955) 151
 Hollywood Cemetery, Richmond

31. LaSalle "Sallie" Corbell Pickett (1843–1931) 156
 Hollywood Cemetery, Richmond

32. Margaret Junkin Preston (1820–1897) 161
 Oak Grove Cemetery, Lexington

33. Eudora Woolfolk Ramsay Richardson (1891–1973) 166
 Hollywood Cemetery, Richmond

34. Mary Roberts Rinehart (1876–1958) 171
 Arlington National Cemetery, Arlington

35. Judith Page Walker Rives (1802–1882) 176
 Rives-Troubetzkoy Cemetery, Albemarle County

36. Ruby Thelma Altizer Roberts (1907–2004) 180
 Sunset Cemetery, Christiansburg

37. Sally Berkeley Nelson Robins (1855–1925) 185
 Ware Episcopal Church Cemetery, Gloucester

38. Anne Spencer (1882–1975) 188
 Forest Hill Burial Park, Lynchburg

39. Mary Newton Stanard (1865–1929) 193
 Hollywood Cemetery, Richmond

40. Amélie Louise Rives Chanler Troubetzkoy (1863–1945) 196
 Rives-Troubetzkoy Cemetery, Albemarle County

41. Edna Henry Lee Turpin (1867–1952) 200
 Hollywood Cemetery, Richmond

CONTENTS

42. Marie Teresa "Tere" Ríos Versace (1917–1999) 203
 Arlington National Cemetery, Arlington

43. Susan Archer Talley Weiss (1822–1917) 207
 Riverview Cemetery, Richmond

44. Annie Steger Winston (1862–1927) 211
 Hollywood Cemetery, Richmond

Notes 215
Select Bibliography 251
About the Author 253

ACKNOWLEGEMENTS

I am grateful to the writers' families who shared personal histories and their private collections, especially Katherine Alden. Thank you to Susan Tucker, Betsy Hodges from the Ashland Museum and Carlene Mitchell Bass. I appreciate the support of Kelly Jones Wilbanks of Friends of Hollywood Cemetery, Clayton Shepherd and Jeffry Burden of Friends of Shockoe Hill Cemetery and all the cemetery staff who were willing to guide me and share invaluable records. I wish to thank Dr. Lauranett Lee for her guidance and support on my intial research that led to this project. Thank you to the River City Cemetarians, my friends and loved ones for continuing to listen to me go on about these amazing women writers. Without the encouragement, support and feedback from Johnathan Shipley, this project would not have been possible.

INTRODUCTION

In *The Victorian Celebration of Death*, James Curl argues that cemeteries were held to be good not only for "morals and public health" but also for "virtue, education, the development of artistic taste, sentiment, kindness, appreciation of sculpture and architecture, instruction in botany and landscape-gardening, and much else."[1] In *199 Cemeteries to See Before You Die*, Loren Rhoads argues that many go out of their way to intentionally visit graveyards, noting that cemeteries can be open-air sculpture parks, habitats for birds and wildlife and arboretums and gardens. Cemeteries are places that appeal to "art lovers, amateur sociologists, birdwatchers, master gardeners, historians, hikers, genealogists, picnickers, and anyone who just wants to stop and smell the roses."[2]

For centuries, pilgrimages have been made to burial grounds for various reasons. During the Victorian era, the rise in garden cemeteries, considered our country's first public parks, offered visitors a place for respite and recreation. In 2020, with the coronavirus pandemic, numerous cemeteries across the nation reported an increase in visitors while indoor attractions closed to help slow the spread of the virus. Individuals and families were encouraged to seek outdoor leisure, and while small public parks became crowded, historic cemeteries with acreage to spare regained visitor attention.

The cemeteries of the Commonwealth of Virginia continue to be places of history, places of natural beauty and places with elaborate outdoor art museums. They are safe havens for wildlife; and with physical distancing in the current COVID-19 pandemic, they are safe for the living.

I have always loved cemeteries. As I am a grandchild of a genealogist, some of my earliest and best memories included helping my grandfather look for family members in old cemeteries. These visits always included connections to the family tree and, if we were lucky, a good story. Today, I am an English professor who still loves a good story. I returned to graduate school for public history when my university called on faculty to become more interdisciplinary in our teaching; throughout the program, my research focused on historic cemeteries.

While a cemetery organization's focus is on interring the dead, cemetery Friends' organizations are concerned with the restoration and conservation of monuments, sculptures and ironwork within the cemeteries. They are able to raise money through community outreach efforts and events, including tours and guest speakers, which active cemeteries are unable to do. One hundred years ago, individual families cared for graves. If a monument was damaged, the family would pay to repair or replace it. Today, with families relocating out of the area, many old graves are left to be cared for by Friends' organizations.

After training to become a master guide, I started giving tours of historic Hollywood Cemetery in Richmond. I donated ticket sales and tour tips to the Friends of Hollywood Cemetery. My work with local cemeteries and establishing the community group River City Cemetarians, which includes individuals who visit old cemeteries together, led me to offering tours at historic Shockoe Hill Cemetery in Richmond with tour profits going to the Friends of Shockoe Hill Cemetery. Friends' organizations include volunteers who are dedicated to preserving and sharing information about these historic places.

Raising awareness about the care of historic cemeteries is important to me. When the pandemic suspended tours, I wanted to continue raising awareness, so I set up online meetings where we could read the works of those authors buried in local cemeteries in a program called Reading the Dead. I quickly found myself focused on women writers. I became curious about the few authors I knew were buried locally and then began researching the women writers buried in Virginia cemeteries and reading their writing.

Visitors come to see the resting places of presidents, military generals, artists, actors and authors. There is nothing unique about visiting individuals whose work was admired during their lifetimes. This is how I enjoy history—physically being in the place where history happened helps me connect with that place's past. This is why so many of us love historic walking tours.

In the Victorian era, visitor guidebooks were sold in cemeteries. Today, many historic cemeteries include self-guided maps and online visitor guides.

These guidebooks are heavily focused on military heroes, founding fathers, political leaders and the who's who in that region's history. As a collector of cemetery maps and guidebooks, I often find myself quickly scanning new guides to find the famous or infamous females who helped build a region's history. More often than not, from the dozens of entries, there are usually only a few women mentioned, rendering the majority of women invisible.

I am drawn to public history locations that showcase the women who had an impact on American history. I hope this collection introduces women writers whose works have not been the focus of scholarly attention and that this book inspires readers to visit cemeteries throughout Virginia. A wealth of history can be found standing in the very locations where these women lived and were buried.

The women writers in this book include those who were widely popular during their lifetimes, those whose work may not have lasted the test of time due to the nature or style of the writing, those who still show up in college anthologies and those whose works were made into popular movies. Through this research, I have been introduced to some fascinating women and learned more about writers with whom I was already familiar. This is not an exhaustive list; I continue to find women writers, and I will continue to search for them after this book is published.

Included in this book is a map showing the locations and a brief history for each of the cemeteries. For each writer, I note the cemetery and burial location, an overview of her story, a brief biography, a description of the grave and a section about what not to miss, which includes other women's histories, related historical locations or places near the grave that may be of interest. When naming authors, research studies show that participants reference male writers by using only their last name while with female writers they are more likely to use the full name. Further, using only a last name elevates the writer's status.[3] I do not wish to perpetuate gender bias in this book; however, surnames for women may change throughout their lifetimes. I use full names or initials when necessary for purposes of clarity.

The Cemeteries

There are twenty-three cemeteries represented. The majority includes one or two women writers buried there. Two exceptions include Hollywood Cemetery in Richmond, which has twelve women writers interred, and Arlington National Cemetery, which has five.

Map denoting the approximate locations of the cemeteries where the women writers are buried. *Author's collection.*

Arlington National Cemetery is a 639-acre military cemetery in Arlington, across the Potomac River from Washington, D.C. Established in 1864, it is the country's largest military cemetery and serves as the final resting place for more than 400,000 military veterans. Arlington is currently one of three cemeteries that has two U.S. presidents—Presidents John F. Kennedy and William Howard Taft—buried there. *1 Memorial Avenue | Fort Myer, VA 22211*

Blandford Cemetery is a 189-acre burial ground located in Petersburg, which makes it the second-largest cemetery in Virginia, with Arlington National Cemetery as the largest.[4] With the first burial occurring in 1702, the cemetery is listed on the National Register of Historic Places.[5] *111 Rochelle Lane | Petersburg, VA 23803*

East End Cemetery, chartered in 1897, was originally part of Greenwood Cemetery. The historically African American cemetery was said to be "*the* place to be buried"[6] with the design including "concrete sidewalks and plot enclosures."[7] When parts of the cemetery became overgrown, some exhumed the bodies of family members to rebury elsewhere. The renowned tap dancer and entertainer Bill "Bojangles" Robinson purchased a plot at East End but was buried in New York, as the cemetery did not appear to have regular upkeep.[8] Volunteers have cleared nearly ten acres and uncovered over three thousand grave markers.[9] In 2019, the State of Virginia granted ownership to the Enrichmond Foundation.[10] *50 Evergreen Road | Richmond, VA 23223*

Forest Hill Cemetery, also called Forest Hill Burial Park, is an active cemetery that was established in 1937. It is a historically African American cemetery and also the newest cemetery in Lynchburg.[11] *2310 Lakeside Drive (Rt. 221) | Lynchburg, VA 24501*

Forest Lawn Cemetery is the largest of Norfolk's eight municipal cemeteries. Originally known as Evergreen Cemetery, it was established in 1906 and includes 165 acres. The cemetery is a natural arboretum that "includes 70+ species of trees such as crape myrtles, black walnut trees, dogwoods, live oaks, Chinese fringe trees, and a variety of hollies and maples."[12] *8100 Granby Street | Norfolk, VA 23505*

Forest Lawn Cemetery and Mausoleum in Henrico was established in 1922. The land was known as Myrtle Grove Plantation. Today, the cemetery includes traditional upright headstones with the streets lined with trees. The property includes Emek Sholom Holocaust Memorial Cemetery, which is one of the first memorials erected in the United States to victims of the Holocaust.[13] *4000 Pilots Lane | Richmond, VA 23222*

Fredericksburg Cemetery, also known as Fredericksburg City Cemetery, was established in 1844. The cemetery adjoins the Fredericksburg Confederate Cemetery.[14] Fredericksburg lowered William Street by several feet, and the Fredericksburg Cemetery gate remains locked (and it is in need of some repairs, based on its appearance).[15] Visitors enter through the Confederate Cemetery entrance at the intersection of Amelia Street and Washington Avenue. *1000 Washington Avenue | Fredericksburg, VA 22401*

Hollywood Cemetery is a 135-acre cemetery in Richmond that was opened in 1849 and constructed on the land known as "Harvie's Woods," which was once owned by William Byrd III, the son of the founder of Richmond. The cemetery was designed in the rural garden style, with its name, Holly-Wood, deriving from the holly trees that are found throughout the property.[16] Hollywood is currently one of three cemeteries that has two U.S. presidents—James Monroe and John Tyler—buried there.[17] *412 South Cherry Street | Richmond, VA 23220*

Ivy Hill is a twenty-two-acre active cemetery located in Alexandria. The land was originally used as a family cemetery with burials beginning in 1811. It became a community cemetery in 1856. It is recognized for its protected flora and fauna.[18] *2823 King Street | Alexandria, VA 22302*

Longwood Cemetery was the original cemetery in Bedford until the early 1800s and once included hitching posts for those visiting on horseback.[19] The grave markers vary in design, with many in the older sections including intricate designs and hand carved marble. *1131 Park Street | Bedford, VA 24523*

Maplewood Cemetery is a city-owned cemetery that was established in 1827 and is located a few blocks from downtown Charlottesville. The cemetery includes 3.6 acres.[20] *425 Maple Street | Charlottesville, VA 22902*

Mount Hebron Cemetery was established in 1844 and was added to the National Register of Historic Places in 2009.[21] Today, the cemetery includes five adjoining graveyards within a common enclosure. Mount Hebron is an active cemetery located in Downtown Winchester with in-ground burial, cremation and scatter garden options.[22] *305 East Boscawen Street | Winchester, VA 22601*

Oak Grove Cemetery is located less than a mile from the Virginia Military Institute campus. The cemetery was previously known as Presbyterian Cemetery and renamed Stonewall Jackson Memorial Cemetery in 1863 to honor the Confederate general. In 2020, the Lexington City Council unanimously voted to rename the cemetery once again.[23] *316 South Main Street | Lexington, VA 24450*

Old City Cemetery, which was known as Methodist Cemetery, was established in 1806 on the land donated by John Lynch, the founder of Lynchburg. The cemetery includes twenty thousand burials, with three-quarters being those from African descent, as it was the primary burial site for African Americans from 1806 to 1865. While it is an active cemetery, the twenty-seven-acre "gravegarden" also functions as a wedding venue. With a variety of events and museums on the property, the cemetery attracts more than thirty-three thousand visitors annually.[24] *401 Taylor Street | Lynchburg, VA 24501*

Olive Branch Cemetery, also known as City Park Cemetery, is a city-owned cemetery in Portsmouth. Although the history of the cemetery's establishment is unclear, burials began in the mid-1800s.[25] Olive Branch Cemetery continues to be an active cemetery with approximately twenty-four thousand burials. *Cpl JM Williams Avenue | Portsmouth, VA 23701*

The Presbyterian Cemetery was founded in 1823 by six members of the Presbyterian Church of Lynchburg. The land was purchased from Edward Lynch, son of Lynchburg's founder, John Lynch. The cemetery is approximately thirty-five acres with ten to fifteen thousand burials. *2020 Grace Street | Lynchburg, VA 24504*

The Rives-Troubetzkoy Cemetery is a family cemetery located on the Castle Hill estate. Today, the historic home and gardens include six hundred acres, while a cidery, Castle Hill Cider, occupies another six hundred acres.[26] There is a roadside historic marker, but the estate itself is private property. The gates are open for those wishing to visit the cemetery for research. *6106 Gordonsville Road (Rt. 231) | Cismont, VA 22947*

Riverview Cemetery is a municipal rural cemetery located on the north bank of the James River in Richmond, resting between Hollywood Cemetery and Mount Calvary Cemetery. The City of Richmond purchased fifty-three acres of land in 1887 to establish the cemetery. Opened for burial in 1891, the cemetery offers "dramatic views of the falls of the James."[27] The cemetery layout includes roundabout and meandering roads with trees dotted throughout. Today, the view of the James River is slightly obstructed in the summer due to overgrown vegetation. *1401 South Randolph Street | Richmond, VA 23220*

St. John's Episcopal Churchyard is a small churchyard with approximately two hundred burials located in historic Tidewater Virginia by the Rappahannock River.[28] *216 Duke Street | Tappahannock, VA 22560*

Shockoe Hill Cemetery was the first city-owned burial ground in Richmond, established in 1820 with the first burial in 1822. Originally known as the New Burying Ground, the cemetery is 12.7 acres and includes approximately thirty thousand burials.[29] The cemetery includes several notable burials, including Union spy Elizabeth Van Lew. It was a significant location for author Edgar Allan Poe, who grew up in the area. His foster mother, Frances Allan, along with his first and last fiancée, Sarah Elmira Royster Shelton, are buried here. While the city maintains the cemetery,[30] Friends of Shockoe Hill Cemetery assists with upkeep and improvement, including organizing the placement of government-issue military markers.[31] *Hospital Street | Richmond, VA 23219*

Sunset Cemetery, also known as Christiansburg Municipal Cemetery, was established in 1891. The cemetery had originally been established as a for-profit company, and the stockholders were paid with a free grave plot. In 1914, the cemetery became a nonprofit cemetery. In 2008, the Town of Christiansburg took ownership of the cemetery.[32] The land where Sunset Cemetery resides has a long history. In 1808, a duel resulting in the death of two men took place here and led to duels being outlawed in Virginia.[33] *501 South Franklin Street | Christiansburg, VA 24073*

Ware Parish Church Cemetery is connected to the historic Episcopal church located in Gloucester County, one of the oldest surviving parish churches in the Commonwealth. The first burial was in 1723. There are nine hundred individuals buried at Ware Episcopal Church Cemetery and over one thousand gravestones in the cemetery, which includes many grave markers that were moved from other local family graveyards in order to preserve them.[34] *7825 John Clayton Memorial Highway | Gloucester, VA 23061*

Woodland Cemetery in Ashland was established in 1862 as Civil War soldiers were dying from various diseases in local makeshift hospitals.

Without a cemetery to bury the dead, the burial grounds were set up just west of town.[35] When you first enter Woodland Cemetery, you will notice an open field of upright headstones. An older section toward the back of the cemetery includes obelisks and a tree stone grave marker. *11310 Hanover Avenue | Ashland, VA 23005*

CEMETERY	WRITER(S) INTERRED
ARLINGTON NATIONAL CEMETERY	Estelle Aubrey Brown
	Katherine Boyce Tupper Marshall
	Mabel Wood Martin
	Mary Roberts Rinehart
	Tere Ríos Versace
BLANDFORD CEMETERY	Virginia Emeline Butts Davidson
EAST END CEMETERY	Rosa Dixon Bowser
FOREST HILL CEMETERY	Anne Spencer
FOREST LAWN CEMETERY, NORFOLK	Frances McEntee Martin
FOREST LAWN CEMETERY, RICHMOND	Judith L.C. Garnett
FREDERICKSBURG CEMETERY	Jane Briggs Howison Beale
	Helen Gordon Beale
HOLLYWOOD CEMETERY	Kate Lee Langley Bosher
	Varina Anne "Winnie" Davis
	Varina Anne Banks Howell Davis
	Ellen Glasgow
	Mary Jane Haw
	Mary Johnston
	Margaret Prescott Montague
	LaSalle Corbell Pickett
	Eudora Woolfolk Ramsay Richardson
	Mary Newton Stanard
	Edna Henry Lee Turpin
	Annie Steger Winston

MAPLEWOOD CEMETERY	Julia Magruder
MOUNT HEBRON CEMETERY	Nancy Larrick Crosby Mary Greenhow Lee Mary Tucker Magill
IVY HILL CEMETERY	Constance Fairfax Cary Harrison
LONGWOOD CEMETERY	Letitia McCreery Burwell
OAK GROVE CEMETERY	Mary Anna Morrison Jackson Margaret Junkin Preston
OLD CITY CEMETERY	Lizzie Chambers Hall
OLIVE BRANCH CEMETERY	V.C. Andrews
PRESBYTERIAN CEMETERY	Cornelia Jane Matthews Jordan
RIVERVIEW CEMETERY	Lizzie Petit Cutler Susan Archer Talley Weiss
RIVES-TROUBETZKOY CEMETERY	Judith Page Walker Rives Amélie Louise Rives Troubetzkoy
SAINT JOHN'S EPISCOPAL CHURCHYARD	Judith Brockenbrough McGuire
SHOCKOE HILL CEMETERY	Lucy Norvell Harrison
SUNSET CEMETERY	Ruby Thelma Altizer Roberts
WARE EPISCOPAL CEMETERY	Sally Berkeley Nelson Robins
WOODLAND CEMETERY	Ella Howard Bryan

1

CLEO VIRGINIA ANDREWS, "V.C. ANDREWS"

(1923–1986)
Olive Branch Cemetery, Portsmouth
Garden location I187-8

Cleo Virginia Andrews was an author who used the penname V.C. Andrews, a decision made by her publishers in an attempt to not disclose that she was a woman.[36] Her first novel, *Flowers in the Attic* (1979), was published by Simon & Schuster's Pocket Books imprint, and within two weeks, the contemporary gothic novel reached best-seller lists. The sequel, *Petals on the Wind* (1980), remained on the *New York Times* best-seller list for nineteen weeks. V.C. Andrews's novels have sold over 107 million copies and have been translated into twenty-five languages.[37] Although there are more than eighty V.C. Andrews novels, Cleo Virginia Andrews published only seven during her lifetime. Andrews died of breast cancer in December 1986. Major newspapers carried Andrews's obituary, but with new books being published posthumously—and the Andrews estate hiring a ghostwriter to continue writing novels mimicking the author's style—her death was overlooked by many of her fans.

HER STORY

Cleo Virginia Andrews was born in Portsmouth on June 6, 1923, to a working-class family. Although in interviews she states that her childhood

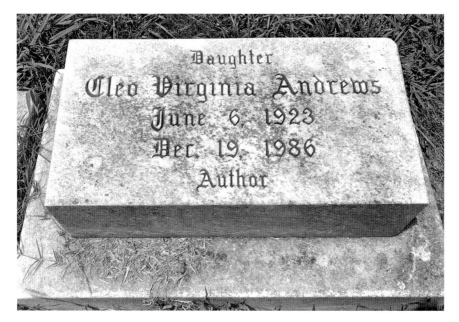

The headstone of author V.C. Andrews. *Author's collection*.

was a happy one, a fall during her teen years resulted in severe back pain and surgeries.[38]

Andrews worked as a commercial artist, portrait painter and fashion illustrator after her father's death in 1957.[39] She began focusing on writing in the 1970s, with her first completed novel *Gods of Green Mountain* being written in 1972, although it would not be released until 2014.[40] Andrews published three gothic romances under a pen name and wrote confession stories, including "I Slept with My Uncle on My Wedding Night."[41] Andrews received a full request for her manuscript *Flowers in the Attic* in 1978. She sold the novel and received an advance of $7,500. By 1981, her third novel received a $75,000 advance.[42]

As the popularity of her novels grew, in 1980, Andrews was interviewed by a reporter for *People* magazine who called her an "invalid" and noted that she had to stand at her desk in order to write, which she frequently did during long stretches of time. She felt the article portrayed her as a disabled and eccentric recluse.[43] Because of this, she refused requests for publicity and interviews, which perpetuated the myth.[44]

In an August 23, 1983 letter to her mother, she writes, "Inside I knew all along that I was someone special and chosen."[45] In 1984, Andrews was named "professional woman of the year" by the City of Norfolk. At this point,

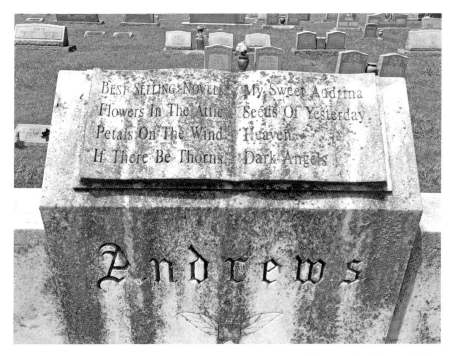

The top of the marker is an open book that lists the author's best-selling novels. *Author's collection.*

her novels had sold millions.[46] With the money, Andrews was able to build a house in Virginia Beach and hired a nurse to assist her when traveling.[47] By 1986, *Flowers in the Attic* was being made into a movie, with Kristy Swanson playing one of the lead roles as the character Cathy Dollanganger. Andrews made a cameo appearance playing the role of a maid. She died from breast cancer before the film was released in 1987.[48] Andrews was buried in Olive Branch Cemetery in Portsmouth, where she had spent her childhood.

In 1993, the Internal Revenue Service required the Andrews estate to pay taxes, arguing that the name V.C. Andrews was valued at $1.2 million. A Norfolk judge, however, ruled that the value of Andrews's name was worth $703,000, which was the first time a court ruled that a deceased person's name was taxable.[49]

THE GRAVE

The memorial includes a large die on base monument and raised top markers for the author and her parents. The author's marker is between the

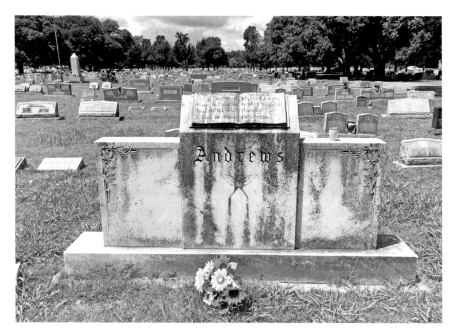

Three individual stones for the author and her parents are in front of this large marker. *Author's collection.*

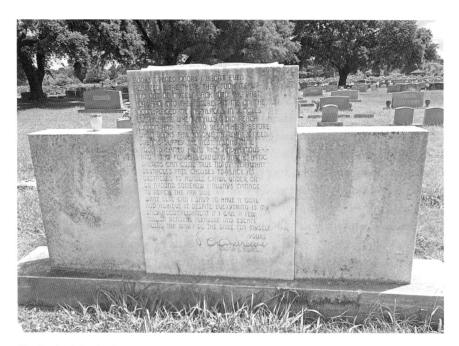

The back of the Andrews marker. *Author's collection.*

markers of her parents. It reads: "Daughter/Cleo Virginia Andrews/June 6, 1923/Dec. 19, 1986/Author." The top of the large family marker reads: "Best Selling Novels/Flowers In The Attic/Petals On The Wind/If There Be Thorns/My Sweet Audrina/Seeds of Yesterday/Heaven/Dark Angels." On the back of the grave marker is a long inscription from the author.

> *Books opened doors I hadn't even realized were there. They took me up and out of myself, back into the past, forward into the future, put me on the moon, placed me in palaces, in jungles, everywhere. When finally I did reach London and Paris—I'd been there before. When books fail to give me what I need, dreams supply the rest. A long time ago I dreamed I was rich and famous—and I saw flowers growing in the attic. Dreams can come true no matter what obstacles fate chooses to place as obstacles to hurdle, crawl under, or go around. Somehow I always manage to reach the far side.*
>
> *What else can I say? To have a goal and achieve it, despite everything, is my only accomplishment. If I give a few million readers pleasure and escape along the way I do the same thing for myself.*
> *Yours*
> *[signature]*
> *Virginia C. Andrews*

HER WRITING

V.C. Andrews's novels include gothic horror with family secrets and forbidden love. Three decades after Andrews's death, her novels are still popular. In 2014, *Flowers in the Attic* was produced by Front Street Pictures Inc. for Lifetime Pictures starring Heather Graham as Corrine Dollanganger and Kiernan Shipka as Cathy Dollanganger. Lifetime has continued to make other films based on Andrews's work, including *Petals on the Wind* (2014), *If There Be Thorns* (2015), *Seeds of Yesterday* (2015), *My Sweet Audrina* (2016) starring India Eisley and William Mosely, *Heaven* (2019), *Dark Angel* (2019), *Fallen Heart* (2019), *Gates of Paradise* (2019) and *Web of Dreams* (2019) starring Annalise Basso, Jason Priestley and Daphne Zuniga. Andrews's novels are still in print and continue being written by a ghostwriter. More details about the upcoming releases can be found on the Simon & Schuster website.[50]

Not to Miss

Approximately eighteen miles from the cemetery is the Grace Sherwood statue (4520–40 North Witchduck Road, Virginia Beach 23455). Called the Witch of Pungo, Sherwood is known as the last person convicted of witchcraft in Virginia. She was a midwife and an herbalist who allegedly "wore men's trousers when planting crops."[51] She was imprisoned for eight years. In 2006, Sherwood was exonerated by the governor on the 300th anniversary of her trial.[52]

JANE BRIGGS HOWISON BEALE

(1815–1882)
Fredericksburg Cemetery, Fredericksburg
Section 8, Lot 86, Stone 18

Jane Briggs Howison Beale was a diarist who is best known for her family's experiences living in Fredericksburg during the Civil War. *The Journal of Jane Howison Beale* was published in 1979 by the Historic Fredericksburg Foundation Inc.; the original diary is on display at the Fredericksburg Area Museum and Cultural Center. The diarist and several of her family members are depicted in the film *Gods and Generals* (2003).[53]

HER STORY

Jane Howison was born in 1815 in Fredericksburg. Her parents were prominent members of the community. At nineteen, she married William Churchill Beale. In 1850, after her husband died unexpectedly, she sold their mill to pay off their debts. She opened a girls' school in her home and took in boarders.[54]

Her journal begins on August 27, 1850, when she writes, "I am sad and lonely…I have been a widow four months and sorrow has made deep inroads upon my mind since that dreadful day." The entries continue until January 20, 1856. In this first part of the diary, readers learn about her daily life, her family and her home. She writes of their possessions, including an

 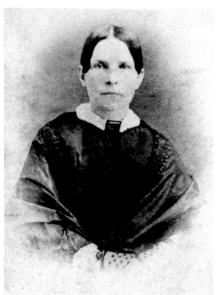

Left: The headstone of diarist Jane Briggs Howison Beale. *Author's collection.*

Right: Portrait of Jane Howison Beale by E. Stuart (Williamsport, Pennsylvania), original negative. *University of Virginia Visual History Collection.*

extensive home library with "valuable reading enough in the house to last 50 years without buying any more books."[55] In the 1860 census, Jane H. Beale is listed as a teacher of the female school.[56]

J.H. Beale's diary reconvenes on July 23, 1861, as she recounts nearby battles and the 1862 occupation of Fredericksburg. Readers have the firsthand experiences of a mother's desperation to gain information about her son's whereabouts during the war and her heartbreak as she learns about his death at the Battle of Williamsburg. A few entries in the diary share her visits to Fredericksburg Cemetery, where she visits her husband's grave.[57] Some of the most cited entries by those interested in the Civil War come from the entries in December 1862, when she and her family are under fire and must flee their home.

After the war, J.H. Beale continued to keep her home as a boardinghouse.[58] By 1880, nearing the end of her life, the census notes she has a disability.[59] J.H. Beale passed away on January 17, 1882. She is buried in a grave next to her husband in Fredericksburg Cemetery.

THE GRAVE

J.H. Beale's headstone sits among members of the Howison and Beale families. Due to weather and age, the epitaph is not legible.

HER WRITING

J.H. Beale's diary is considered one of the best accounts of life in a southern town during the 1850s and 1860s. Historians consider Beale's diary as an invaluable resource for its depiction of life in Fredericksburg before and during the Civil War. Ronald F. Maxwell, the writer and director of the film *Gods and Generals*, read Beale's journal while researching the screenplay.[60] *A Woman in a War-Torn Town: The Journal of Jane Howison Beale* is available from the Historic Fredericksburg Foundation Inc. and is sold by online retailers.

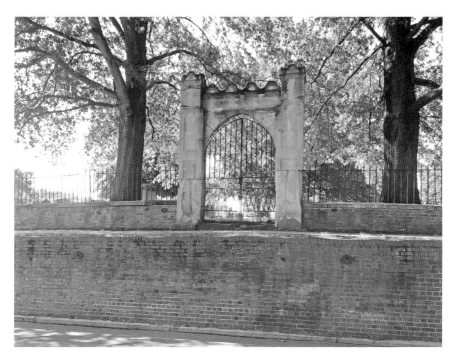

Fredericksburg City Cemetery gate with the lowered William Street. *Author's collection.*

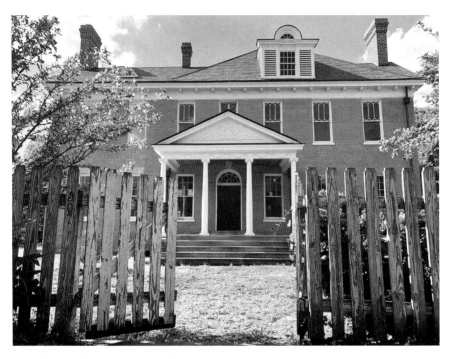

Beale lived at 307 Lewis Street in Fredericksburg. *Author's collection.*

NOT TO MISS

Within walking distance of the cemetery on the corner of Lewis and Charles Streets is the house where J.H. Beale lived while writing about her town during the Civil War. In her diary, Beale notes her house was "untouched" and that she "escaped so much better than any one [*sic*] else."[61] Her home was not burned or looted. She continued to live in this house until her death.

3

HELEN GORDON BEALE

(1834–1885)
Fredericksburg Cemetery, Fredericksburg
Section 8, Lot 86, Stone 21

Helen G. Beale was a teacher and the author of the serial publication "Lansdowne" (1868). She was the daughter of diarist Jane Howison Beale, whose writing recounted the family's experiences living in Fredericksburg during the Civil War. Like her mother, Helen G. Beale spent the day of the bombardment of Fredericksburg on the cellar floor with her family.

HER STORY

Helen G. Beale was born to Jane Howison Beale and William C. Beale in Fredericksburg on November 5, 1834. When her father died in 1850, Beale was just a teen. She was educated by Reverend G. Wilson-McPhail, who taught at a female seminary in Philadelphia; served as the president of Davidson College, a private liberal arts college in Davidson, North Carolina, and Lafayette College, a private liberal arts college in Easton, Pennsylvania; and was a director at Princeton Theological Seminary in Princeton, New Jersey.[62]

From J.H. Beale's journal entries, Helen G. Beale was away from home in September 1850: "The next letter I opened was from my eldest daughter

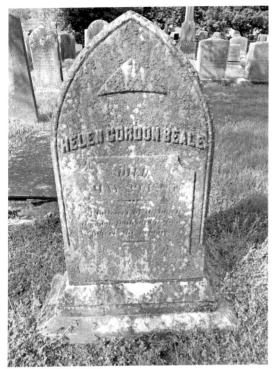

Left: The headstone of author Helen G. Beale. *Author's collection.*

Below: Fredericksburg City Cemetery. *Author's collection.*

and I always feel as if I were poring over the pages of some delightful author when reading her letters."[63]

In an October 5, 1850 entry, her mother writes, "My eldest daughter has commenced her studies with an energy which promises success in the acquisition of knowledge and as I watch the openness of her superior mind, I feel that her career in life will be a useful one." J.H. Beale also explains that her daughter was more dependent on herself for happiness. She writes that "she is of a quiet turn of mind not easily excited, and makes very few outward demonstrations of her feelings whether pleasurable or sad….Shut her up in a room by herself and you need only fill her little table with books and she is perfectly content." She expresses concern that "she is too dreamy and imaginative now to be useful, and we must not live for ourselves in this world."[64] Like her mother, in the 1860 census, Helen G. Beale is listed as a "teacher of female school."[65] In the 1870 census, Helen G. Beale is listed as a teacher, although in 1868, she could have added writer to her occupation, as she had her work "Lansdowne" published serially in the Baltimore weekly journal *Southern Society*.[66]

Helen G. Beale focused on being the best possible teacher, and her days were filled with educating and caring for young children. "Lansdowne," she explains, was written "one winter, in the evenings, after tea, for amusement."[67] The piece was well-received by readers and critics.[68]

The 1880 census lists Helen G. Beale as living at home with her family. She no longer worked as a teacher.[69] She never married, and on May 29, 1885, just three years after her mother's death, Helen G. Beale died. She was fifty years old. She is buried near family members, including her mother, in Fredericksburg Cemetery.

The Grave

Helen G. Beale's grave marker is a headstone resembling a gothic arch. It sits among members of the Howison and Beale families. Due to weather and age, the epitaph is not legible.

Her Writing

H.G. Beale's writing was included in the *Southern Society* journal, which focused on elegant and imaginative literature as well as creative fiction

based on war stories that excluded any "political subjects."[70] At the time of the journal's publication, Professor F.A. Marsh of Easton, Pennsylvania, argued that H.G. Beale's writing "is decidedly worthy of the honor of appearing in book form, on the score of its value as a memorial of the society which it depicts."[71] "Lansdowne" was not published as a book, and the *Southern Society* journal remained in operation for less than one year.[72] Copies of the serial are rare.

NOT TO MISS

Within walking distance of the grave is the Fredericksburg Masonic Cemetery, where Christiana Campbell, a prominent tavernkeeper from Williamsburg, is interred. Campbell specialized in offering genteel accommodations and entertainment to a clientele that included Presidents George Washington and Thomas Jefferson. Her tavern burned down in 1859 but was reconstructed in 1956 by the Colonial Williamsburg Foundation.[73]

KATE LEE LANGLEY BOSHER

(1865–1932)
Hollywood Cemetery, Richmond
Section: 16-129

Kate Lee Langley Bosher was a suffragist and one of the most noted Virginia authors during her lifetime.[74] Her most popular novel, *Mary Cary, "Frequently Martha"* (1910), sold over 100,000 copies within the first year of its release. The story of a spunky orphan who navigates her life in an orphanage with a corrupted caregiver was a huge success. The novel was adapted into the 1921 silent feature *Nobody's Kid* starring Mae Marsh as Mary and directed by Howard Hickman. Upon her death, Bosher's estate was valued at $165,000, equivalent to about $3 million today.[75]

HER STORY

Kate Langley was born in Norfolk on February 1, 1865, to Charles Henry Langley and Portia Virginia Deming Langley. She attended the Norfolk College for Young Ladies and later moved to Richmond in 1887 when she married Charles Gideon Bosher. She would live in Richmond for the next forty-four years, write ten novels and take part in civic and political organizations.[76]

Bosher wrote commercial fiction that was quite popular in her day, yet she joked that she did not look the part of a writer. In 1912, while attending

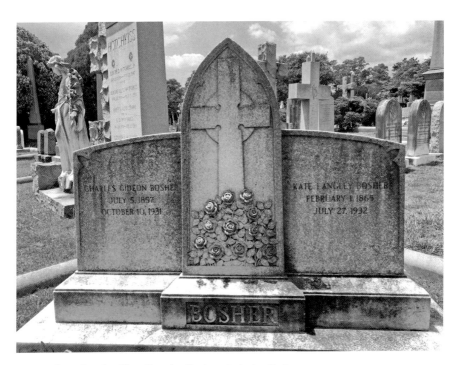

The marker of author Kate Langley Bosher. *Author's collection.*

a national meeting of booksellers, she denied she was *literary*, although she had written three novels in three years. She shared an anecdote about being introduced to a woman who inquired if she was *"the* Mrs. Bosher who writes?" When Bosher responded she indeed was the writer, she hung her head; the woman responded, "Nobody would ever guess it from looking at you."[77]

Although the anecdote makes Bosher appear unassuming, this was the same year she spoke before the Virginia House of Delegates on the rights of women. Bosher was one of the founding members of the Equal Suffrage League of Virginia, where she used her writing talent to publish a pamphlet for the cause. Not a passive spectator, Bosher spoke in front of various audiences, including the Virginia Press Association in 1916. She was elected president of the Equal Suffrage League of Virginia in 1919,[78] and she became a leader in the League of Women Voters in 1920.[79]

While Bosher continued to be involved with women's rights, she also advocated for children even though she did not have any of her own. She wanted all children to have safe homes and good educations. In 1916 and

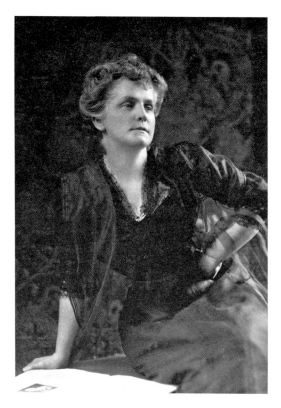

Portrait of Kate Langley Bosher.
Courtesy of Katherine Alden Family Collection.

1922, the governor appointed her to the board of the Virginia Home and Industrial School, a reformatory for girls. In her will, Bosher bequeathed money to the Children's Home Society in the hopes of placing children in permanent homes.[80] Bosher died on July 27, 1932, of bronchopneumonia at sixty-seven years old, nine months after her husband's death.[81] She is buried in Hollywood Cemetery.

THE GRAVE

Kate Langley Bosher shares a grave with her husband, Charles Gideon Bosher. The marker is die on base with the center featuring a gothic arch that stretches above the sides of the stone. The arch includes a large cross. At the foot of the cross is an arrangement of engraved roses. Below the arch is the family name, Bosher. Traditional inscriptions with birth and death dates are included on either side of the arch.

Her Writing

Bosher wrote popular fiction set in Virginia or other southern locations that focused on the experiences of southerners after the Civil War. Her writing is considered "sentimental and romantic; her characters are lively and their adventures amusing."[82] Bosher's writing is accessible in Project Gutenberg, an online library of free eBooks. Her personal archives remain with her descendants.[83]

Not to Miss

While numerous women's rights activists are buried in Hollywood Cemetery, Mary Johnston (1870–1936) was a popular author whose writing lent a voice to women's suffrage and who worked closely with Bosher. While looking directly at Bosher's grave, to the right, buried in section 16-126/128, is the grave of Mary Johnston.

ROSA DIXON BOWSER

(1855–1931)
East End Cemetery, Richmond
GPS Location: 37°32'11.4"N 77°23'09.6"W

Rosa Dixon Bowser was an educator, civic leader, suffragist and writer who was an instrumental leader in Richmond's African American community. She served as president of the Virginia State Teachers Association, founded the Richmond Woman's League and became the organization's first president.[84] She also helped found the National Association of Colored Women. The first branch of the Richmond public library to be opened to African Americans was named after Bowser.[85]

HER STORY

Rosa Dixon was born on January 7, 1855, in Amelia County to Henry Dixon and Augusta A. Hawkins Dixon. Her father was a carpenter and her mother was a domestic servant. After the Civil War, the Dixon family moved to Richmond, where she was enrolled in the city's public schools. She excelled at her studies and became a schoolteacher. She married fellow teacher James Herndon Bowser, who died of tuberculosis within two years of their marriage. The couple had one son, Oswald Barrington Herndon Bowser.[86]

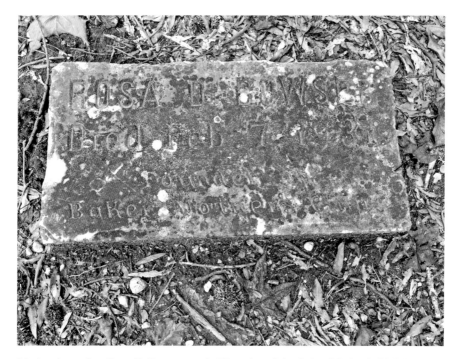

Marker for author Rosa D. Bowser reads "Founder of the Baker Mother's Club." *Author's collection.*

Rosa D. Bowser's career as an educator began in 1872. By 1884, Bowser was supervising teachers at the Baker School in Richmond. By 1896, she had become the principal. Bowser established reading circles for teachers as a way to share classroom strategies, which, in 1887, led to the formation of the Virginia Teachers' Reading Circle, the first professional African American educational association in the state.[87] Bowser was a member of the Woman's Era Club, an organization that raised money to create kindergartens for African American children.[88]

For *Woman's Era*, she wrote articles focused on freedom, women's advocacy and civil rights.[89] In 1902, her article "What Role Is the Educated Negro Woman to Play in the Uplifting of Her Race?" was published in a collection of African American literature.[90] That same year, another article, "The Mother's Duty to Her Adolescent Sons and Daughters," was published.[91]

Bowser was an active voice in the community, working with other renowned Richmond leaders to assist those in need. In 1912, when a young woman was being sentenced to death for murder, combining efforts with other community leaders, Bowser appealed to the governor of Virginia, to no avail.[92]

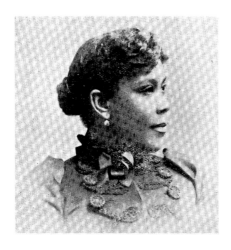

This portrait of Rosa Dixon Bowser was included in *Women of Distinction: Remarkable in Works and Invincible in Character* (1893).

Bowser publicly opposed lynching and racial segregation. She was an advocate for universal woman suffrage. Bowser immediately registered to vote in her precinct on the first day Virginia women were permitted after the Nineteenth Amendment of the U.S. Constitution was ratified.[93] Her words, which originally were directed toward motherhood, resonate with her work in social justice:

> *The good must be encouraged, cultivated and developed, while that which is bad must be discountenanced, condemned and repressed.*[94]

Bowser retired from teaching in 1923. In 1925, to recognize her contributions to the community, the first branch of the Richmond public library that was opened to African Americans was named in her honor.[95]

Bowser died on February 7, 1931, from complications with diabetes.[96] According to her death certificate, she was buried in Greenwood Cemetery. In 1897, the cemetery originally named Greenwood was renamed East End Cemetery, although the original name would continue to be used.[97]

THE GRAVE

Bowser's grave includes two markers. One is a large granite slant marker on base including her name, birth and death dates and a burning oil lamp. The other marker is a lawn level marker that includes her name; her death date, February 7, 1931; and the inscription "Founder of the Baker Mother's Club."

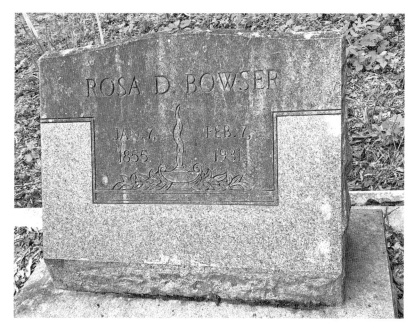

A newer grave marker for Rosa D. Bowser includes her birth and death date. *Author's collection.*

Bowser family plot showing the author's two gravestones. *Author's collection.*

East End Cemetery. *Author's collection.*

One unique feature of Bowser's grave and other graves in East End Cemetery is the erection of multiple grave markers for one individual. Members of the Friends of East End Cemetery explained, "We've encountered burials at East End that have up to five gravestones, each inscribed with a different benefactor. We've seen where family members, friends, employers, churches, fraternal orders, and beneficial societies contributed a gravestone."[98]

For Bowser's grave, members of the Friends of East End Cemetery stated, "We assume her family provided the large granite stone, while the Baker Mother's Club (inscribed) provided the rectangular marble gravestone—both exist in the same plot."[99]

HER WRITING

Bowser's writing was political in nature and focused on freedom, women's advocacy and civil rights. Bowser's writing can be found online through the Emory Women Writers Resource Project Collections[100] and in eBook format.

Not to Miss

Next to East End Cemetery is Evergreen Cemetery, which includes the grave of Maggie Lena Walker. Walker was an African American businesswoman and in 1903 became both the first African American woman to charter a bank and the first African American woman to serve as a bank president.[101]

6

ESTELLE AUBREY BROWN

(1877–1958)
Arlington National Cemetery, Arlington
Section 7, Grave 9813

Estelle Aubrey Brown was a teacher and a writer of fiction and nonfiction whose work appeared in *The Century*, *Ladies Home Journal*, *Travel*, *Psychology*, *Plain Talk* and *Sunset* magazines. She wrote three books: *With Trailing Banners* (1930), *Around Two Worlds* (1938) and *Stubborn Fool* (1952), an autobiographical narrative of her experience working in the U.S. Bureau of Indian Affairs Schools from 1902 until 1918.

HER STORY

Estelle M. Aubrey was born on January 3, 1877, to James Nelson Aubrey and Alta Augusta Hastings Aubrey in Constable, New York. She attended the Malone Academy and Chateaugay Normal School in New York, where she received her teaching certificate. She taught in rural New York schools from the age of sixteen to twenty-five.[102]

In her autobiographical narrative, *Stubborn Fool*, she argues for her own way of making a living:

> *The marital knot…tied biology to the gold standard, as represented by masculine purses. I wanted a purse of my own.*[103]

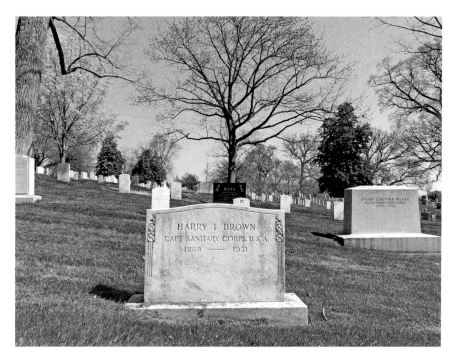

The grave of author Estelle Aubrey Brown. Only her husband's name is listed on the grave. *Author's collection.*

In 1897, she married Gibson William Cunningham in Bangor, New York. Their marriage did not last long, as he was remarried by 1901.[104] In 1903, while working for the Bureau of Indian Affairs Schools, she took a kindergarten teaching position at the Crow Creek Industrial Boarding School near Chamberlain, South Dakota. She was not able to communicate clearly with the children and struggled with the position. Her view of the Bureau of Indian Affairs policy was not positive, and she believed the purpose of the school was not quite natural. She writes, "I instinctively felt that, in teaching Indian children to like and want the things we liked and wanted, we were headed in the wrong direction."[105]

Noticing a lack of classroom materials, Aubrey spent a substantial proportion of her earnings on magazine subscriptions.[106] She criticized the schools for underfeeding their students. She writes, "These children drank coffee three times daily. For that there was no sugar, nor milk. Butter, cheese, fresh fruit, and vegetables were never seen in that dining room."[107] Although Aubrey did not view the bureau's overall treatment of the children positively, she continued working in hopes of making small improvements.

From 1904 to 1906, Aubrey worked at the Seneca Indian Training Boarding School with students from Peoria, Ottawa, Quapaw, Modoc, Seneca, Eastern Shawnee, Miami and Wyandotte tribes. In 1904, at the age of twenty-seven, she married Silas Armstrong, the sixty-year-old son of a wealthy Wyandot Indian chief. He died in 1907.[108]

From 1907 to 1908, Aubrey worked at the Carlisle Industrial Boarding School in Carlisle, Pennsylvania. She resigned from the position due to her mother's illness; that same year, her father died.[109]

Aubrey was reappointed as assistant matron to Fort Yuma in Yuma, Arizona, where she worked from 1908 to 1909. She then moved to the Leupp School, where she worked as an assistant clerk from 1909 to 1910. In a twelve-year period working for the bureau, she ended up holding nine positions.[110]

In 1918, she married Major Harry Brown. They traveled and worked with the American Red Cross in Paris.[111] By 1921, the couple had made their home in Washington, D.C., and Estelle Aubrey Brown was recognized as a writer. She organized a short story class for beginners associated with the district's branch of the League of American Pen Women. During the fall of 1924, Brown was honored for her contributions.[112]

Having returned to Arizona for her husband's army transfer, Brown contributed to the Phoenix women writers group affiliated with the National League of Pen Women.[113] By 1930, she had published her first book, *With Trailing Banners* (1930).[114] Major Brown passed away the next summer in 1931.

Estelle A. Brown continued to write. Her second book, *Around Two Worlds*, was published in 1938.[115] She wrote for newspapers throughout her career, and in 1939, Brown's play *A Woman of Character* was performed in Atlantic City, New Jersey.[116] Her last book, *Stubborn Fool*, was published in 1952.[117]

Brown was an active member of the Daughters of the American Revolution and the League of American Pen Women. Her biography appeared in *Women of the West*, *Who's Who in America* and *Principal Women in America*.[118]

Estelle A. Brown died on January 23, 1958, in Arizona, where she had lived for over twenty years. She was cremated, and her ashes were sent to Arlington National Cemetery, where her husband, Major Harry Brown, was buried.[119]

THE GRAVE

Estelle Aubrey Brown shares a private die on base monument with her third husband. The gravestone includes the inscription for her husband,

Arlington National Cemetery. *Author's collection.*

"Harry T. Brown/Capt. Sanitary Corps. U.S.A./1868–1931." Her name is not inscribed on the grave.

HER WRITING

Estelle Aubrey Brown's writing is a personal account of her life. In 2017, her work *Stubborn Fool* was reproduced by Andesite Press and can be found online for purchase.

NOT TO MISS

Arlington National Cemetery includes a list of Prominent Women on its website. Not far from Estelle Aubrey Brown's resting spot is the Nurses Memorial in section 21, which includes a memorial designed by Frances Rich, a Smith College graduate who studied art.[120]

ELLA HOWARD BRYAN, "CLINTON DANGERFIELD"

(1872–1954)
Woodland Cemetery, Ashland
Section: 426 West, Grave: 3

Ella Howard Bryan used the pseudonym Clinton Dangerfield. Known as a writer of westerns and pulp fiction, Dangerfield wrote poetry, short stories and novels, with the original piece "Behind the Veil" (1899) driving the journey of what would become a lifetime career in writing, receiving praise from literary critics and even President Theodore Roosevelt.

HER STORY

Ella Howard Bryan was born on February 19, 1872, to Major Henry Bryan and Jane Wallace Bryan in Savannah, Georgia. She was educated at home. Through letters with her cousin Joseph Bryan, the renowned newspaper publisher in Richmond, the two discussed finances, family history and other personal matters. In one letter dated May 6, 1895, Ella H. Bryan mentions that both she and her brother had chosen agriculture for their professions.[121]

In 1897 at the age of twenty-five, she moved to Cambridge, Massachusetts, to work as a governess until she published her first novella in 1899.[122] At that point, she immediately returned home to pursue writing as a career.

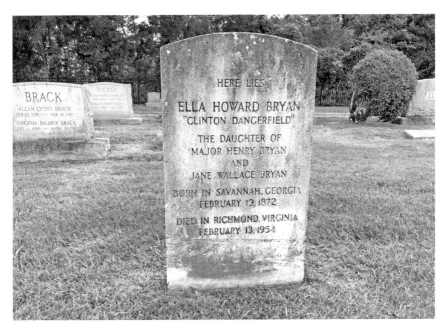

The headstone of author Ella Howard Bryan, who wrote under the penname "Clinton Dangerfield." *Author's collection.*

Her letters reveal that the Howard family was poor and that they struggled to have enough money to pay the debts on their home. On July 5, 1902, Ella H. Bryan writes she "hates the American way of living only one or two generations on a piece of land."[123] In order to save their ranch, the family decided to sell their family possessions from their more famous ancestors, including her great-great-grandfather General Jonathan Bryan "of revolutionary fame, who defended Savannah against the British, and for whose head the British offered a fabulous reward."[124]

By 1902, the author would spend about six hours per day writing poems and short stories while also working on a novel.[125]

In a letter to Joseph Bryan dated July 5, 1902, which marks the first time she uses a typewriter for a letter, her humor comes through as she speaks about marriage and the benefits of being single:

> *I like to have you speak enthusiastically of marriage—but you mustn't forget that we are not all as good as Cousin Belle. As Ella Bryan, I get on very well with people—as Mrs. Smith I might be throwing teacups at my husband's head. Marriage is very beautiful, no doubt Swedenborg was right*

when he said that it is an ideal state, but single life is not without arguments in its favor.[126] *Above all, if you are happy where you are, where is the logic in being anxious to see if you could be happy under other conditions.*

I don't talk heresy like this outside! When I write stories, I marry the hero and heroine in the most approved style.[127]

Later in this same letter to her cousin, she mentions *overworking* is part of their family inheritance. Although she would go on to produce seventy short stories, poems and novels, she writes, "Indeed, I am the only comfortably lazy person on the place."[128]

The only known picture of Bryan was sent to President Theodore Roosevelt after he wrote to the editor to inquire about Clinton Dangerfield. In a letter dated November 12, 1901, from President Roosevelt at the start of his presidency, he writes to Bryan about one of her recent poems only after learning her identity.[129] While the president had learned who Clinton Dangerfield was, her identity was not revealed publicly until a newspaper printed an exposé in 1902.[130] Instead of an adverse response, she became the talk of literary circles and made headlines. Her family history, with a Revolutionary War hero and a renowned female novelist, usually took up much of the space in these articles, keeping Dangerfield a bit mysterious.[131] Six years after the first letter, Roosevelt wrote to Bryan requesting she dine with him at the White House on November 18, 1907.[132]

Bryan lived at Lookout Mountain in Georgia, but she also traveled to visit friends and family. She lived in New York and Florida; spent time in Chattanooga, Tennessee; and finally made her way to Virginia.[133]

Throughout the early 1900s and 1910s, Bryan showed up in the *Chattanooga News* society section quite frequently as a visitor of the town. Bryan traveled to various cities, where she would visit and stay with family and "a large number of friends."[134] Her close friends included a circle of women writers, among them her dear friend Mrs. Mark Morrison (Caroline Wood Morrison), an author who wrote with "The MacGowan Girls."[135]

Bryan's story "Vain Justice" was made into a film in 1915.[136] In 1917, she headed to New York, where she was "engaged in the production of short stories and moving picture scenarios."[137]

While Bryan's writing was gaining more attention, she experienced personal loss. Her close friend Caroline Morrison died in 1919.[138] Her sister died in 1921, and their mother, Jane Wallace Bryan, died in 1922.[139]

For much of the 1920s, there is little information in the papers except a mention she was taking an "indefinite stay" in Florida.[140] Bryan would have

The only known photograph of Ella Howard Bryan. *Theodore Roosevelt Papers, Library of Congress Manuscript Division.*

been forty-eight years old in 1920. Women of a certain age can become overlooked, yet she continued to publish stories and books into the 1930s and is mentioned in a 1944 Chattanooga article that reminisces about the women writers who used to frequent the town.[141]

Around 1940, Bryan's adventures slowed down, and she settled in Ashland, not quite twenty miles north of Richmond. Ashland resident Carlene Mitchell Bass, who graduated from high school in 1950, still remembers seeing the author in town. She shared that while in her teens she saw Ella Howard Bryan walking to and from the post office and the train station, approximately two blocks. The author would have been about seventy-eight years old at the time. Bass believed she was seeing the author send off her manuscripts to the publisher. She recalls Bryan was "reclusive," "stern" and "foreboding," almost "like a witch" with her hair pulled back in a bun. She does not recall seeing the author with anyone but remembers she always "dressed in black with a high lace collar."[142] Bryan lived in Ashland until she entered a nursing home in Richmond just a few years before her death on February 13, 1954, at the age of eighty-one.[143]

THE GRAVE

Bryan's headstone includes her penname as well as her lineage being the daughter of Major Henry Bryan of the Civil War and Jane Wallace Bryan. Near the end of her life, Bryan purchased five cemetery plots in Woodland Cemetery. She never married and did not have any children. Her family members had all passed away. Upon her death, her will noted she wished to be buried in the middle plot, leaving two empty plots on either side of her grave.[144] Woodland Cemetery has continued to respect Bryan's wishes by not selling the vacant plots beside her.[145]

Her Writing

Although Clinton Dangerfield's work was quite popular in her day, commercial fiction does not have the same lasting power as literary works. Fortunately, many of her stories have been made available as Kindle eBooks. The author's archival papers are available at the Georgia Historical Society.[146]

Not to Miss

Approximately one mile from the cemetery is the Ashland train station. Ashland is known affectionately by residents as the "Center of the Universe" for its central location within the state. Ashland was originally developed by the RF&P Railroad as a resort for Richmond residents.[147] Today, the railroad tracks are still in use by Amtrak. Down the street from the train station is the Ashland Branch of the Pamunkey Regional Library, which is on land where the author once lived.[148]

8

LETITIA "LETTIE" McCREERY BURWELL

(1831–1905)
Longwood Cemetery, Bedford
Sec II–Lot 40

Letitia McCreery Burwell was a diarist and author of *A Girl's Life in Old Virginia Before the War* (1895), which documented her life at Avenel Plantation, a manor house built in 1838 on forty acres in Bedford. Renowned guests included Confederate general Robert E. Lee and possibly the author Edgar Allan Poe.[149]

Her Story

Letitia "Lettie" McCreery Burwell was born on August 16, 1831. Her father, William Burwell, served in the Virginia House of Delegates. He was a classmate of author Edgar Allan Poe while at the University of Virginia, and it is speculated the author may have visited Burwell while visiting Bedford.[150]

William Burwell was away from home quite frequently. Letitia's mother, Frances Steptoe Burwell, tended to the daily tasks of the home. After the Civil War, Letitia Burwell's father left his family and moved to New Orleans during Reconstruction, only returning to Avenel on his deathbed in 1888.[151]

Letitia Burwell was a diarist throughout her life; in 1895, wanting to document life on the plantation where she grew up, she wrote *A Girl's*

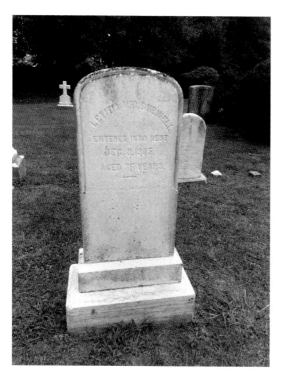

Left: The headstone of Letitia McC. Burwell. *Author's collection.*

Below: A gravestone in Longwood Cemetery showing the detail in craftmanship. *Author's collection.*

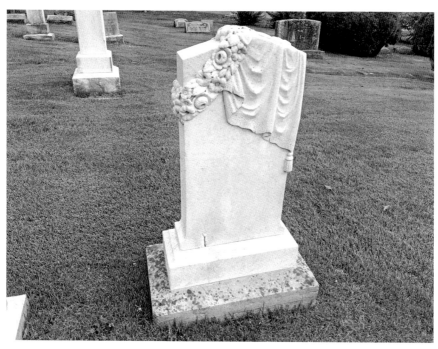

Life in Old Virginia Before the War. She opens her diary, explaining her upbringing, "My lot in life cast on a Virginia plantation, my ancestors, for nine generations, owners of Virginia plantations," and further notes she was "confined exclusively to a Virginia plantation during [her] earliest childhood."[152]

The plantation, which was part of Burwell's mother's dowry, was left to Letitia M. Burwell in 1899 when her mother died.[153] She remained on the estate until her death on December 8, 1905.[154] She is buried in Longwood Cemetery in Bedford. The following year, Avenel was purchased by J.W. Ballard and remained with that family until 1985, when it was purchased by the Avenel Foundation.[155]

THE GRAVE

The gravestone is a die in socket. The epitaph reads: "Letitia McC. Burwell/Entered Into Rest/Dec. 8, 1905/Aged 75 Years/He giveth his beloved sleep." Her grave is near her parents' graves and the graves of two of her sisters, Catherine Steptoe Burwell Bowyer and Fannie Burwell Breckinridge.

HER WRITING

Letitia Burwell's writing offers a glimpse into the lives of women in the antebellum South. Today's readers will likely find the depictions of enslaved Africans problematic. The text also includes an account of "modern" women of the 1890s, including how scandalous it was for these new women to work and travel alone without being accompanied by their male guardians. Burwell argues, "It is certain that these widely opposed methods must result in wholly different types of feminine character."[156] *A Girl's Life in Old Virginia Before the War* (1895) can be found for purchase online and accessed for free through Project Gutenberg's online library.

Letitia Burwell was not the only writer in the family. Her youngest sister, Rosalie "Rosa" Burwell Todd, wrote for popular magazines and penned *Virginia Hospitality in the Fifties and Sixties* (1910), which recounts a visit by General Lee in 1867.[157] Rosa B. Todd was buried in Rosehill Elmwood Cemetery in Daviess County, Kentucky.

Longwood Cemetery. *Author's collection.*

NOT TO MISS

Less than one mile from the cemetery is Historic Avenel Plantation, which is listed on the National Register of Historic Places and the Virginia Landmarks Register.[158] Today, Avenel has been restored and is rented for weddings and parties and offers historic tours. It is located on the Virginia Civil War Trail.[159] Avenel is also a popular destination for paranormal investigators and for those who enjoy ghost tours, as it is considered one of the more haunted sites in the area.[160] Considered one of the top fifteen haunted places in Virginia, hauntings include a child, a ghost cat and the white lady.[161]

A year after Letitia Burwell's death, apparitions of a "Lady in White" began to be reported on the property. The house name, Avenel, derives from a family name of characters in *The Monastery: A Romance* (1820) by Sir Walter Scott. Not so ironically, the novel includes a spirit known as the "White Lady of Avenel."[162]

9

NANCY LARRICK CROSBY

(1910–2004)
Mount Hebron Cemetery, Winchester
Section B Plot 331

Nancy Larrick Crosby was an author and an internationally recognized expert on reading. She was an editor of over twenty anthologies of poetry for children and also a founder and past president of the International Reading Association. Her groundbreaking article was for the *Saturday Review of Literature* in 1965, "The All-White World of Children's Books." She was honored in Virginia as a laureate for authors and educators in 1992.[163]

HER STORY

Nancy Larrick was born on December 28, 1910, in Winchester to Nancy Nulton Larrick and Herbert Scaggs Larrick. She attended Goucher College in Towson, Maryland, and followed her mother's path of becoming an English teacher. In 1936, she earned her master's degree in education from Columbia University in New York. During World War II, she worked as an education director for the U.S. Treasury Department. Afterward, she became involved in publishing as an editor for *Young America Readers.*[164] In 1949, she cowrote *Printing and Promotion Handbook.* From 1952 to 1959, she worked at Random House as the education director in the children's book department. In 1955, she earned a doctorate in education from New York University.[165]

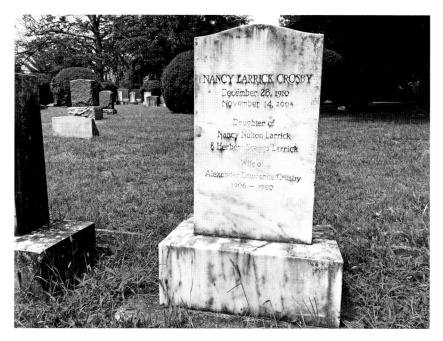

The gravestone for author and educator Nancy Larrick Crosby. *Author's collection.*

On February 15, 1958, Nancy Larrick, who was forty-seven years old, married Alexander Lawrence Crosby, a freelance writer, reporter and author of thirteen children's books.[166] He was also a lecturer at Lehigh University in Bethlehem, Pennsylvania.[167] That year, continuing to write under the name Larrick, she published *A Parent's Guide to Children's Reading*. She continued to write for other teachers, including *A Teacher's Guide to Children's Books* (1960) and *A Parent's Guide to Children's Education* (1963).[168]

From 1964 to 1979, Nancy Larrick Crosby worked as an adjunct professor at Lehigh University. She also taught at NYU and Indiana University. She wrote dozens of articles for education journals and dozens of anthologies for children, including *You Come Too: Poetry of Robert Frost* (1959), *Piping Down the Valleys Wild* (1967) and *Crazy to Be Alive in Such a Strange World* (1977).[169]

In 1965, she wrote "The All-White World of Children's Books" for the *Saturday Review of Literature*; the article focuses on the absence of diversity in books for young readers and advocates for change. She retired from Lehigh University in 1979 but continued writing, editing, attending conferences and lecturing.[170]

Her husband passed away in late January 1980. Afterward, Nancy Larrick Crosby returned to her home in Winchester. In 1991, she edited *To Ride a*

Mount Hebron Cemetery. *Author's collection.*

Butterfly: Original Pictures, Stories, Poems & Songs for Children by 52 Distinguished Authors & Illustrators.[171]

Nancy Larrick Crosby received numerous honors, including being named to the Reading Hall of Fame in 1977 and being named to the list of "Seventy Women Who Have Made a Difference in the World of Books" by the Women's National Book Association in 1987.[172] She was honored in Virginia as a laureate for authors and educators in 1992.[173] During her speech at the International Reading Association in 1996, she recalled her experiences throughout her career, "My early experience as a classroom teacher in Virginia and now my involvement in the production and use of children's literature in the classroom and in the home had strongly influenced my philosophy of education."[174]

Through her work and talks at conferences, she was able to reach other teachers to help mold their pedagogies. On November 14, 2004, Nancy Larrick Crosby died in Winchester. She was ninety-three.[175]

THE GRAVE

Nancy Larrick Crosby's gravestone is a die on base, and her epitaph reads: "Nancy Larrick Crosby/December 28, 1910/November 14, 2004/ Daughter of Nancy Nulton Larrick &/Herbert Scaggs Larrick/Wife of/ Alexander Lawrence Crosby/1906–1980."

HER WRITING

Nancy Larrick Crosby's writing focuses on pedagogical materials for educators and literature for children. Her books can still be purchased, and her articles can be found online.

NOT TO MISS

Within walking distance from the cemetery is the Ruth Jackson Memorial Park, located on the property that was once Ruth's Tea Room. Ruth E.P. Jackson owned the establishment on the corner of East Cecil Street and South Kent Street from 1925 to 2005 and welcomed all patrons regardless of race.[176] Ruth's Tea Room was included in the *Green Book*, a guide for African American travelers during Jim Crow segregation laws.[177]

10

ELIZABETH "LIZZIE" PETIT CUTLER

(1831–1902)
Riverview Cemetery, Richmond
Plot B, Division 3, Grave 4

Lizzie Petit Cutler was a popular author and orator in Virginia and New York. She wrote *Light and Darkness* (1855), *Household Mysteries* (1856) and *The Stars of the Crowd, or Men and Women of the Day* (1858).

HER STORY

Lizzie Petit was born in Milton in 1831. Her maternal ancestors included Monsieur Jean Jacques Marie René de Motteville Bernard, who married in Virginia and lived on his wife's family estate on the James River. Petit's mother passed away when she was young.[178] While there are limited records about her family, biographies share that she lived with her grandmother and aunt near Charlottesville, where she attended a seminary until she was fourteen. She also had private tutors.[179]

In 1855, she wrote her first novel, *Light and Darkness*. It was a successful piece that was republished in London and translated into French. In 1856, her second novel, *Household Mysteries, a Romance of Southern Life*, was published.[180]

> *Within the world of her own home, a woman of fine intellect and feelings may…create an atmosphere redolent of all that the most dreamy and ideal worshipper of the holy and beautiful could desire.*[181]

The grave of Lizzie Petit Cutler. *Author's collection.*

After an eighteen-month break from writing, Petit submitted another manuscript, only to have it rejected.[182] She began giving dramatic readings in order to make a living. In 1858, she gave a reading of Shakespeare's *Much Ado About Nothing* to an audience in West Virginia that admired her performance.[183] Later that year, she began a tour of southern cities, where she continued reading the works of Shakespeare as well as her own poems. Throughout the newspapers, her "classic beauty" was commented upon.[184] Also that year, her next book, *The Stars of the Crowd, or Men and Women of the Day*, was published. She continued her lectures and moved to New York, where she had more work and was admired by New York society.[185]

In early 1860, while preparing to give one of her readings, her gown caught fire and she had to be rescued by a friend. While she was recuperating, many of her friends and admirers visited her. One particular friend, Peter Y. Cutler, proved himself to be quite attentive.[186] By April 1860, she had recovered enough to consider returning to public readings.[187] On May 2, 1860, "as an expression of [their] personal esteem" for Petit, she was publicly invited to return to her readings by a group of admirers and she announced her return would occur the following evening, May 3, 1860, at the Dodworth's Rooms, a small hall situated on Broadway.[188]

Life for Lizzie Petit was improving, with admirers and a courtship that led to marriage. On November 5, 1861, during the American Civil War, Lizzie Petit married Peter Y. Cutler in Cold Spring, New York.[189] The two remained in New York, where Cutler was a prominent lawyer.[190]

Lizzie P. Cutler paused her writing and focused on helping Confederate soldiers in Union prisons. She refrained from attending any social outings as well. To the war prisoners, she delivered boxes of clothing, tobacco, preserves and "jar pickles" and added personal notes sharing her concerns.[191] The couple offered aid and even financial support to the Virginians in need. In a letter, she emphasized her husband's involvement, explaining, "Remember how he even sought out cases of southerners in distress in what was at one time almost a city of refugees."[192]

After the war, Lizzie Petit Cutler continued writing and was a contributor to the *New York Era*.[193] By 1869, the couple had a happy life residing in Staten Island. Peter Y. Cutler became an orator, which many believed was thanks to Lizzie Cutler's success and connections. The couple socialized within influential New York society.[194] During her marriage, Lizzie Cutler did not write as much as her admirers would have liked. Instead, she said she "lived poems instead of writing them."[195]

On April 21, 1869, the newspaper reported that Peter Y. Cutler had taken his own life through an overdose of laudanum and was found dead at the Pacific Hotel.[196] The next day, the newspaper reported the correction that Cutler had not committed suicide but "died from Bright's disease of the kidneys."[197] This same year, Lizzie P. Cutler was listed as one of the names in *The Living Writers of the South*, which included fewer than a dozen female authors.[198]

In January 1873, Lizzie P. Cutler was in England and hosted a party, although she still was in mourning. Descriptions note her mourning attire was "only relieved by a few natural flowers."[199] By March 1874, she had returned to New York and was giving lectures. The topic of her lecture was "Married Flirts."[200] She continued giving lectures and touring the country throughout the 1870s and 1880s.[201] One of the last pieces she published was "New Words to Auld Lang Syne."[202]

By the 1890s, she was still traveling and even spent the winter of 1893 in Richmond.[203] She may have remained in Richmond, for in October 1900, a gentleman by the initials J.S.B. who had been in Company G of the Fourth Virginia Cavalry wrote to the *Richmond Dispatch* explaining Lizzie P. Cutler was "a lady in want."[204] He shared that she had been quite ill with heart disease and had been at St. Luke's Hospital receiving the care

she needed thanks to the generosity of Hunter Holmes McGuire, MD.[205] Unfortunately, her health had relapsed and she was all but abandoned. Although she had received an income from her publishers, those publishing houses had failed and she was now without any money.[206] J.S.B. requested a fund be started for her, which was received within weeks. Cutler returned her thanks by acknowledging "the generous donation" she received. She deflected her own contribution and focused on how none of her work toward the imprisoned soldiers could have occurred without the support of her generous husband.[207]

Lizzie P. Cutler died on January 16, 1902. Her funeral and interment were on January 17 at Riverview Cemetery in Richmond.[208] She was buried in the Confederate Women section.[209] The day after she was buried, *The Times* ran an article that included a request from Lizzie P. Cutler about being buried beside "the veterans of war" section of Hollywood Cemetery. The article notes the Ladies' Auxiliary granted the request, and "the devoted woman was laid to rest in the cemetery of her choice."[210] With an unmarked grave, this created some confusion about where Lizzie P. Cutler was buried. Riverview Cemetery verified she was buried in the Confederate Women section in Plot B, Division 3, grave 4, on January 17, 1902.[211]

The Grave

Although Lizzie Petit Cutler does not have a marked grave, she is buried in the Confederate Women section. The section includes curbing around the entire section with "Confederate Women" engraved between two small octagonal pillars. Within the section is a walkway that leads to a pyramid that is approximately twelve feet tall. A flagpole behind the pyramid holds the threads of what once was a flag. Because of the condition, it was unclear if it was the first national Confederate flag or the Christian flag. A 2018 article in the *Richmond Free Press* shared the "Confederate flag" had been replaced with "the Christian flag, a white banner with a red cross centered in a small, blue square in the flag's top left corner." The first national flag of the Confederacy is the official banner of the United Daughters of the Confederacy, the group that owns this section of the cemetery. Why the flag was replaced remains a mystery.[212]

The Confederate Women section in Riverview Cemetery. *Author's collection*.

HER WRITING

Lizzie Petit Cutler's writing includes romance novels. Her writing can be purchased online in reproduced versions and in eBook form.

NOT TO MISS

Less than one mile from the cemetery is Maymont, a one-hundred-acre Victorian estate that serves as a public park. Named after Sallie May Dooley, the mansion was built in 1893.[213] Today, Maymont includes numerous exhibits, among them those that explore women's roles in American history.[214]

VIRGINIA EMELINE BUTTS DAVIDSON

(1833–1911)
Blandford Cemetery, Petersburg
Ward A-Old Ground, Square 49

Virginia Emeline Butts Davidson was a schoolteacher who, after the Civil War, became a writer out of necessity. Her work "Bloody Footprints" was written during the war and later published in *The Southern Opinion* under the name "Virginia."[215] She wrote two novels: *Philanthropist* (1867) and *Principle and Policy* (1868).[216]

HER STORY

Virginia Emeline Butts Davidson was born in 1833 to Colonel James Davidson and Mary Harrison Butts.[217] Her younger and more well-known sister, Nora Fontaine Maury Davidson, worked in Confederate hospitals throughout Petersburg during the Civil War and has been credited with being the originator of Decoration Day (June 9, 1866), which later became Memorial Day, at Blandford Cemetery.[218]

While Virginia Davidson's siblings wrote poetry and her father was conversant on a variety of subjects and also "occasionally wrote verses," she felt "so illiterate" as she was not familiar with "the commonest branches of education" until a friend visited and struck up a conversation with her father.[219] Virginia Davidson was only sixteen at the time, but that visit

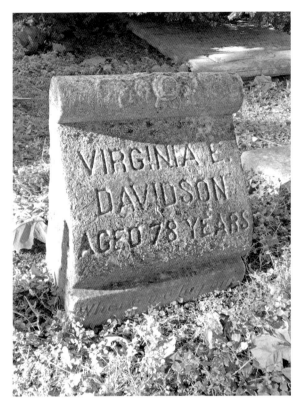

Left: The gravestone of Virginia E. Davidson. *Author's collection.*

Below: Blandford Cemetery. *Author's collection.*

sparked her quest for knowledge. The "commencement" of her education included reading ancient history and mythology, presumably from the home library.[220]

Recounted details that Davidson had learned during the war were included in her writing. She wrote two novels: *Philanthropist* (1867) and *Principle and Policy* (1868).[221] She became a teacher, and in the census records, she is listed as working as a schoolteacher until the age of seventy-seven.[222]

Virginia Emeline Butts Davidson did not marry, and she lived with her younger sister throughout her life.[223] She died of Bright's disease on April 12, 1911, and is buried in the family plot in Blandford Cemetery in Petersburg.[224]

The Grave

Virginia Emeline Butts Davidson's gravestone is an ornate slant marker resembling the shape of a scroll with a rose motif on the top and drooping flowers on the sides. It is relatively small in size compared to the stones of her family members. Based on its shape, location and size, the gravestone could be mistaken as a footstone that lies opposite of a headstone.

The epitaph has been weathered and it is nearly illegible unless the sun shines directly on it: "Virginia E./Davidson/Aged 78 years." On the base there appears to be an incomplete sentence. It reads: "Where we lay our…" With the rose lying on the top, and knowing a well-read woman is buried here, this could reference the prologue of Shakespeare's *Romeo and Juliet*, "Two households, both alike in dignity,/In fair Verona, *where we lay our* scene…"

Her Writing

Virginia E. Davidson's writing was published in *The Southern Opinion*. The magazine ran from 1867 to 1869. Like other southern women of her time, Davidson wrote out of necessity. Today, access to her writing is limited. Print copies can be found through antique dealers and online retailers. Copies of *The Southern Opinion* can be read through the Library of Congress.[225]

Another view of the author's gravestone showing the ornate details of artwork. *Author's collection.*

NOT TO MISS

Approximately four miles from Blandford Cemetery, one can drive by the locally notorious "tombstone house." With rumors of it being haunted, the house has a connection with another local cemetery in Petersburg. Located at 1736 Youngs Road, the house was built in the 1930s after the superintendent of the Poplar Grove National Cemetery decided to reduce costs by removing the upright grave markers, cutting off the bottoms that had been in the ground and replacing the top portions of the markers by lying them down flat. This helped the grounds crew with maintenance, which has been an ongoing battle in many cemeteries. The 2,220 bottom portions of the markers were sold to a gentleman who proceeded to build his dream house out of the materials.[226] While some may see this as macabre, others would consider this upcycling.

VARINA ANNE "WINNIE" DAVIS

(1864–1898)
Hollywood Cemetery, Richmond
Lawn Lot A

Varina Anne "Winnie" Davis was an author known as the "Daughter of the Confederacy." She published *An Irish Knight of the 19ᵗʰ Century* (1888), *The Veiled Doctor: A Novel* (1895) and *A Romance of Summer Seas* (1898).

HER STORY

Varina Anne "Winnie" Davis was born on June 27, 1864, one year before the conclusion of the Civil War, to parents Jefferson Davis and Varina Howell Davis at the White House of the Confederacy in Richmond. Before her first birthday, she and her mother left Richmond just before Union troops seized the city; her father was imprisoned for the next two years.[227]

Davis was educated at home in her early years. When she was thirteen years old, her parents sent her to Germany, where she would study for five years. She also briefly studied in Paris before returning home.[228] By 1886, in her early twenties, Davis was called the "Daughter of the Confederacy," and she attended numerous Confederate memorial events as the personal companion of her father.[229] She also wrote during this time, and in 1888, her first book, *An Irish Knight of the 19ᵗʰ Century*, was published. The novel focuses on Robert Emmet and the history of Ireland.[230]

The marble angel for Varina Anne Davis. *Author's collection.*

Right: Photograph of Varina Anne
Winnie Davis, *Davis & Sanford Photography*,
nineteenth century.

Below: Dedication by the New York
Division of the United Daughters of
the Confederacy naming her a "real
daughter." *Author's collection.*

While she was courted and had romantic relationships, she never married. Her father died in 1889, and she and her mother had no financial means except for writing. Both Davis and her mother worked as correspondents for the *New York World* newspaper. Davis also wrote for *The Ladies' Home Journal*. Her second book, *The Veiled Doctor: A Novel*, and third book, *A Romance of Summer Seas*, were both moderately successful.[231]

Davis became quite ill and died on September 18, 1898, from malarial gastritis at thirty-four years old.[232] She was buried in the family plot at Hollywood Cemetery along with her father and siblings.[233]

THE GRAVE

The marker for Davis is frequently called the "angel of grief." The statue is by sculptor George Julian Zolnay.[234] The marble angel at the grave looks downward and holds a wreath of flowers. Varina A. Davis's grave is part of the family plot in the cemetery.

HER WRITING

Winnie Davis's writing was described as having "a clear style, a sprightly manner that was almost witty, and a remarkable flow of story telling [*sic*] power."[235] While some reviewers noted her work was "well written," others pointed to "the interest attached to the appearance of 'The Daughter of the Confederacy' as a novelist which lies quite outside the story itself."[236] Reviewers also noted Davis's writing improved. One reviewer acknowledged that Davis's prior novels had not been favorably reviewed by the newspaper, as the plots were "strange and unnatural," but that her final novel was one they would "praise for its strong points, and as a decided advance in restraint of style, ability in firmly and consistently differentiating character and in directness and virality of description."[237] Davis's writing can be read online or purchased in reissued print editions.

NOT TO MISS

Close to Davis Circle, visitors can find the grave of Mary Munford (Lawn Lot 17). Munford became interested in social welfare issues at a young

age. In the 1890s, she organized and headed a Saturday Afternoon Club, a weekly study and social club made up of women from Richmond's social elite. She helped establish and served as president of the Richmond Education Association. Munford regretted the fact her mother had not allowed her to attend college, despite Munford's fervent pleas to do so. Hoping to improve women's opportunities for higher education, Munford headed a campaign to found a college for women at the University of Virginia. By 1910, Munford had begun to devote more attention to the plight of African Americans. She became an advocate of African American uplift and interracial cooperation. The Mary Munford Elementary School in Richmond was named in her honor.[238]

13

VARINA ANNE BANKS HOWELL DAVIS

(1826–1906)
Hollywood Cemetery, Richmond
Lawn-A

Varina Anne Banks Howell Davis is best known as the only first lady of the Confederate States of America and the wife of Jefferson Davis. Davis became a writer after the war and completed her husband's memoir, *Jefferson Davis, A Memoir* (1890). She also wrote regular columns for the *New York World*. After she was widowed, Davis moved to New York City with her youngest daughter, Winnie, and continued writing out of necessity.

HER STORY

Varina Anne Banks Howell was born on May 7, 1826, in Natchez, Mississippi, to William Burr Howell and Margaret Louisa Kempe. She was the second child of eleven.[239] Although her father declared bankruptcy when she was thirteen, the family was able to rely on relatives so she could be educated at the prestigious academy for young ladies, Madame Deborah Grelaud's French School in Philadelphia, Pennsylvania.[240] Afterward, she returned home and continued her studies by being privately tutored by a Harvard graduate and family friend, Judge George Winchester.[241] Varina Howell was considered intelligent and better educated than many of her peers. This led to strains with some relatives regarding southern expectations for women.[242]

The grave of Varina Howell Davis. *Author's collection.*

On February 26, 1845, she married Jefferson Davis. After seven years of marriage, the couple began having children, which led to mourning, since Varina Davis would outlive all but one of her children.[243] Their first child, Samuel Emory Davis, was born on July 30, 1852. He died on June 30, 1854, of an undiagnosed disease. Their second child, Margaret Howell Davis, was born on February 25, 1855. She lived until the age of fifty-four and died on July 18, 1909. Their third child, Jefferson Davis Jr., was born on January 16, 1857. He died of yellow fever at the age of twenty-one on October 16, 1878. Their fourth child, Joseph Evan Davis, was born on April 18, 1859, and due to an accidental fall from the porch at the presidential mansion in Richmond, he died on April 30, 1864; he was five years old. Their fifth child, William Howell Davis, was born on December 6, 1861, and died of diphtheria on October 16, 1872. Just two months after his death, their sixth and final child, Varina Anne "Winnie" Davis, was born on June 27, 1864. At the age of thirty-four, she died on September 18, 1898, of gastritis.[244]

Varina Howell Davis and Jefferson Davis lived separately for extended periods of time for various reasons. After the war, rumors of Jefferson Davis being in love with another woman made the press, but the choice to divorce was difficult during the time.[245]

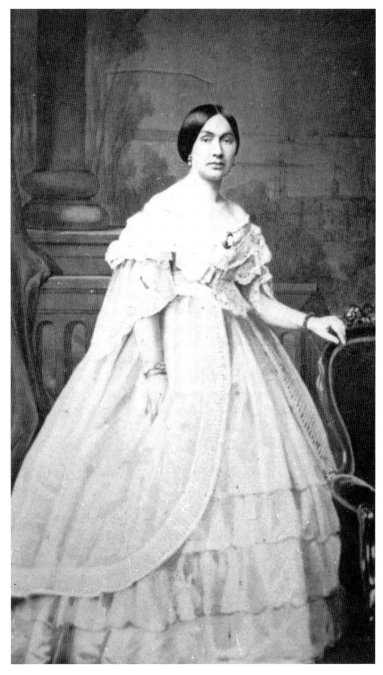

Mrs. Jefferson Davis, full-length studio portrait, standing, facing slightly right with left hand resting on the back of a chair, between 1860 and 1870. *Library of Congress.*

Hollywood Cemetery landscape with the Richmond skyline and the James River in the background. *Author's collection.*

After her husband died of pneumonia in 1889, Varina Howell Davis and her daughter Winnie moved to New York City. To support themselves, the mother and daughter wrote articles for the *New York World.*[246] Davis continued to live in apartment-hotels in Manhattan, never returning to the South. By 1891, her relationship with Confederate organizations had become so antagonistic that the staff of Hollywood Cemetery threatened there would not be enough room to bury her in the Davis plot.[247] On October 16, 1906, after contracting pneumonia, she died in her apartment overlooking Central Park. She was eighty years old.[248] She is buried in the Davis family plot in Hollywood Cemetery along with her husband and children.

THE GRAVE

Varina Howell Davis is buried beside her husband, Jefferson Davis, in the family plot in the part of the cemetery known as Davis Circle. The design of the grave is a French cradle grave that includes ivy. Her inscription reads: "Varina Howell Davis/At Peace." Her birth and death dates are included underneath.

HER WRITING

Varina Howell Davis wrote out of necessity to support herself and her daughter. As a columnist for the *New York World*, Davis offered advice regarding social etiquette and marriage. She cited works such as Alfred, Lord Tennyson's "The Lady of Shalott," demonstrating that she was well-read. She also wrote a piece, "The Humanity of Grant," that argues Ulysses Grant was a great man who did not gloat over the misfortune of Southerners after the Union army defeated the Confederate army.[249] Today, her writing can be found on the internet and in the archives for the *New York World* newspaper.

NOT TO MISS

Jefferson Davis was originally interred in Metairie Cemetery in New Orleans, Louisiana. Varina Howell Davis selected the plot in Hollywood Cemetery for the family's final resting place.[250] If you turn away from their graves, you will see one of the best views of the Richmond skyline.

14

JUDITH L.C. GARNETT

(1862–1938)
Forest Lawn Cemetery and Mausoleum, Henrico
Garden section 4, Lot 136 B grave #2

Judith L.C. Garnett was an author and poet. Her first publication was *Who? Which? And What? A Story* (1885). She wrote poems for *National Magazine*, including an ironic love poem called "Kate's Answer" (1901). Her other publications include *Sermons in Rhyme* (1916), *Twenty-Two Messages for You* (1918), *Temple Torches* (1921) and *The Celestial Garment* (1927). Several of her poems have been put to music to become church hymns, including "Handle with Care."

HER STORY

Garnett was born on January 19, 1862, to Laura Speir Garnett of New York and George William Garnett of Virginia. When she was a young child, the Garnett family lived with their in-laws in Brooklyn, New York. She grew up having two sisters and one brother.[251] The Speir family owned a brownstone that had an estimated worth of $25,000 in 1865.[252] They were financially well off and had English servants residing in the household. Garnett's father worked as a merchant in New York; later, during the Civil War, he worked in the Treasury Department for the Confederate States of America. He became a prisoner of war in Forts LaFayette and Delaware.[253]

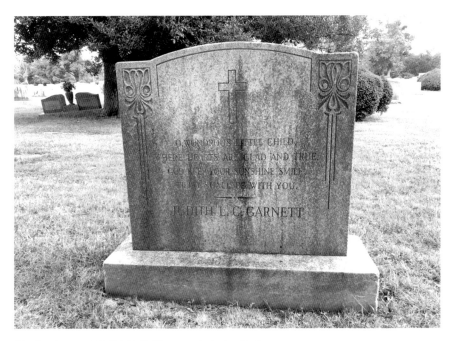

The headstone of Judith L.C. Garnett. *Author's collection.*

By 1880, Judith Garnett had moved to Staunton to work as a teacher at the Staunton Female Seminary.[254] Along with other teachers, she lived in the home of the seminary founder and principal, Reverend J.I. Miller. Reverend Miller established the seminary in 1870 and continued to run the school until 1882. The seminary remained open until 1894, when it was sold due to financial struggles.[255]

By 1900, Garnett had returned home to Essex and was living with her family, who owned their property free from a mortgage. There are no occupations listed for any of the family members, including her father, who would have been in his early seventies.[256]

By 1910, Garnett's mother is listed as the head of the household in the census, with her job listed as "own income."[257] Even with complex economic times, the Garnett family appeared to have their finances in order.

By 1920, Judith Garnett was still living in Essex and had adopted two daughters, Ellen C. Boughner and Bernice Pierce, who were both listed as being nine years old at the time of the census.[258] Bernice Pierce, who had not attended school prior, would continue to be listed as the adopted daughter while Ellen Boughner, who had attended school, would not show up again on any future census associated with Garnett.[259]

The *Times Dispatch* newspaper reporter mentions Garnett had adopted another child, a young boy named Joseph Kish. In January 1930, this six-year-old caught his clothes on fire outside of a local store. He would later die from the burns. An investigation occurred, since on his deathbed the young boy accused some playmates of dousing him with gasoline. The coroner, however, concluded that the evidence pointed to the young boy playing with gasoline and fire outside of a local store and subsequently setting himself on fire. The death was ruled an accident with only the young boy to blame for his demise.[260]

Judith Garnett continued to write and publish throughout her life, although she never listed this as a source of income. Her occupation on the census is listed as "none." She did not struggle financially. In 1926, she was able to donate $1,000 to help establish Bryan College, a private Christian liberal arts college in Dayton, Tennessee.[261]

While few might recognize her name today, in 1935, the *Times Dispatch* reported Garnett was one of nineteen women selected for the *Who's Who of U.S. Women* while noting that other women writers, including Ellen Glasgow and Mary Johnston, had been omitted.[262] Garnett's popularity continued, and in 1937, she was included in the second edition of *American Women*.[263]

Forest Lawn Cemetery and Mausoleum. *Author's collection.*

The gravestone of the author's adopted son Joseph Kish. *Author's collection.*

From Garnett's teaching position at the seminary in the 1880s, the topics and focus of much of her writing, her charitable acts of donations and adopting children and even her letters to the editor of the *Times Dispatch*, the author exhibited a strong Christian religious faith.

After a long illness, Judith Garnett died of an accidental paraldehyde poisoning on June 25, 1938.[264] She is buried in Forest Lawn Cemetery in Henrico County.[265]

THE GRAVE

In Find a Grave, Garnett is the only woman listed in the famous memorials section.[266] Her grave is located in one of the older sections, section 4 or "garden 4" near Edge Hill Road. Her monument is a die on base that faces Edge Hill Road. A cross is etched into the top of the stone. Underneath, the inscription reads, "O, Wondrous Little Child Where Hearts Are Glad and True God Keep Your Sunshine Smile Till I Shall Be With You."

Garnett's grave did not appear to be part of a family plot. However, behind her grave marker there is a small lawn-level marker for her adopted son, Joseph Kish, the boy who set himself on fire.

HER WRITING

Judith Garnett's writing can be described as both traditional and spiritual. One reviewer of *Temple Torches* writes, "She is somewhat a moralist and takes occasion to denounce the suffragette."[267] Another reviewer writes, "Perhaps only one word, the word 'exalted' may be chosen to characterize the intensely spiritual atmosphere of this new collection of poems by Judith L.C. Garnett."[268] Today, Garnett's papers are housed in the William & Mary Special Collections Research Center.[269] Facsimile reprints of her original work can be found through Kessinger Publishing's Rare Reprints.[270]

NOT TO MISS

While visiting Forest Lawn Cemetery, consider visiting one of the few mausoleums on the grounds, one that was erected to Diamond Peters.[271] The entrance includes two life-size marble statues on either side of the entrance; on the left, Peters is depicted as a young bride, while the statue on the right resembles a more matronly image of the deceased. Included is an epitaph for her husband, Angelo John Peters, that reads, "Born for the purpose of marrying Diamond."[272]

15

ELLEN GLASGOW

(1873–1945)
Hollywood Cemetery, Richmond
Section DE, Plot 15

Ellen Glasgow was a popular writer who published twenty novels and was frequently on the best-sellers list. She also produced novels of enduring literary merit. Glasgow was a lifelong Virginian who, through her writing, portrayed the changing world of the South. While she spoke on women's suffrage, it was not a major theme in her books. Glasgow felt Richmond could not get beyond the Civil War. She wrote critically of what she saw as the false sentimentality of southern society. Her last novel, *In This Our Life* (1941), earned a Pulitzer Prize in 1942.[273]

Her Story

Ellen Glasgow was born into Richmond society to Anne Jane Gholson and Francis Thomas Glasgow on April 22, 1873; she was frail and sickly.[274] She was schooled at home due to her poor health.[275] She read widely and deeply and was conversant in a variety of subjects, yet she had hearing loss and was terribly shy about asking others to repeat what they said.[276] Glasgow tried an early form of hearing aids that proved to be unhelpful.[277] She struggled with face-to-face communication throughout her life, although she clearly expressed herself through her letters.[278]

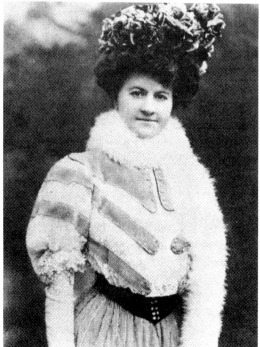

Above: The gravestone of Ellen Glasgow. *Author's collection.*

Left: Portrait of Ellen Glasgow by Aimé Dupont featured in *The World's Work*, 1905.

When she was twenty-four years old, she published her first novel, *The Descendant* (1897), which was published anonymously.[279] Glasgow would go on to publish twenty novels and fourteen short stories. Her work focused on the changing environment of the South after the 1850s, including *The Battle-Ground* (1902), *The Deliverance* (1904) and *Virginia* (1913). Even when her involvement with the Equal Suffrage League of Virginia waned after the death of her sister, she still included themes of women's rights in her writing. "The Call," a poem published in *Collier's* magazine in 1912, was a "contribution to the cause."[280] She also published an article, "Feminism," for the *New York Times* in 1913, which explains the significance of the women's movement.[281]

Glasgow's last novel, *In This Our Life* (1941), included a progressive view toward African Americans, a bold inclusion for its time.[282] The book earned her a Pulitzer Prize, and it was made into a film starring Bette Davis and Olivia de Havilland in 1942.

Although Glasgow was engaged twice, she never married.[283] She valued her close friendships, writing:

> *Two things had never failed me: my gift of friendship and my sense of laughter.*[284]

She deeply loved animals, and the bulk of her estate was left to the SPCA, with the local chapter being named in her honor. She loved her dog Jeremy so much that when he became sick, she spared no expense to seek treatment to save his life. Specialists from Philadelphia and New York were consulted. Upon Jeremy's death, the *Richmond Times Dispatch* ran an obituary with a picture of Jeremy and then later for her dog Billie. Both were buried in the garden behind her home.[285] Glasgow died in her sleep at home on November 21, 1945. It is believed that upon Glasgow's death, the bones of her dogs were placed at her feet when she was buried.[286]

The Grave

Glasgow is buried in the Glasgow family plot. Her gravestone is a large, die on base marker. The headstone reads: "Ellen Glasgow/1874/1945/ Tomorrow to/Fresh woods/and Pastures/New." The inscription includes lines from John Milton's pastoral elegy "Lycidas." The typeface of her epitaph is distinctly art deco, with elongated lettering.

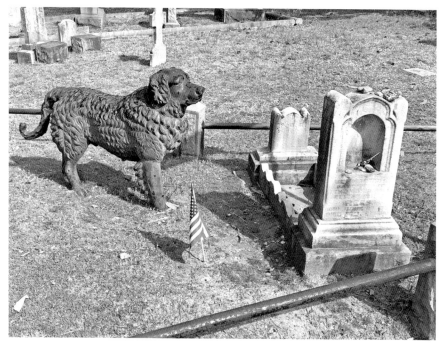

The iron dog in Hollywood Cemetery. *Author's collection.*

HER WRITING

Ellen Glasgow's novels include female characters who become increasingly independent in thought and action. *The Barren-Ground* (1925) explores the early twentieth-century changes that affected Virginia and the South. *The Sheltered Life* (1932) is often referenced as Glasgow's best novel by critics. *In This Our Life* (1941), which includes a portrayal of southern racial discrimination, earned Glasgow the Pulitzer Prize.[287] Today, her novels can be found in libraries and for purchase through various booksellers. Her papers are held in the Albert and Shirley Small Special Collections Library at the University of Virginia.[288]

NOT TO MISS

Because of Glasgow's love of animals, it seems fitting that not far from her grave is the iron dog of Hollywood Cemetery. The cast-iron Newfoundland

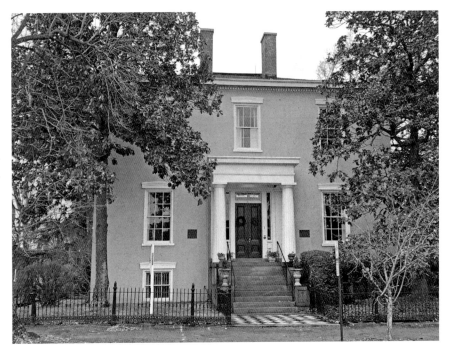

The Ellen Glasgow house, 1 West Main Street, Richmond. *Author's collection.*

stands over the cradle grave of a little girl. There are numerous legends associated with the statue, with a popular version being that it was moved to the cemetery to keep it from being melted down into bullets during the Civil War.[289]

Approximately one mile from the cemetery is 1 West Main Street, known as the Ellen Glasgow house, which she called "the old gray house on Main Street." This is where she lived from 1887 when she was thirteen years old until her death in 1945. This is where she wrote all but one of her novels. The house is a large Greek Revival and is currently a private residence.[290]

LIZZIE CHAMBERS HALL

(1874–1965)
Old City Cemetery, Lynchburg
Section 108.AB

L izzie Chambers Hall was a schoolteacher, a poet and a Baptist pastor's wife who held an active role in the church. Her poetry was published in local newspapers. Throughout her life, she compiled a scrapbook of poems, prayers and other religious memorabilia that shares African American family life and religious practices during the period.

HER STORY

Lizzie Chambers was born in Lynchburg on February 16, 1874, to Annie Lampkin and Phillip B. Chambers.[291] Her father worked as an ironworks laborer while her mother was a seamstress. She grew up in a large family with siblings William Duval, Roxie, Julia, Hattie, Maudie and Bertha.[292]

At the age of twenty-two, she married William Thomas Hall, a promising young Baptist pastor. They married in her hometown of Lynchburg on September 16, 1896.[293] That October, they were living in Richmond; Reverend Hall delivered an address at First Baptist Church when the congregation was looking for a permanent pastor.[294]

Richmond was a temporary stop for them. The couple moved to Danville, and by January 1898, Reverend Hall had been appointed as the permanent

The Hall family monument. *Author's collection.*

pastor of High Street African American Baptist Church. The appointment acknowledged the good work Reverend Hall and his "estimable wife" had done while associated with the church.[295]

In 1901, an accidental fire burned down the church. Fortunately, the church, which was one of the largest African American churches in the area, was insured for $8,000.[296] The church prospered, and the congregation credited this to the Halls. In 1902, the church was able to purchase a pipe organ for $1,200. The announcement reads, "With such a man as Rev. W.T. Hall, our leader [*sic*] success will crown our efforts."[297] The couple would stay at the Danville church from 1897 to 1907.

In 1908, a newspaper lists Reverend Hall and Lizzie C. Hall as those attending a funeral in Richmond for his aunt.[298] The Halls soon moved north, and Reverend Hall became the pastor of the Galilee Baptist Church in Roxboro, Pennsylvania, from 1913 to 1928.[299]

As a pastor's wife, Lizzie C. Hall remained active in the church. She collected religious tracts and broadsides and created a personal archive for church-related events. In 1918, she attended the Twenty-Third Annual Session of the Baptist State Education Convention of Virginia

as an associate member of the Executive Board, as they were living in Pennsylvania at the time.[300]

Throughout her life, Lizzie C. Hall kept newspaper clippings and pictures that she organized in a scrapbook. She wrote poetry, with some of her original work being included in her scrapbook. In 1927, one of her poems was published in the local newspaper.[301]

By 1930, the Halls had returned to Lynchburg; Reverend Hall had retired. Lizzie Hall's family lived with them.[302] Reverend Hall died on August 7, 1933, and was buried at Methodist Cemetery, known today as Old City Cemetery.

In 1936, Lizzie C. Hall was announced as the guest speaker during the Baptist Ministers Conference in Danville.[303]

Three years before her death, Lizzie C. Hall moved to Newport News and lived with her sister, Bertha Chambers. She passed away at the age of ninety on February 6, 1965. Her obituary and death certificate list her as a retired schoolteacher.[304] She is buried beside her husband in Old City Cemetery in Lynchburg.[305]

Old City Cemetery.
Author's collection.

The Grave

Lizzie C. Hall is buried in the family plot that includes a pedestal monument with an urn at the top. Although no epitaph is included for Lizzie C. Hall on the gravestone, cemetery records confirm her burial in the family plot along with several of her siblings.[306]

Her Writing

Lizzie C. Hall's writing can be described as religious lyric poetry. In 1927, her poem "In Memoriam" was published in the local newspaper as a requiem to a friend from the point of view of his wife and children.[307] Today her writing can be found at the UNC Southern Historical Collection at the Louis Round Wilson Special Collections Library and through old newspapers.[308]

Not to Miss

Old City Cemetery offers a wealth of information to visitors through twelve thematic self-guided tours. Brochures can be found at the cemetery entrance. The cemetery also includes one hundred plaques on the grounds to interpret its history and those who are interred there. A gift shop sells a variety of items, including books and honey from the beehives in the cemetery.[309]

CONSTANCE FAIRFAX CARY HARRISON

(1843–1920)
Ivy Hill Cemetery, Alexandria
Section O/FH, Lot 15 Grave 11

Constance Fairfax Cary Harrison was an author of plays and novels, and she was considered one of the best novelists during her day. She wrote for *Scribner's Monthly*, *Harper's New Monthly Magazine* and *The North American Review*. She was a diarist during the Civil War and may be best known for sewing the first example of the Confederate battle flag with her cousins.[310] She also persuaded Emma Lazarus to write her 1883 poem "The New Colossus" as part of a fundraiser for the construction of the Statue of Liberty. The poem is inscribed on the base of the statue.[311]

HER STORY

Constance Fairfax Cary was born on April 25, 1843, to parents Archibald Cary and Monimia Fairfax into a prominent family. In 1854, after the death of her father, she lived near Alexandria at Vaucluse, an estate belonging to her maternal grandfather, Thomas Fairfax.[312] She attended Hubert Pierre Lefebvre's boarding school in Richmond and also had a French governess for her education.[313] In 1861, Constance Cary was eighteen years old when the Civil War began. She and her mother sought shelter in Richmond, where Constance Cary would remain during the war. Their family home,

 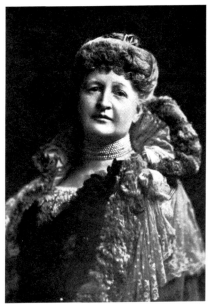

Left: The grave of Constance Cary Harrison. *Author's collection.*

Right: Portrait of Harrison in E.F. Harkins and C.H.L. Johnston, *Little Pilgrimages among the Women Who Have Written Famous Books* (1902), L.C. Page & Co., Boston.

Vaucluse, was seized and then demolished in order to construct Fort Worth.[314] During the war, Cary worked with her mother as a nurse. At the request of a Confederate congressional committee, she and her cousins Hetty and Jennie Cary sewed a battle flag, which now can be seen at the Museum of the Confederacy in Richmond.[315]

In 1862, under her nom de plume "Refugitta," she wrote for the *Southern Illustrated News* and *Magnolia: A Southern Home Journal.*[316] Her writing was a response to what she had witnessed during the war. In the fall of 1865, Cary went to Europe with her mother. They remained for a year, and Cary studied music, art and languages.[317] When she returned home, she had a courtship with Burton Norvell Harrison, a lawyer who, during the war, had worked as the private secretary to Jefferson Davis. When Davis was captured, Burton Harrison was also held in solitary confinement for two years. He studied law while in prison. Once freed, he traveled to Europe and then started a practice in New York.[318] Cary and Harris married on November 26, 1867.[319]

Along with being a wife and mother to three sons, Constance Harrison continued writing. She began publishing both serious and popular fiction as serials in magazines such as *The Century*, *Scribner's Monthly* and *Harper's*. She

The Harrison ledger under trees. *Author's collection.*

had fourteen stories published as serials, five dramatic works and twenty-six published novels throughout her career. Her 1890 novel, *The Anglomaniacs*, received attention as a comedy of manners that satirized the modern-day social climber.[320] In 1904, Burton Harrison died.[321]

Her last published work was her 1911 novel, *Recollections Grave and Gay*, a memoir of her experiences during the Civil War.[322]

On November 21, 1920, after being ill for several years, Constance Cary Harrison died in Washington, D.C., at the age of seventy-seven.[323] She is buried at Ivy Hill Cemetery in Alexandria.

THE GRAVE

The couple's gravestone includes a ledger marker, a thick slab of stone covering the entire grave. Scrollwork borders the epitaph, which reads: "Here lie Burton Harrison/1838–1904/Son of Burton Harrison/and Frances Brand/And/Constance Cary/1843–1920/Daughter of Archibald Cary/and Monimia Fairfax/They were married/November 26, 1867 and left/Three sons to honor their/Father and their Mother/RIP."

Ivy Hill Cemetery. *Author's collection.*

HER WRITING

Constance Cary Harrison was a prolific writer. The majority of her writing is focused on southern life and includes a variety of topics and social commentary. Some critics note her sharp wit.[324] Today, her work can be found in published print and through online resources for free.

NOT TO MISS

Alexandria Women's History Tour is a free self-guided tour that is a one-and-a-half-mile loop that begins at the Visitor's Center (221 King Street) and ends on the waterfront, two blocks from the tour's beginning. Details can be found on the Alexandria government website.[325]

LUCY NORVELL HARRISON

(1878–1955)
Shockoe Hill Cemetery, Richmond
Range 21, Section 6

Lucy Norvell Harrison was an author of fiction. Her most popular work was "Another William Tell," published in *Werner's Readings and Recitations* in 1915.[326] From 1901 until 1920, she published several short stories for popular magazines, including *Woman's Home Companion*, *McClure's Magazine*, *Harper's Month Magazine*, *The Red Book Magazine*, *Frank Leslie's Popular Monthly* and *The Smart Set*. She also wrote with her brother Henry Sydnor Harrison, who was a renowned post–World War I novelist.

HER STORY

Lucy Norvell Harrison was born on March 17, 1878, in Sewanee, Tennessee, to Caskie and Margaret Harrison. She was the middle child of five with two older sisters, Margaret Caskie Harrison Guignard and Alice Perry Harrison, and two younger brothers, Henry Sydnor Harrison and Edmund Caskie Harrison. Her father was an educator and the head of the Brooklyn Latin School. Prior, he had been a professor at the University of the South at Sewanee, Tennessee.[327]

Lucy Norvell Harrison's piece "Celibacy of Man" was published in *Frank Leslie's Popular Monthly* in August 1901.[328] Her short story "Another William Tell" was published in the *Criterion* the next year.[329] In June, "De Profundis"

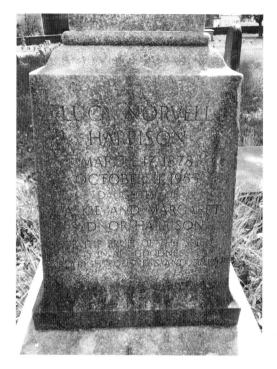

The epitaph of Lucy Norvell Harrison. *Author's collection.*

was published in another issue of *Frank Leslie's Popular Monthly*.[330] In 1903, she had three stories published. One was "The Lady and the Boy" in *McClure's Magazine* in February; "A Misunderstanding" in *Harper's Monthly Magazine* in April, published as "Corvell" Harrison; and "With the Help of the Alphabet" in *The Red Book* in July.

By January 1905, she was living in Richmond and publishing under the name Norvell Harrison with another short story in *The Smart Set*.[331] By September, "The Scarlet Fever Letter" was featured in *McClure's Magazine*.[332]

Harrison's work was gaining popularity. Critics praised her writing: "She is a clever writer, and gives promise of falling in line with the galaxy of Virginia women who have contributed to literature, and which include the names of Mary Johnston, Ellen Glasgow."[333]

Harrison spent her summers at Rawley Springs and her winters in Chase City, which was a popular tourist city. Another reporter commented on her "charming, refined personality" and "her cleverness."[334]

In the 1910 U.S. Census, the family lived in West Virginia, where her brother Henry Sydnor was an editor and her brother Edmund was a lawyer. Even with several publications, no occupation is listed for Norvell Harrison.[335] The next year, she published "Having a Man" with her brother

The grave of Lucy Norvell Harrison. *Author's collection.*

Henry Sydnor Harrison in *Adventure*.[336] She also published "The Boarding-House Graphophone" in *Woman's Home Companion*.[337]

Norvell and her brother Henry traveled to Europe in 1913.[338] Norvell never stayed away from Virginia for long. In 1914, she socialized in Warm Sulphur Springs along with several society ladies and author Mary Johnston and her family.[339] In August of that year, Johnston hosted a tea at her home Three Hills in honor of Norvell Harrison and her mother.[340]

Her brother Edmund, who was beyond the draft age, enlisted in the army to fight in World War I on April 24, 1918, when he was thirty-five years old. In November, he was struck by a shell fragment and died.[341]

By 1920, Norvell Harrison had moved to New York and was living in Manhattan. For the first time in the census, her occupation is listed as a writer of magazines.[342]

On Christmas Day 1921, members of the Women's Peace Society, including Norvell Harrison, along with other churchgoers, took part in picketing New York churches calling on church members "to refuse sanction or participation in war in the future." Members of the protest noted that early Christians believed it was unlawful to bear arms and noted the evil of warfare.[343]

While Norvell Harrison continued living and writing in New York,[344] she spent her winters in Richmond with her remaining brother, Henry Sydnor.[345] In 1929, while spending time in Richmond, she invited Alice A. Bailey, writer, lecturer and renowned "occult expert," to give a talk on modern psychology and Spiritualism, beginning with a defense of occultism, to the Collegiate School for Girls.[346] Prior to the lecture, which included the "growing wonders of telepathy," Norvell Harrison had organized a like-minded group interested in topics associated with the occult.[347]

In 1930, following an operation for appendicitis, Henry Sydnor died.[348] Norvell Harrison continued living in New York and traveled to visit friends.[349] Around 1943, she moved to Columbia, South Carolina.[350] She passed away on October 11, 1955, and is buried in Shockoe Hill Cemetery in Richmond.

THE GRAVE

Lucy Norvell Harrison shares a grave with her brother Henry Sydnor Harrison. The marker is an obelisk. Her inscription reads: "Lucy Norvell/ Harrison/March 17, 1878/October 11, 1955/Daughter of/Caskie and Margaret/Sydnor Harrison/For the fruit of the spirit/is in all goodness/ and righteousness and truth." The verse is from Ephesians 5:9.

Shockoe Hill Cemetery. *Author's collection.*

HER WRITING

Lucy Norvell Harrison's writing was noted as humorous and clever.[351] Her stories focused on contemporary issues, including matrimonial relationships and quarantined people stuck in a hotel.[352] Many of her stories are available online for free through various magazine and journal archives.

NOT TO MISS

While visiting the grave of Lucy Norvell Harrison, follow signs toward Hospital Street to see the grave of Union spy Elizabeth Van Lew (1818–1900). The grave is a large boulder. Known by locals as "Crazy Bet," she organized spy missions and shared critical data to General U.S. Grant.[353] The plaque on her marker reads: "She risked everything that was dear to her—friends, fortune, comfort, health, even life itself—all for one absorbing desire of her heart—that slavery might be abolished and the Union preserved. This Boulder from the Capitol Hill in Boston is a tribute from Massachusetts friends."

19

MARY JANE HAW

(1835–1927)
Hollywood Cemetery, Richmond
B-138

Mary Jane Haw was an author of poetry and fiction. She wrote *The Beechwood Tragedy* and contributed to the *Magnolia Weekly* and the *Christian Observer*.[354] In 1864, she won $1,000 for the best illustrated romance, "The Rivals: A Tale of the Chickahominy."[355] In 1910, her piece "My Visits to Grandmother," published in the *Christian Observer*, recounts her grandmother's experience during the Civil War when Union troops seized her home.[356]

HER STORY

Mary Jane Haw was born on September 15, 1835, in Hanover to John Haw and Mary Austin Watt Haw. She had five brothers and one sister.[357] Haw's grandmother was Sarah Bohannon Kidd Watt, who resided at Springfield Plantation, which included several hundred acres for farming. On June 27, 1862, the house became the headquarters for a Union commander, and Sarah Watt was forced to leave. After the battle, Mary Jane Haw writes, "the walls and roof were torn by shot and shell, the weatherboarding honeycombed by minie balls, and every pane of glass shattered….There was scarcely a space of flooring as large

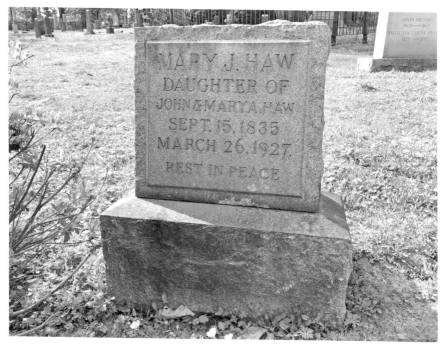

The gravestone of Mary J. Haw. *Author's collection.*

as a man's hand that did not bear the dark purple stain of blood."[358] She would recount the details of the ordeal in her piece "My Visits to Grandmother," published in the *Christian Observer* in 1910.

Haw attended the Richmond Female Institute and became a schoolteacher.[359] She contributed to the *Magnolia Weekly*, which published her story "The Beechwood Tragedy" in 1863. She also contributed poems, including "Christmas-day A.D. 1861," to a collection of poetry that the *Richmond Dispatch* would republish decades later in a Christmas edition.[360] In 1864, she won $1,000 for the best illustrated romance, "The Rivals: A Tale of the Chickahominy."[361]

In 1886, she attended the Union Female College and had her poetry published in the *Christian Observer*.[362] In 1889, Haw expanded her story into a full novel, *The Beechwood Tragedy*.[363]

Throughout her life, M.J. Haw taught in Virginia, Tennessee, Kentucky and Louisiana. She died on March 26, 1927, in her hometown at the age of ninety-one. She is buried in Hollywood Cemetery.

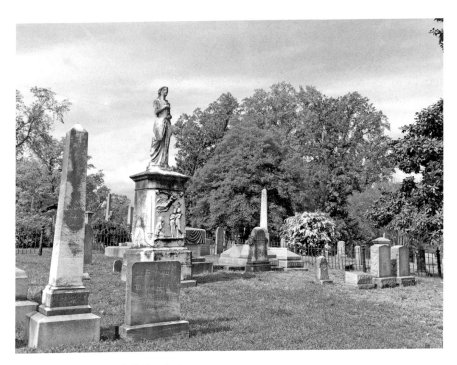

Hollywood Cemetery. *Author's collection.*

The Grave

Mary J. Haw's grave is a midsize slant marker on base with an overgrown bush beside it. The epitaph reads: "Mary J. Haw/Daughter of/John & Mary A. Haw/Sept. 15, 1835/March 16, 1927/Rest in Peace." Although two of her brothers are buried in the cemetery, their graves are not located near one another.

Her Writing

Mary Jane Haw's writing is focused on living in the South during the time of the Civil War. Today, reproduced print copies of her novels are available from online retailers. Her novel *The Rivals: A Chickahominy Story* is available in a free electronic edition through the University of North Carolina at Chapel Hill as part of the UNC-CH digitization project Documenting the American South.[364]

Not to Miss

Hollywood Cemetery contains some of the finest examples of native trees and historic roses in the Commonwealth. There are over two thousand trees, with some predating the cemetery, and a vast collection of heritage roses. While visiting, pick up the trees and roses self-guided tour maps in the visitor's chapel.[365]

MARY ANNA MORRISON JACKSON

(1831–1915)
Oak Grove Cemetery, Lexington
Under General Jackson Statue

Mary Anna Morrison Jackson was known as the "Widow of the Confederacy" for approximately fifty years after the death of her husband, Confederate army general Thomas "Stonewall" Jackson. She wrote *Life and Letters of General Thomas J. Jackson (Stonewall Jackson)* (1892), *Memoirs of Stonewall Jackson* (1895) and *Julia Jackson Christian, Daughter of Stonewall Jackson* (1910).

HER STORY

Mary Anna Morrison was born on July 21, 1831, to Reverend Robert Hall Morrison and Mary Graham. Her father was the pastor of Sugaw Creek Presbyterian Church in Mecklenburg County and then became the first president of Davidson College.[366] She was educated at Salem Academy.[367] She met Major Thomas Jonathan Jackson, who was a faculty member of the Virginia Military Institute. On July 16, 1857, they married at Cottage Home, her father's plantation. Julia, their only child to survive infancy, was born on November 23, 1862. Mary Jackson's husband died the following year on May 10, 1863.[368]

Jackson returned to her father's home and lived with him until 1873, when she moved to Charlotte for her daughter to complete her education. She then lived with her daughter in Richmond and later moved back to North Carolina.[369]

After her daughter's death in 1889, Jackson wrote and published books about her family members, including *Life and Letters of General Thomas J. Jackson (Stonewall Jackson)*, published by Harper and Brothers in 1892. *Memoirs of Stonewall Jackson*, published in 1895, was a revision of her first text. *Julia Jackson Christian* was published by the Stone and Barringer Company of Charlotte in 1910. In the foreword, Jackson writes, "This little memorial is published simply for the sake of my grandchildren, who, having grown to maturity, can appreciate the rich heritage that is left to them in the life and character of their sainted mother."[370]

Mary Anna Jackson, *Memoirs of Stonewall Jackson by His Widow, Mary Anna Jackson*, (Louisville, KY: The Prentice Press, Courier-Journal Job Printing Company, 1895), 148.

In 1911, with the publication of Mary Johnston's best-selling *The Long Roll* (1911), Jackson publicly spoke out against the novel, believing Johnston had created a caricature out of her late husband.[371]

Jackson died in Charlotte on March 24, 1915. She was eighty-three years old. She was buried next to her husband and daughters at Oak Grove Cemetery in Lexington.

THE GRAVE

Mary Anna Jackson's gravestone is a bevel marker. The back edge of the marker rests against her husband's monument. Her epitaph reads: "Mary Anna Jackson/Wife of Stonewall Jackson/July 21, 1831/March 24, 1915."

HER WRITING

Mary Anna Jackson's writing focuses on personal accounts of family and life in the South during the Civil War. Her books can still be purchased in print form and are available online.

The marker for Mary Anna Jackson with tribute lemons. *Author's collection.*

Oak Grove Cemetery. *Author's collection.*

Not to Miss

Lemons! There is a myth that Stonewall Jackson loved fruit and sucking on lemons. Today visitors may notice lemons left near Jackson's grave as part of a tribute.[372]

21

MARY JOHNSTON

(1870–1936)
Hollywood Cemetery, Richmond
Section 16-126/128

Mary Johnston was a popular novelist and a suffragist. She was the first woman to top the best-seller lists in the twentieth century.[373] *To Have and to Hold*, which was serialized in the *Atlantic Monthly* in 1899, was published as a book in 1900 by Houghton Mifflin and became the best-selling novel in the United States that year. Her novel *Audrey* (1902) was a best-seller, and it was made into a silent film in 1916.[374] Johnston's best-selling *The Long Roll* (1911), a novel about the Civil War, was not appreciated by Stonewall Jackson's widow, who felt Johnston created a caricature out of her late husband.[375]

HER STORY

Mary Johnston was born on November 21, 1870, in Buchanan to John William Johnston and Elizabeth Dixon Alexander Johnston. She was chronically ill in her youth and was educated at home.[376] When her mother passed away in 1889, Johnston, the eldest of six children, became responsible for the household. Even with these additional responsibilities, by the time the family moved to Richmond in 1902, Johnston had already published a few books, including *To Have and to Hold* (1900), which sold over 500,000 copies and would be made into a movie twice.[377]

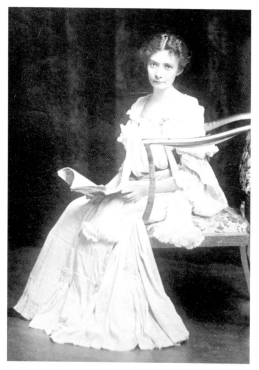

Right: Portrait of Mary Johnston. *The World's Work*, 1909.

Below: The gravestone of Mary Johnston. *Author's collection.*

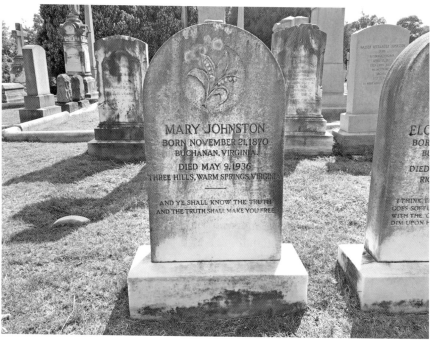

She was the first female novelist to top twentieth-century best-seller lists, even though her novels, including *Hagar* (1913), were overtly political.[378] Johnston's status as a popular novelist was a great benefit to the suffrage movement. She used her writing talent to publish two leaflets for the Equal Suffrage League of Virginia.

Death may silence me, but men shall not bend me.[379]

Johnston supported other reforms, including the labor movement and child labor legislation, but she did not always make her beliefs public in fear they would eclipse her support of women's suffrage.[380] After the Nineteenth Amendment passed, Johnston promoted racial justice through her novel *The Slave Ship* (1924) and her short story in *The Century Magazine*, "Nemesis" (1923), which depicts the lynching of a Black man in a small southern town. Walter White, the assistant secretary of the NAACP, wrote to Johnston, stating he had never "read any story on this great national disgrace of ours which moved me as yours did."[381]

Mary Johnston and her two sisters built Three Hills, their home in Warm Springs. Johnston became better known for her social activism than for her writing during the latter part of her life.[382] On May 9, 1936, she died of Bright's disease.[383] Mary Johnston's sisters, Eloise Johnston and Elizabeth Johnston, were buried next to her grave in Hollywood Cemetery.

THE GRAVE

Mary Johnston's grave marker is a die in socket monument. The epitaph reads: "Mary Johnston/Born November 21, 1870/Buchanan, Virginia/ Died May 9, 1936/Three Hills, Warm Springs, Virginia/And Ye Shall Know the Truth/And the Truth Shall Make You Free." A lily of the valley, signifying innocence, humility and renewal, is at the top of her gravestone.

HER WRITING

Johnston's writing has not received the same scholarly focus as some of her contemporaries such as Ellen Glasgow. Today, her writing is considered historical romance. Johnston's writing is accessible in Project Gutenberg, an online library of free eBooks.

Not to Miss

The location of Mary Johnston's grave is a great place to view the James River, which is the twelfth-longest river in the United States that remains entirely within a single state. There is a seven-mile gradual drop.[384] Across the river is Belle Isle, which served as a prison for Union soldiers during the American Civil War.[385]

CORNELIA JANE MATTHEWS JORDAN

(1830–1898)
Presbyterian Cemetery, Lynchburg
Section/Range 10, Lot 13, Space 3 East

Cornelia Jane Matthews Jordan was a poet and lyricist. She used the nom de plume "Hope Dare" during the Civil War. She contributed to magazines and newspapers and is known for her poem "The Battle of Manassas." Her book *Corinth, and Other Poems* was seized and burned in the courthouse yard at Lynchburg as objectionable by Union general Alfred Terry. She later told the newspapers, "The timorous military commander [had seized her work for being] dangerous and heretical."[386]

HER STORY

Cornelia Jane Matthews was born on January 11, 1830, in Lynchburg to Edwin Matthews and Emily Mildred Goggin Matthews. She was born into wealth and power; her father was the mayor of the city. She was not quite four years old when her mother passed away, at which point she and her three sisters were sent to live with their maternal grandmother in Bedford.[387]

The poet recalls that "at a time when phrenology was in fashion," a phrenologist visited her grandmother's home and, looking for a subject, selected the young Cornelia. The phrenologist stated, "A pretty hard head,

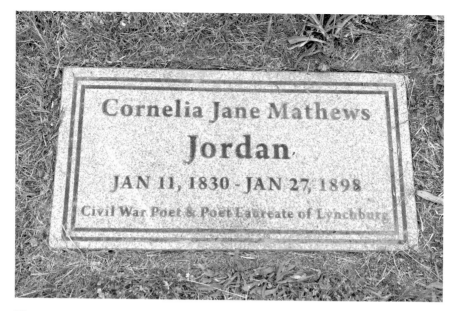

The grave of Cornelia Jane Mathews [*sic*] Jordan. *Author's collection.*

The family plot of Cornelia Jane Matthews Jordan. *Author's collection.*

to be sure; but one that will some of these days make a poet." She would later recount how the man's words gave "her courage and confidence."[388]

In 1842, she attended the Sisters of Visitation in Georgetown, D.C. It was during this time she began to express herself as a poet. She became known as the poet laureate among her peers. Upon her commencement in 1846, she received the highest prize in poetry and prose. The same year, her sister Emily died at the age of thirteen.[389]

In 1851, she married Francis Hubert Jordan. They lived in the Valley of Virginia. Cornelia Matthews Jordan wrote profusely.[390] In 1852, their first child, Edwin Matthews Jordan, was born but only lived two days.[391]

In January 1861, their second child, Francis Nelson Jordan, was born. The next month, just before the start of the Civil War, her first book, *Flowers of Hope and Memory: A Collection of Poems*, was published in Richmond. Her dedication reads, "To the Fireside and the Grave: The Living and the Dead of a Broken Home Circle, This Volume Is Affectionately and Tearfully Inscribed."[392] By June, the infant Francis had died.[393]

In January 1863, their third child, Mary Theresa Jordan, was born. She lived into adulthood and married Philip St. George Ambler. She died at the age of thirty-seven, just a few years after her parents passed.[394]

During the early 1860s, health issues led to the author becoming blind. She continued writing and was able to correspond with several journals with the help of a secretary.[395] Like many southerners after the war, she lost all of her possessions and hoped the sale of her poetry would help her to live a modest life. In December 1865, "A Christmas Poem" in three parts was published for children, although one reviewer criticized the style of writing as not being appropriate for young readers.[396]

In 1867, Jordan published *Richmond: Her Glory and Her Graves* and continued to contribute poems to magazines and newspapers. Her best-known war poems are "The Battle of Manassas," "The Death of Jackson" and "An Appeal for Jefferson Davis."[397]

In the 1880s, Jordan continued writing and sharing her poetry, which appealed to Confederate veterans and their families.[398]

In August 1896, her husband, Francis H. Jordan, died and was buried with his first wife in Luray. On January 26, 1898, after being ill for several years, Cornelia Jane Matthews Jordan died at the home of her daughter.[399] She is buried in the Matthews family grave at Presbyterian Cemetery.[400]

THE GRAVE

Cornelia Matthews Jordan is buried in the family burial plot, which includes a tall obelisk. Her children are all buried here along with her daughter's husband, Philip St. George Ambler. Mary Theresa Jordan Ambler and Philip St. George Ambler have small bevel markers while Edwin Matthews Jordan and Francis Nelson Jordan have inscriptions on the obelisk. In 2017, Cornelia Matthews Jordan's family added a lawn-level marker that includes her name, birth and death dates and the inscription "Civil War Poet and Poet Laureate of Lynchburg."[401]

HER WRITING

Cornelia Matthews Jordan was known as a Civil War poet and the poet laureate of Lynchburg; her writing was a product of her time and focused on being a southerner. Her poetry relates to events associated with the Civil War. Her writing can be found online through free eBooks and through southern literature collections.

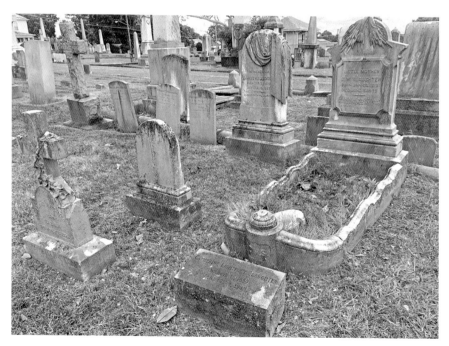

Presbyterian Cemetery. *Author's collection.*

NOT TO MISS

One of Lynchburg's leading suffragists, Elizabeth Dabney Langhorne Lewis, is buried in Presbyterian Cemetery in section J, lot: 12 and space: 2 East. Not far from the cemetery is the Lynchburg Museum, which has an exhibit on the women's suffrage movement in America and highlights the work of Lynchburg's two leading suffragists, Elizabeth Langhorne Lewis and her daughter, Elizabeth Otey. The museum also tells the story of African American activists who fought for suffrage and against Jim Crow laws.[402]

Another notable burial is Emma Serena Dillard Stovall, better known as the folk artist Queena Stovall. Her art depicts rural scenes from everyday life. She painted both her white and Black neighbors. She is buried in C-22-3 West.[403]

23

MARY GREENHOW LEE

(1819–1907)
Mount Hebron Cemetery, Winchester
OLD-257

Mary Greenhow Lee was one of the famed "Devil Diarists" who lived in Winchester during the Civil War. She was a supporter of the Confederacy, and because of her attitude toward Union soldiers, she and other women in Winchester were given the nickname of "she-devils."[404] Her diary, which was written between March 1, 1862, and February 24, 1865, and intended for her close friend Jeanne Mason, is considered one of the most informative records of daily life in Virginia during the Civil War.[405]

HER STORY

Mary Greenhow was born on September 9, 1819, in Richmond to Robert Greenhow and Mary Lorraine Charlton Greenhow. From a wealthy socialite family, Greenhow's father was a former mayor and member of the General Assembly who owned land in Richmond and Henrico.[406]

In 1843, Mary Greenhow married her distant cousin and lawyer, Hugh Holmes Lee, and the two made their home in Winchester.[407] Hugh Holmes Lee died on October 10, 1856. The couple did not have children. His two sisters, Antoinette and Laura, along with nephews and nieces from a deceased sister, lived with Mary Greenhow Lee.[408]

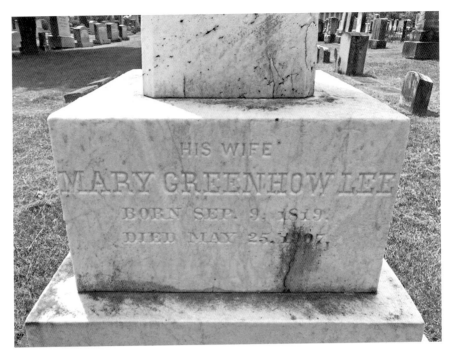

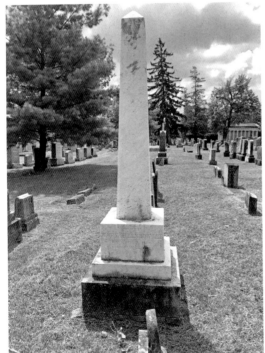

Above: The epitaph of Mary Greenhow Lee. *Author's collection.*

Left: The grave of Mary Greenhow Lee. *Author's collection.*

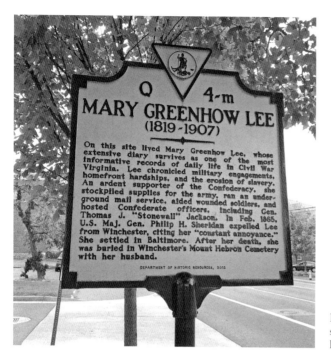

Historic marker at the site of Lee's former home. *Author's collection.*

Throughout the Union occupation of Winchester, Lee wrote in her diary from March 1, 1862, to February 24, 1865. It was intended for her close friend Jeanne Mason. She recounts daily life in Winchester during the war. Also, during the war, Lee behaved rebelliously and smuggled goods and letters through the enemy lines. She and the other women in Winchester would snub Union soldiers to the point that in February 1865, General Philip Sheridan banished her from Winchester.[409]

After the war, Mary Greenhow Lee moved to Baltimore and opened a boardinghouse. She died on May 25, 1907, and is buried in Mount Hebron Cemetery in Winchester.[410]

THE GRAVE

Mary Greenhow Lee shares a white marble obelisk with her husband. Her epitaph reads: "His Wife/Mary Greenhow Lee/Born Sep. 9, 1819/Died May 25, 1907."

HER WRITING

In 2011, Mary Greenhow Lee's journal, *The Civil War Journal of Mary Greenhow Lee*, was published. Her original Civil War diary is housed in the archives of Winchester's Handley Library. Lee also wrote another diary while staying with her brother in Washington, D.C., which is at the Maryland Historical Society's offices in Baltimore.[411]

NOT TO MISS

A Virginia Historic Highway Marker near the parking lot of the George Washington Hotel marks the site of Mary Greenhow Lee's former home on 132 North Cameron Street.

24

MARY TUCKER MAGILL

(1830–1899)
Mount Hebron Cemetery, Winchester
OLD-78

Mary Tucker Magill was a writer and educator. She wrote for newspapers and magazines, wrote several novels and published *The History of Virginia* (1873).[412] She helped to establish the Valley Female Seminary school for girls in 1866.[413]

HER STORY

Mary Tucker Magill was born on August 21, 1830, in Frederick County to Dr. Alfred T. Magill and Ann Evelina Tucker. Her father was a professor of medicine at the University of Virginia, where Mary Magill was later educated. Just before her seventh birthday, her father passed away. In 1848, the family moved to Winchester. In 1866, she helped her mother establish the Valley Female Seminary and became one of the first instructors.[414]

In 1871, she published her first novel, *The Holcombes: A Story of Virginia Home-Life*, and in the same year followed with a sequel, *Women: Or Chronicles of the Late War*. In 1873, her textbook, *The History of Virginia for the Use of Schools*, was published for students in the fourth and fifth grades. The Virginia State Board of Education required its use in teaching Virginia history for

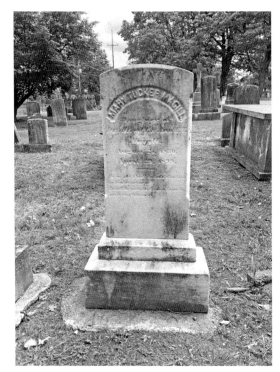

Left: The grave of Mary Tucker Magill. *Author's collection.*

Below: Mount Hebron Cemetery. *Author's collection.*

more than forty years; Magill's textbook shaped the historical perspective of several generations of Virginians.[415]

Magill's other publications included a physical education textbook, *Pantomimes; or, Wordless Poems, for Elocution and Calisthenic Classes* (1882);[416] "A Georgian at the Opera" (1885); "Sis" (1886); *Under the Pruning-Knife. A Story of Southern Life* (1888); *Stories from Virginia History, for the Young* (1897); and *Magill's First Book in Virginia History* (1908).[417]

Along with writing, Magill traveled and gave readings of her work.[418] She lived in New York for many years, and when her health became poor, she moved to Staunton to a home she called Fair Haven Cottage a year before she passed away.[419]

She passed away on April 29, 1899, while visiting a friend. She was sixty-eight years old.[420] She is buried near her family members in Mount Hebron Cemetery.

The Grave

Mary Tucker Magill's grave marker is die in socket. Her epitaph reads: "Mary Tucker Magill/Daughter of/Dr. Alfred Thurston Magill/August 21, 1830/April 29, 1899/As for me I will behold thy face/In righteousness/I shall be satisfied when I wake/with thy likeness."

Her Writing

Mary Tucker Magill's textbook was required reading for primary grade students in Virginia public schools for more than forty years after it was published. Her writing shaped the historical perspective of several generations of Virginians.[421] Magill's writing can be purchased through reproductions and auctions online.

Not to Miss

Pulitzer Prize–winning author Willa Cather was born outside of Winchester in 1873. Although she only lived in Winchester as a child, her childhood home, Willow Shade, which is a private residence along Northwestern Pike (U.S. 50) near Gore, is listed on the National Register of Historic Places and is sometimes open to visitors.[422]

JULIA MAGRUDER

(1854–1907)
Maplewood Cemetery, Charlottesville
Division A, Block 8, Section 1 (near Eighth Street brick wall)

Julia Magruder was a novelist who wrote for popular magazines such as *Lippincott's Magazine*; several of her novels were serialized in the *Ladies' Home Journal*.[423] Her essays addressed more serious social issues, such as child labor laws and the changing roles of women. In 1907, Magruder became the first American woman to be awarded the "Order of the Palms" by the French Academie, conferred on those distinguished in the literary world.[424]

HER STORY

Julia Magruder was born on September 14, 1854, to Allan Bowie Magruder and Sarah Gilliam Magruder, members of a prominent family in Charlottesville. She was the second youngest of five daughters. Her father was a prominent lawyer, and the family moved between their homes in Virginia and Washington, D.C. Magruder was educated at home by her parents and governesses. With access to numerous books, she read widely, with George Eliot being a favored writer.[425]

At the age of sixteen, Magruder published her first story, "My Three Chances," in the local newspaper. While she continued writing in her youth,

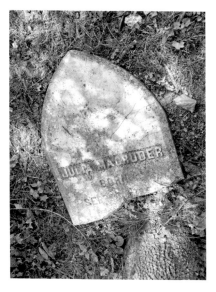

JULIA MAGRUDER.
Drawing from *Ladies' Home Journal* portrait.

Left: The broken grave of Julia Magruder. *Author's collection.*

Right: The portrait of Julia Magruder. Drawing from *Ladies' Home Journal* portrait.

her first major work, *Across the Chasm*, was published anonymously in 1885 and was considered "the best of the year."[426]

She published sixteen novels, several short stories and magazine articles focused on social issues during the 1880s, 1890s and early 1900s. Newspaper reports shared that Magruder spent only three hours each morning writing and averaged nearly one thousand words an hour.[427] After reaching that goal, her work was put aside until the next morning.[428]

Magruder was quoted as saying:

Most of us are so afraid to enjoy ourselves in our *way.*[429]

Magruder lived most of her life in Washington, D.C. She became close friends with novelist Julia Grinnell Storrow Cruger, who used the pseudonym Julien Gordon.[430] While she lived in Washington, D.C., she traveled and frequently stayed with friends, including novelist Amélie Rives, Princess Troubetzkoy, and stayed at Castle Hill, Rives's home in Albemarle County. Magruder visited her sister, Emily Gibson, in Concord, North Carolina, where she even had a book club named after her. She also spent several years abroad.[431]

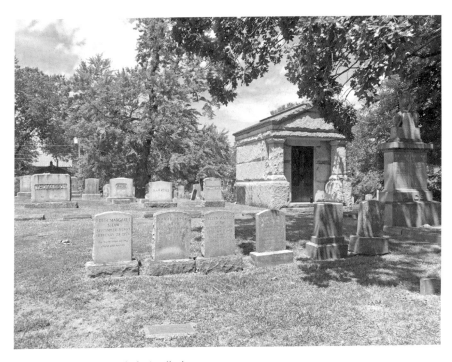

Maplewood Cemetery. *Author's collection.*

Magruder became the first American woman to be awarded the "Order of the Palms" by the French Academie. This decoration was conferred on those distinguished in the literary world. She received word of the prestigious honor just one week before her death. She died on June 9, 1907, in Richmond after a long illness. She was fifty-two years old. She is buried next to her parents in Maplewood Cemetery in Charlottesville.[432]

The Grave

Julia Magruder's gravestone is a gothic arch-shaped headstone that has been broken into two pieces, with the top of her grave marker lying by a tree near the brick wall of the cemetery. Since this author's visit to the cemetery in July 2020, a Find a Grave member posted a picture showing more vandalism occurred around October 2020. Magruder's epitaph reads: "Julia Magruder/Born/Sept. 14, 1854/Died/June 9 1907/Thy will be done." The last line quotes the sixth chapter of the Gospel of Matthew.

Julia Magruder's broken gravestone, taken in July 2020 before the marker was vandalized. *Author's collection.*

HER WRITING

Scholars consider her literary work to be sentimental, with most of her novels depicting love stories in which the heroine must face obstacles in pursuit of her goal to find true love. Today, her work can still be purchased from online booksellers and is accessible in Project Gutenberg, an online library of free eBooks. Her papers can be found at the University of Virginia libraries in archival materials.[433]

NOT TO MISS

As Julia Magruder was a romance novelist who enjoyed having fun, visitors may wish to consider the Monticello Wine Trail, which includes thirty-three wineries.[434] Charlottesville is known as being one of the finest areas for wine in Virginia. In the region, there are numerous women winemakers and female landowners who founded vineyards. Felicia Warburg Rogan, sometimes called the "First Lady of Virginia Wine," founded

Oakencroft Vineyard & Winery, the first winery in Albemarle County. Blenheim Vineyards, one of the wineries on the Monticello Wine Trail, is run by winemaker Kirsty Harmon, one of several female winemakers in Virginia.[435]

KATHERINE BOYCE TUPPER MARSHALL

(1882–1978)
Arlington National Cemetery, Arlington
Section 7, Grave 8198

Katherine Boyce Tupper Marshall was the author of *Together, Annals of an Army Wife* (1946) about her life with her husband, General George C. Marshall, who was awarded the Nobel Peace Prize.[436] Earlier in life, she was a Shakespearean actress in London.[437]

HER STORY

Katherine Boyce Tupper was born on October 8, 1882, in Harrodsburg, Kentucky, to Reverend Henry Allen Tupper Jr. and Marie Louise Pender Tupper. Her father was a prominent Baptist minister. In 1898, Katherine Tupper attended Hollins College in Roanoke with her sister. She graduated in 1902. Tupper then attended the American Academy of Dramatic Arts in New York, studied with the Comédie-Française in Paris and became a known Shakespearean actress in London while performing under the name Katherine Boyce.[438]

In 1911, she returned to the United States and married her first husband, Clifton Stevenson Brown, who worked as a lawyer. The couple had three children. In 1928, Brown was shot and killed by a client over a counsel fee.[439] Their children were in their early teens when they lost their father.

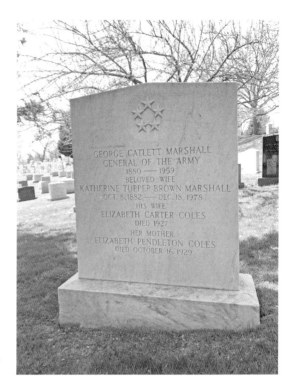

Right: The gravestone of
Katherine Tupper Marshall.
Author's collection.

Below: The Marshall gravestone
in Arlington National Cemetery.
Author's collection.

When visiting a friend from Hollins College, Katherine Tupper Brown met George C. Marshall. The couple married in 1930. The wedding was supposed to be somewhat quiet since it was the second marriage for each of them; however, Marshall's best man, General John J. Pershing, caused much excitement, and curious spectators filled the streets outside of the Baltimore Emanuel Episcopal Church.[440]

In 1943, General Marshall had to deliver the news to his wife that her son, Allen Tupper Brown, had been killed under fire in Italy.[441]

In 1945, both General Marshall and Katherine Tupper Marshall retired. In 1946, she wrote *Together, Annals of an Army Wife* about her life with General Marshall.[442]

In 1953, General Marshall received the Nobel Peace Prize for his work while Secretary of State; he advocated for an economic and political commitment to postwar European recovery known as the Marshall Plan. In 1959, General Marshall died.[443]

Katherine Tupper Marshall remained active by traveling and maintaining residences in Virginia and North Carolina. On December 18, 1978, Katherine Tupper Marshall died at the Loudon Memorial Hospital in Leesburg. She was taken to Arlington National Cemetery to be interred by her husband.[444]

THE GRAVE

Katherine Tupper Marshall shares a die on base marker with her husband, General George Marshall. It is a private vertical upright gravestone. The back of the grave marker reads, "Marshall/Chief of State U.S. Army/Secretary of State/President of American Red Cross/Secretary of Defense." The epitaph reads, "George Catlett Marshall/General of the Army/1880–1959/Beloved Wife/Katherine Tupper Brown Marshall/Oct. 8, 1882–Dec. 18. 1978/His Wife/Elizabeth Carter Coles/Died 1927/Her Mother/Elizabeth Pendleton Coles/Died October 16, 1929." Above the epitaph is a five-star symbol carved into stone.

HER WRITING

Katherine Boyce Tupper Marshall's writing is a personal account of her life with her husband. *Together, Annals of an Army Wife* (1946) is available from online booksellers and has been republished by Franklin Classics.

NOT TO MISS

The Marshall grave is near the Tomb of the Unknown Soldier, a monument dedicated to deceased U.S. service members whose remains have not been identified. In 1997, Sergeant Heather Lynn Johnson became the first woman to earn the tomb guard identification badge. She was the 389th soldier in thirty-eight years to earn one of the military's most prestigious emblems.[445] Additional female sentinels have been awarded the tomb guard identification badge since that time, including Sergeant Danyell Wilson (1997), Staff Sergeant Tonya Bell (1998), Sergeant Ruth Hanks (2015) and Sergeant First Class Chelsea Porterfield (2021).[446]

FRANCES McENTEE MARTIN

(1906–1998)
Forest Lawn Cemetery, Norfolk
Section Live Oak, Block T, Lot 20, Row 0, Space NW 0

Frances McEntee Martin was a children's author and playwright who wrote under the name Fran Martin and is known for her books *Knuckles Down* (1942), *No School Friday* (1945), *Sea Room* (1947), *Nine Tales of Coyote* (1950), *Nine Tales of Raven* (1951) and *Pirate Island* (1955). She frequently collaborated with her sister, Dorothy Layng McEntee, who was an artist-illustrator for children's books.

HER STORY

Frances Gardiner McEntee was born on October 23, 1906, in Nutley, New Jersey, to Frances Layng and Thomas Lockley McEntee and had one older sister, Dorothy Layng McEntee. In 1921, their father passed away. The family continued living in New Jersey for a few years.[447]

On April 25, 1925, Frances "Fran" McEntee married Frederick "Fred" Ellis Martin in Brooklyn, New York.[448] The family moved to Norfolk. Fred Martin worked as a lawyer and later had his own practice. Their family grew with the birth of their daughter, Jane Lockley, on June 23, 1926. Their first son, Frederick Ellis, was born on June 23, 1928. Their younger son, Thomas McEntee, was born on October 2, 1931.[449]

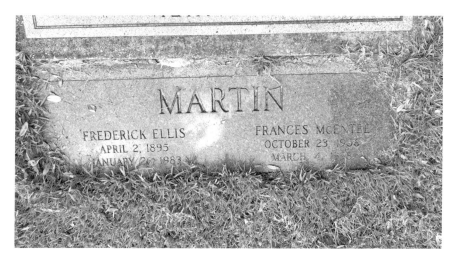

The grave of Frances McEntee Martin. *Author's collection.*

As her children became older, Fran Martin began writing and publishing her books through Harper. By the mid-1950s, she was a regionally known author of children's literature.[450] In 1953, with over five children's books published, Fran Martin was one of the honored Norfolk writers at the annual Authors Party at Thalhimers, a department store based in Richmond, which included a book department. The department store had over three thousand book buyers and spent a good amount on advertising its book selection.[451] Martin was an advocate for children's literature and believed all adults should become familiar with a variety of titles so they could recommend them to the children in their lives. Martin maintained, "The books we read twenty-five years ago often seem different now. This does not mean that old books are not good choices." Instead, she argued, "Books, new or old, must be evaluated on their present merits in light of the personality of the child for whom they are being selected."[452] As she frequently collaborated with her sister, Dorothy Layng McEntee, an artist-illustrator whose work can be viewed in the National Gallery of Art, Fran Martin was also a supporter of quality artwork within children's books, emphasizing that these illustrations were the chief art influence in children's lives.[453]

The author's younger son, Thomas McEntee, was a writer like his mother. He attended the University of Virginia and was the editor-in-chief for the student newspaper, *The Cavalier Daily*. Thomas McEntee also was a Marine Reserve pilot. On August 29, 1957, while completing

Forest Lawn Cemetery. *Author's collection.*

The grave of sister and artist Dorothy Layng McEntee. *Author's collection.*

a two-week training in Orange, California, he was killed in a crash of his Banshee jet. He was twenty-five years old. He is buried in Arlington National Cemetery.[454] After her son's death, Fran Martin focused on her family and did not return to writing.

On January 26, 1983, Fran Martin's husband, Frederick Ellis, passed away at the age of eighty-seven.[455] They had been married for fifty-seven years. Her sister, Dorothy Layng McEntee, died on May 16, 1990. Her oldest son, Fredrick Ellis, passed away on June 4, 1997, at the age of sixty-eight.

Frances Gardiner McEntee died on March 4, 1998, when she was ninety-one years old. She is buried at Forest Lawn Cemetery.[456]

THE GRAVE

Fran Martin shares a grave marker with her husband. It is a lawn-level marker flush with the ground. The epitaph reads: "Martin/Frederick Ellis Frances McEntee/April 2, 1895 October 23, 1906/January 26, 1983 March 4, 1998." Fran Martin's sister, Dorothy Layng McEntee, is buried in an adjacent grave.

HER WRITING

Fran Martin's writing focused on children's literature, and she frequently collaborated with her sister, Dorothy Layng McEntee. Today, her work can be found online and through vintage booksellers.

NOT TO MISS

The Norfolk Society for Cemetery Conservation, a nonprofit organization that helps preserve, protect and promote the eight municipal cemeteries in Norfolk, offers a variety of tours of its historic cemeteries, including The Women in Norfolk Historic Cemetery Tour.[457]

MABEL WOOD MARTIN

(1888–1956)
Arlington National Cemetery, Arlington
Section 8, Lot 21 E H

Mabel Wood Martin was the author of novels and short stories in popular magazines such as *Everybody's Magazine* and *Scribner's*. She received her literary training from Ambrose Bierce, the American short story writer and poet.[458] She wrote *The Green God's Pavilion: A Novel of the Philippines* (1920) and *The Lingering Faun: A Novel* (1927).

Her Story

Mabel Gertrude Wood was born on January 25, 1880, in Toronto, Ontario, Canada. In 1903, she married West Point graduate and army officer Charles Fletcher Martin in West Point, New York.[459] Mabel Wood Martin began writing for popular magazines in 1904, the same year their daughter was born.

With his military career, the Martins moved rather frequently. Mabel Wood Martin continued making a name for herself by publishing in popular magazines, including *Scribner's* and *Everybody's Magazine*. In 1909, she wrote the story "The Heritage of the Rice Fields: A Story."[460] At the time, the couple lived at Yellowstone National Park in Wyoming. In 1914, her story "Charity" was published in *Scribner's Magazine*.[461]

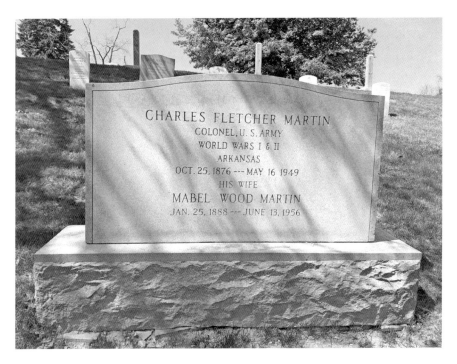

Above: The gravestone of Mabel Wood Martin. *Author's collection.*

Left: Arlington National Cemetery with the Washington Monument in the background. *Author's collection.*

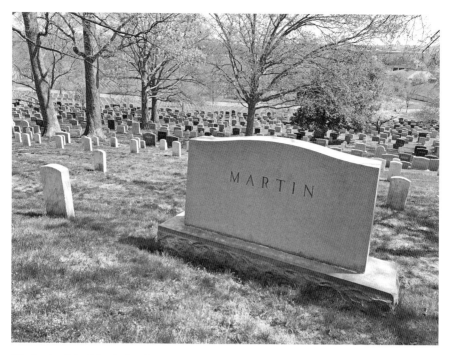

The back of the Martin headstone in Arlington National Cemetery. *Author's collection.*

For several years, they lived in Manila, the capital of the Philippines. Her experience there inspired her to write her first novel, *The Green God's Pavilion: A Novel of the Philippines* (1920). While the couple was living in California, Martin published a suspense novel, *The Lingering Faun: A Novel* (1927).

By the 1930s, the Martins had moved to El Paso, Texas.[462] By the 1940s, they were living in the District of Columbia.[463] On May 16, 1949, Martin's husband, Charles Fletcher, passed away at the age of seventy-two. Mabel Wood Martin continued to live in Washington, D.C., with their daughter Kelsey Loftus Martin, who was married to Colonel John Winthrop Mott. Mabel Wood Martin died on June 15, 1956, at the age of seventy-six. She is buried beside her husband in Arlington National Cemetery.[464]

THE GRAVE

Mabel Wood Martin shares a private die on base monument with her husband in Arlington National Cemetery. The gravestone is a vertical upright marker. On the back of the marker reads the family name Martin. On the front

of the gravestone, the epitaph reads: "Charles Fletcher Martin/Colonel. U.S. Army/World Wars I & II/Arkansas/Oct 25, 1876–May 16, 1949/His Wife/Mabel Wood Martin/Jan. 25, 1888–June 13, 1956.

Her Writing

Mabel Wood Martin's writing includes female characters on personal adventures; her writing has been described by critics as "American uplift."[465] Today, Mabel Wood Martin's writing is available through free access to online magazines such as *Everyday Magazine* and *Scribner's Magazine* and eBooks.

Not to Miss

The Martins' grave is near the World War I Memorial Tree. Arlington National Cemetery features 142 Memorial Trees, which serve as living memorials. Many have been dedicated by U.S. presidents and visiting dignitaries or representatives from service organizations. More information about Memorial Trees can be found on Arlington National Cemetery's website.[466]

29

JUDITH BROCKENBROUGH McGUIRE

(1813–1897)
St. John's Episcopal Churchyard, Tappahannock
Grave located on eastern side of the church near third Gothic window

Judith Brockenbrough McGuire was a Civil War diarist who recorded her experiences from 1861 to 1865. In 1867, her diary, *The Diary of a Southern Refugee*, was published and told of how private citizens were uprooted from their homes and communities. In 1873, she published *The Life of General Robert E. Lee, The Christian Soldier*, a biography with a special focus on his religious beliefs and time in his hometown church.[467]

HER STORY

Judith White Brockenbrough was born on March 19, 1813, to Judith Robinson Braxton White Brockenbrough and Judge William Henry Brockenbrough and was one of eight children. Her mother had connections to Dolley Madison and even inscribed her initials into the glass in an upstairs window at Mount Vernon. Her father was a prominent lawyer and judge who had attended the college at William and Mary and became a member of the General Assembly in Virginia. In 1834, he was appointed to the Virginia Court of Appeals.[468]

Left: The ledger marker of Judith Brockenbrough McGuire. *Author's collection.*

Right: Saint John's Episcopal Churchyard. *Author's collection.*

Judith W. Brockenbrough grew up in Hanover County at the family home, known as Westwood.[469] In 1818, John Brockenbrough, her cousin, was commissioned to build a large residence. In 1861, the house that was known as the Brockenbrough House would become the Executive Mansion of the Confederate States of America.[470]

In 1846, she married Reverend John Peyton McGuire in Hanover. Reverend McGuire became rector of Christ Church in Alexandria.[471] In 1853, Reverend McGuire was appointed the headmaster of the Episcopal High School in Alexandria. The couple settled into a prosperous existence in Alexandria until May 1861, when they had to close the Episcopal High School and leave due to the Civil War. Judith Brockenbrough McGuire recorded her experiences in her diary from 1861 to 1865. Her last days in Alexandria were spent going to chapel, sewing uniforms, baking for the soldiers, gardening and packing. Their sons enlisted in the military, and their daughters were sent to live with relatives.[472]

The McGuires left Alexandria in June and stayed in Fairfax County; by July, they had moved to Winchester, where they stayed with one of Judith Brockenbrough McGuire's sisters. In February 1862, they moved to

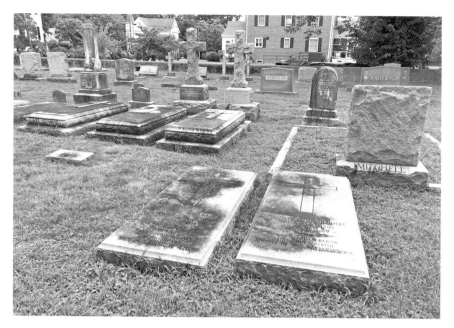

The graves of Judith White Brockenbrough McGuire and her husband. *Author's collection.*

Richmond. Reverend McGuire found a job in the post office since he could not find a position as chaplain and no teaching positions were available. In December 1863, she sought her own employment as a clerk in the Army Commissary Department.[473]

In 1867, Judith Brockenbrough McGuire's diary, *The Diary of a Southern Refugee*, did not include her name originally but was published by "a lady of Virginia."[474] After the war, the couple moved to Tappahannock, where Judith Brockenbrough McGuire ran an academy for young ladies. Reverend John Peyton McGuire was known as "Apostle of the Rappahannock" for his success in reviving the postrevolutionary Episcopal Church in this region of Virginia.[475] In March 1869, Reverend McGuire passed away.

In 1873, Judith Brockenbrough McGuire published *The Life of General Robert E. Lee, The Christian Soldier*, a biography with a special focus on Lee's religious beliefs and his hometown church.[476]

Judith White Brockenbrough McGuire died on March 21, 1897, in Tappahannock, when she was eighty-four years old.[477] She is buried in St. John's Episcopal Churchyard.

THE GRAVE

Judith Brockenbrough McGuire and Reverend McGuire each have a ledger marker, a thick slab of stone covering the entire grave. Their graves are nearest to the church, on the eastern side, and near the third Gothic church window. At the top of her marker is a large cross. Her epitaph reads: "Judith Brockenbrough/McGuire/March 19 1813/March 21 1897/Wife of/John Peyton McGuire/Authoress of/Diary of a Southern Refugee."

HER WRITING

Judith Brockenbrough McGuire's work has continued to be published for historians. Her work was republished in 2013 through the University Press of Kentucky.

NOT TO MISS

McGuire's husband was the first rector of the church and is memorialized by a Tiffany window above the pulpit.[178] One block from the churchyard is the Essex County Museum, which offers exhibits on the Civil War.[179] The website also includes a virtual cemetery tour.[480]

MARGARET PRESCOTT MONTAGUE

(1878–1955)
Hollywood Cemetery, Richmond
Section 11-35

Margaret Prescott Montague was a novelist and short story writer who contributed to *The Atlantic Monthly*. Her short story "England to America," which was praised by President Woodrow Wilson, was awarded the O. Henry Award in 1919.[481] Several of her novels were made into movies in the 1920s.[482]

HER STORY

Margaret Prescott Montague was born on November 29, 1878, in Greenbrier, West Virginia, to Russel Wortley and Harriet Cary Montague. She had one older brother. Her education began at home. In her teens, she attended Miss Gussie Daniel's school in Richmond.[483]

Her first novel, *The Poet, Miss Kate and I* (1905),[484] was the start of a fruitful career that was followed by *The Sowing of Alderson Cree* (1907),[485] *In Calvert's Valley* (1908),[486] *Linda* (1912),[487] *Of Water and the Spirit* (1916)[488] and *Up Eel River* (1928).[489]

Writing seemed to come spontaneously almost without taking thought.[490]

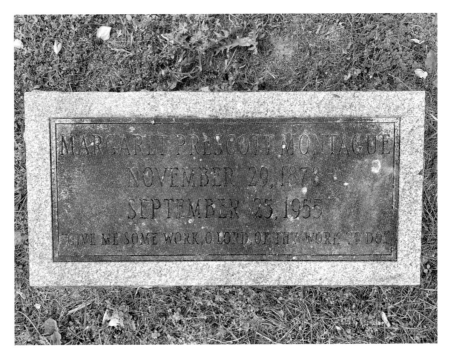

The grave of Margaret Prescott Montague. *Author's collection.*

In 1909, she became partially deaf and blind and required glasses and hearing aids.[491] Her brother, Russel Cary Montague, was a principal at the West Virginia School for the Deaf and Blind at this time.[492] Later, he would become superintendent.[493] Her connection to the school and her personal experiences with her hearing and sight deteriorating would influence future writing.

By 1912, Montague's writing was starting to gain attention. One critic argued, "Margaret Prescott Montague has wrought for herself a place in the ranks of great, present-day novelists."[494] Montague was seen as a deeply religious person who was interested in Christian mysticism and philosophy. Much of her beliefs could be seen throughout her writing.[495]

As her writing was gaining popularity, she was also a beloved member of the West Virginia School for the Deaf and Blind. While Montague visited Boston, the school paper noted how much the students and staff missed her presence.[496] By 1915, her connection with the school community had made such an impact that she published *Closed Doors*, which one reviewer noted did not include "subnormal children" but rather "ordinary children, quite like [any] other" and complimented her writing for not sensationalizing deaf

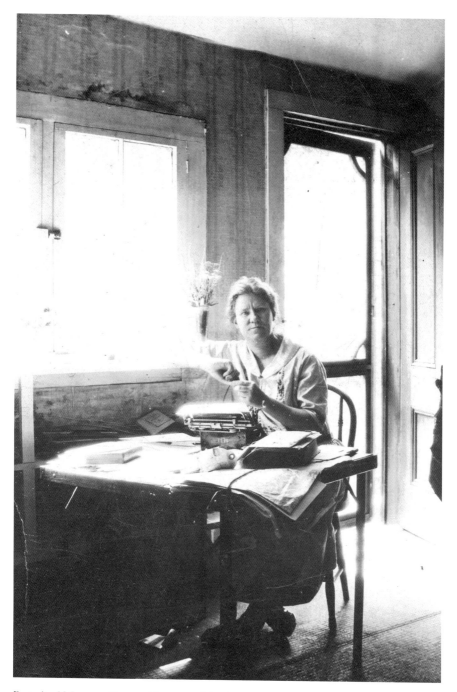

Portrait of Margaret Prescott Montague. *West Virginia and Regional History Center, WVU Libraries.*

children as "sentimental nor morbid."[497] Dr. Richard C. Cabot, a professor of Harvard University, used the book in his courses.[498]

After *Closed Doors*, Montague focused on shorter prose and poetry. In 1919, her writing included wartime stories, and her story "England to America" won the O. Henry Memorial Prize. In 1920, "Uncle Sam of Freedom Ridge" incorporated her interest in politics.[499] The work was made into a film and became a topic of discussion in the presidential election. In an interview, President Woodrow Wilson stated, "[Montague] has written a story which breathes of a patriotism so pure and wholesome as to make other things of life seem so little consequence. I wish that every person that questions the benefits to humanity that will be guaranteed by the League of Nations, might read it."[500] Three other novels were made into films.[501]

By the mid-1920s, Montague was living in Richmond and was recommended to the Woodrow Wilson Foundation for her public service. Those who nominated her argued her writing showed "conclusively the patriotic, idealistic and Wilsonian trend."[502]

Her last published novel, *Deep Channel*, was released in 1923.[503] She continued writing shorter prose and poetry and even wrote a novel in the 1930s that was not published.[504] Margaret Prescott Montague died in Richmond on September 26, 1955, and is buried in Hollywood Cemetery.[505]

THE GRAVE

Margaret Prescott Montague's gravestone is a bevel marker that is raised approximately two inches from the ground. Her epitaph reads: "Margaret Prescott Montague/November 29, 1878/September 25, 1955/"Give me some work O Lord, of Thy Work to Do."

HER WRITING

Montague's early writing was influenced by local colorists. Her later work included her own personal struggles as well as those who she encountered. *Lucky Lady*, which was first published in *The Atlantic Monthly* and then later as a book, addressed her struggles with her hearing and sight deteriorating.[506] Abridgements of her writing focusing on deafness for the *Reader's Digest* and *The Atlantic Monthly* were republished in newspapers.[507] Today her novels and many of her short stories and poems can be accessed online for free.

Not to Miss

Margaret Prescott Montague was one of the founders of the Virginia Writers' Club. While visiting her grave, note that other members of the club, including Kate Langley Bosher, Mary Newton Standard and Annie Steger Winton, have graves within walking distance.[508]

31

LaSALLE "SALLIE" CORBELL PICKETT

(1843–1931)
Hollywood Cemetery, Richmond
Gettysburg Section, Pickett's Corner

Lasalle "Sallie" Corbell Pickett was an author and lecturer who was better known for being the third wife of Confederate general George E. Pickett. Similar to other wives of leaders in the Confederate States Army, LaSalle Corbell Pickett wrote about her husband after the Civil War, *Pickett and His Men* (1899). She also published other works, such as *Kunnoo Sperits and Others* (1900), *Ebil Eye* (1901), *Digging Through to Manila* (1905), *Literary Hearthstones of Dixie* (1912), *The Heart of a Soldier* (1913) and *What Happened to Me* (1917). Her writing was popular in the late nineteenth and early twentieth centuries.

HER STORY

LaSalle "Sallie" Corbell was born on May 16, 1843, in Nansemond County, which is now part of Suffolk, to David John Corbell and Elizabeth Phillips. She was the oldest of nine children.[509] She attended the Lynchburg Female Seminary.[510]

On September 15, 1863, Corbell married Confederate general George E. Pickett at St. Paul's Episcopal Church in Petersburg.[511] In July 1864, their

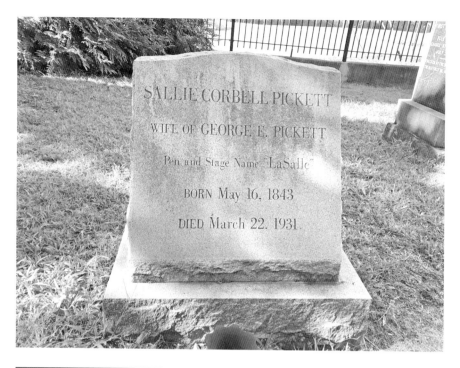

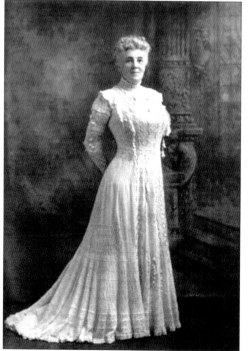

Above: The grave of Sallie Corbell Pickett. *Author's collection.*

Left: The portrait of LaSalle Pickett after 1910. *History and Art Collection Alamy Stock Photo.*

son George Edward Pickett was born in Richmond. After the Civil War, the family moved to Montreal, Canada, where Sallie Pickett obtained a professorship in belles-lettres and supported the family for a few months before returning to Richmond.[512] In May 1866, their second son, David Corbell Pickett, was born. He died in 1874, one year before his father's death in 1875.[513] Sallie Pickett secured a government position and was able to support herself and her son independently.[514]

In the 1880s, Sallie Pickett reinvented herself as LaSalle Corbell Pickett, "child-bride of the Confederacy," changing her age to up to five years younger and becoming a popular writer and speaker.[515] In 1891, after an accident, she nearly became completely blind.[516]

In 1899, her first book, *Pickett and His Men*, was published. From that point until the early 1930s, she toured America and wrote for popular magazines, including *Cosmopolitan* and *McClure's*.

LaSalle Corbell Pickett continued writing and published *Kunnoo Sperits and Others* (1900), *Yule Log* (1900), *Ebil Eye* (1901), *Jinny* (1901), *Digging Through to Manila* (1905), *Literary Hearthstones of Dixie* (1912), *The Bugles of Gettysburg* (1913), *The Heart of a Soldier, As Revealed in the Intimate Letters of Gen'l George E. Pickett, C.S.A.* (1913), *Across My Path: Memories of People I Have Known* (1916) and *What Happened to Me* (1917).

Sallie Pickett died on March 22, 1931, while staying at a private sanitarium in Rockville, Maryland. She had been there for several months. Although she had hoped to be buried beside her husband, she was buried in the Abbey Mausoleum in Arlington since the Hollywood Ladies' Memorial Society controlled the title to the Gettysburg Hill section of the cemetery and would not allow women to be buried in the Confederate section. Founded in 1924, the Abbey Mausoleum was considered one of the most luxurious in the area. The mausoleum fell into disuse and disrepair. In the 1970s, the mausoleum was vandalized on a regular basis.[517] By the early 1990s, vandalism continued along with indications of Satanic rituals and body desecration.[518] All the bodies were removed by January 2001, and it was demolished on February 5, 2001.[519] In 1998, LaSalle Pickett was reinterred to a plot in front of her husband in Hollywood Cemetery after Civil War heritage groups arranged for the move due to concerns of vandalism.[520] This marked the first time a woman was buried in this section of the cemetery.[521]

Right: The grave of Sallie Corbell Pickett, located in front of her husband's marker. *Author's collection.*

Below: Completed in 1869, this is a monument to the eighteen thousand Confederate soldiers buried nearby. *Author's collection.*

THE GRAVE

Sallie Pickett's gravestone in Hollywood Cemetery is a slant on base marker. Her epitaph reads, "Sallie Corbell Pickett/Wife of George E. Pickett/Pen and Stage name LaSalle/Born May 16, 1843/Died March 22, 1931."

HER WRITING

LaSalle Pickett's writing is categorized as Lost Cause literature, which perpetuates myths about enslaved Africans being happy. Today, LaSalle Pickett's writing can be found online, through traditional publishing houses and as eBooks.[522]

NOT TO MISS

There are eighteen thousand Confederate soldiers buried in Hollywood Cemetery, with nearly three thousand from the dead at Gettysburg. The Hollywood Ladies' Memorial Society raised money for a monument "intended that it would be the first thing that visitors would see upon entering the cemetery."[523] Charles Dimmock designed this ninety-foot pyramid-shaped Confederate monument with granite quarried from the James River. This was dry-laid. The Hollywood Ladies' Memorial Society raised $26,000 to erect this monument in 1869. It took one year to build.[524]

32

MARGARET JUNKIN PRESTON

(1820–1897)
Oak Grove Cemetery, Lexington
Preston family plot

Margaret Junkin Preston was an author and poet who wrote for the *Southern Literary Messenger*, *Harper's Magazine* and *The Century Magazine*. Although she wrote and published before the Civil War, she is known informally as the Poet Laureate of the Confederacy and for being a Southern war poet whose best-known works include *Beechenbrook: A Rhyme of War* (1865), *Old Song and New* (1870) and *Aunt Dorothy: An Old Virginia Plantation Story* (1890).[525]

HER STORY

Margaret Junkin was born in Milton, Pennsylvania, on May 19, 1820, to Reverend George Junkin, DD, and Julia Rush Miller Junkin. Her father was a Presbyterian minister, the founder of Lafayette College[526] and a pronounced abolitionist.[527] She was the oldest daughter of seven children. One of her younger sisters, Eleanor Junkin, became the first wife of Thomas Jackson, who, a decade after Eleanor's death, would become the Confederate Civil War general known as "Stonewall" Jackson.

By the age of twelve, Margaret Junkin was proficient in Ancient Greek and Latin. In the early 1840s, Margaret Junkin began having her poetry

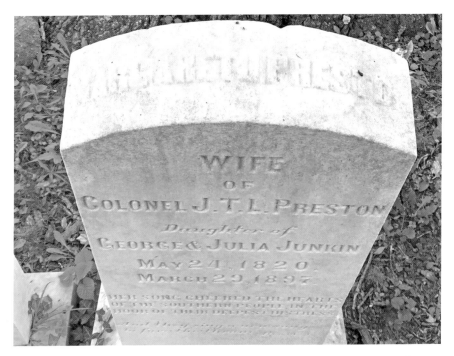

The grave of Margaret Junkin Preston. Her name appears only at the top of the marker. *Author's collection.*

published in local newspapers.[528] In 1848, the family moved to Lexington, where she would remain the majority of her life.[529] In 1849, her brother Joseph died. Her mother passed away in 1854 along with her sister Eleanor just a few months after.[530]

Her 1856 book *Silverwood: A Book of Memories* "is an exploration of the clash between traditional values of honor and family and the new market economy that was sweeping through the United States and the Shenandoah Valley."[531]

In 1857, she married Colonel John Thomas Lewis Preston, a Latin professor at the Virginia Military Institute and a widower with seven children.[532]

Like many women of the time, as her husband went off to fight in the Civil War, she kept a detailed journal, which became a source for her poetry. Dissimilar to many of her Southern contemporary female writers, Margaret Preston wrote because she could, not because she was forced to do so to make ends meet. Unlike many women writers of that time, she did not need to make money.[533]

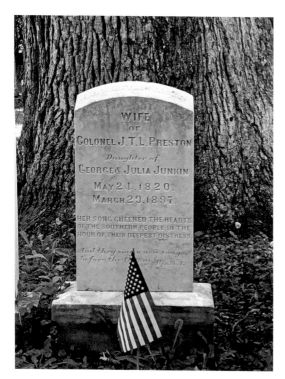

Left: The grave of Margaret Junkin Preston in the family plot. *Author's collection.*

Below: Oak Grove Cemetery. *Author's collection.*

After the war, Margaret Preston spent much of her time reviewing books for publishing companies and publishing her own compositions in prose and verse.[534] Her works include *Beechenbrook: A Rhyme of War* (1865), *Old Song and New* (1870) and *Cartoons* (1875). She went to Europe during the summer of 1884. It was there she produced her last prose. She became blind in the late 1880s. She continued to release several works, including *A Handful of Monographs: Continental and English* (1886), *For Love's Sake: Poems of Faith and Comfort* (1886), *Colonial Ballads, Sonnets and Other Verse* (1887), *Semi-Centennial Ode for the Virginia Military Institute: Lexington, Virginia, 1839–1889* (1889) and *Aunt Dorothy: An Old Virginia Plantation Story* (1890).[535]

On July 15, 1890, her husband passed away. She continued to live in Lexington until December 1892, when she moved to Baltimore to live with her son, Dr. George Junkin Preston. She died in Baltimore on March 19, 1897.[536] She is buried in the family plot at Oak Grove Cemetery in Lexington.

THE GRAVE

Margaret Preston's grave is a die in socket. Her name is included on the top portion of the marker and has been weathered over time. The epitaph reads: "Wife/of/Colonel J.T.L. Preston/Daughter of/George & Julia Junkin/May 24, 1820/March 29, 1897/Her song cheered the hearts/of the Southern people in the/Hour of their deepest distress./And they sing a new song/before the throne. Rev. 14.3."

HER WRITING

Margaret Preston is considered a Southern Civil War poet. Today, her writing can be found on the internet and through archival collections. Her collection of papers, including private letters, can be found at the University of North Carolina in The Southern Historical Collection at the Louis Round Wilson Special Collections Library. Several of the letters to famous Confederate leaders are digitized and available to view online.[537]

NOT TO MISS

The grave of Ruth Floyd Anderson McCulloch is located just northeast of the Stonewall Jackson statue that is located within the cemetery. In 1939, McCulloch helped found the Rockbridge Historical Society. After her death, her stories about living in Lexington, titled *Mrs. McCulloch's Stories of Ole Lexington*, were published.[538]

EUDORA WOOLFOLK
RAMSAY RICHARDSON

(1891–1973)
Hollywood Cemetery, Richmond
Section Midvale, Plot 10

Eudora Woolfolk Ramsay Richardson was a women's rights advocate, a suffragist and a writer. She began her career as a newspaper reporter. She published in *Weird Tales*, the *Ladies' Home Journal* and *Argosy All-Story Weekly*. She was a technical writer and later a chief of the history branch of the Quartermaster Technical Training Service at Fort Lee. In addition to her contributions to magazines, she also published several books, including *Little Aleck: A Life of Alexander H. Stephens* (1932).

HER STORY

Eudora Woolfolk Ramsay was born in Kentucky on August 13, 1891, to David Marshall Ramsay and Mary Woolfolk Ramsay. She grew up in Charleston, South Carolina, and moved to Richmond in 1907 when her father became the pastor of Grace Street Baptist Church.[539]

In 1910, she graduated from Hollins College.[540] She attended the University of Richmond, where she was the editor of *The Spider*, the college yearbook. She graduated in 1911, and the next year she became the head

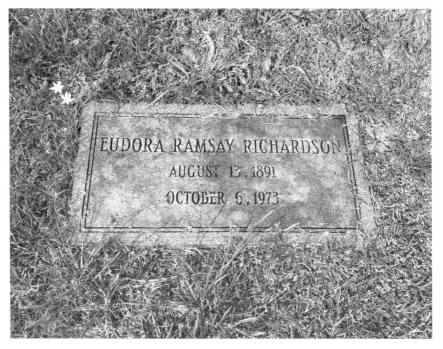

The grave of Eudora Ramsay Richardson. *Author's collection.*

of the English Department at Greenville Woman's College (now part of Furman University) in Greenville, South Carolina.[541]

In March 1913, Ramsay marched in the national woman suffrage parade in Washington, D.C., and became the founding secretary of the Greenville suffrage league.[542]

In 1914, she graduated from Columbia University, where she earned a master's degree. In 1915, she moved to Pennsylvania and worked as a field organizer for the National American Woman Suffrage Association. In 1916, she returned to Virginia and joined other suffragists to work for the cause.[543]

On December 13, 1917, Ramsay married Fitzhugh Briggs Richardson at her parents' home in Greenville, South Carolina.[544] Richardson was an attorney. The couple moved to Richmond, where she worked with the Richmond Equal Suffrage League. On December 3, 1920, their daughter, Eudora Ramsay Richardson, was born.[545]

Eudora W. Ramsay Richardson contributed two stories to *Weird Tales*: "The Voice of Euphemia" (March 1924) and "The Haunting Eyes" (April 1925).[546]

While she continued her work with the women's rights movement throughout her life and lent her voice to the cause through her writing, she

also wrote broadly.[547] In 1932, she published *Little Aleck: A Life of Alexander H. Stephens*, a biography of the vice-president of the Confederacy.[548] She wrote *The Woman Speaker* (1936), a handbook focused on public speaking that included technical fundamentals such as voice and diction, and gesture and posture.[549] And, she wrote *The Influence of Men—Incurable* (1936).

During the 1930s, she also worked for the Federal Writers Project, an agency of the Work Projects Administration (WPA), known as the Works Progress Administration until 1939, which issued *Virginia: A Guide to the Old Dominion* (1940) and *The Negro in Virginia* (1940). She wrote a preface for *Roanoke: Story of a County and City* (1942). And she wrote scholarly articles for the *Journal of the Illinois State Historical Society*.[550]

In the 1940s, she wrote twenty-eight training guides for the Quartermaster Reserve Officers' Corps, an army pamphlet and the history of the Quartermaster School.[551] After working as a technical writer, she became the chief of the history branch of the Quartermaster Technical Training Service at Fort Lee.[552] During this time, she was a lecturer and head of the Virginia Writers' Project.[553]

She continued lecturing on various topics, including religion, throughout the 1950s and 1960s.[554] She was an active Book Club participant.[555] By 1963, Eudora Ramsay Richardson was the secretary for the Arthritis Foundation.[556]

On October 6, 1973, Eudora Ramsay Richardson died at Westport Manor Nursing Home in Henrico. She was eighty-two years old. She was buried in the family plot at Hollywood Cemetery.[557]

The Grave

Eudora Ramsay Richardson has a flat, lawn-level marker that includes her name, her date of birth and her date of death. She is buried among several family members, including her husband, Fitzhugh Briggs Richardson; her daughter, Eudora Ramsay Richardson Smith; and her daughter's husband, Mason Smith. Behind the row of markers is a die on base that reads: "Richardson/Smith."

Her Writing

E. Ramsay Richardson wrote broadly, with handbooks, historical texts and even fictional short stories in *Weird Tales*. Her writing is available in archival

The Richardson Smith family plot in Hollywood Cemetery. *Author's collection.*

form for free and in reproductions in eBook form. Print copies can be found through antique dealers and online retailers. Her papers are located at the University of Virginia Library.[558]

Not to Miss

Not far from Eudora Ramsay Richardson's grave, in section I, plot 95, is the grave of Lila Meade Valentine. Valentine cofounded the Equal Suffrage League of Virginia and served as its first president. In 1915, Valentine paid for part of Ramsay's salary as she traveled across Virginia speaking to various groups.[559] Approximately 1.5 miles from the cemetery, visitors can see both Richardson and Valentine's names, along with numerous other women mentioned in this book, on the Wall of Honor at the *Voices from the Garden: The Virginia Women's Monument* located on the grounds of the Virginia State Capitol.[560]

MARY ROBERTS RINEHART

(1876–1958)
Arlington National Cemetery, Arlington
Section 3, Lot 4269-B N

Mary Roberts Rinehart was a best-selling mystery author often called the "American Agatha Christie" who wrote sixty novels, hundreds of short stories, poetry and plays. During World War I, she was the first female war correspondent on the Belgian front. At the time of her death, her book sales were over eleven million copies.[561]

HER STORY

Mary Ella Roberts was born in Allegheny City, Pennsylvania, on August 12, 1876, to Thomas Beveridge Roberts and Cornelia Gilleland Roberts.[562] In 1896, she married Stanley Marshall Rinehart, a physician she had met at the Pittsburgh Training School for Nurses.[563] In 1897, their first son, Stanley Marshall Rinehart Jr., was born. In 1900, their son Alan Gillespie Rinehart was born. And, in 1902, their third son, Frederick Roberts Rinehart, was born. In 1903, during the stock market crash, the family lost all of their savings and acquired $12,000 in debt. Mary Roberts Rinehart began writing in hopes of paying off that debt.[564] The first year, she sold a story to *Munsey's Magazine*, which it purchased for $34. The next year, she sold

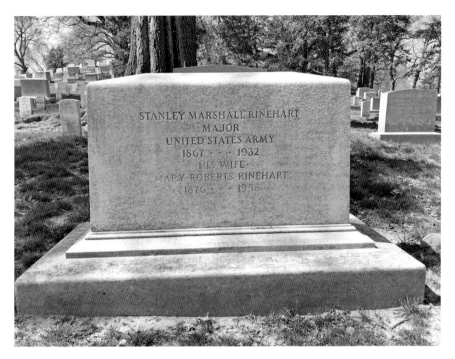

The grave of Mary Roberts Rinehart. *Author's collection.*

forty-five stories and earned $1,800.[565] Her first novel, *The Circular Staircase,* which boosted her to national fame, was published in 1907. She continued publishing novels and stories during World War I, when she served as a war correspondent for *The Saturday Evening Post.*[566]

In 1922, Mary Roberts Rinehart and her husband moved to Washington, D.C., when he was appointed to a post in the Veterans Administration. She continued to live in Washington, D.C., even after her husband's death in 1932.[567] In 1935, she moved to New York City, where she assisted her sons in their publishing house, Farrar & Rinehart.[568]

While Rinehart's stories were filled with mysteries and crimes, she experienced her own personal encounter with crime in 1947, when her cook, who had been a longtime employee, fired a gun at her twice. Her chauffeur and butler leaped to save her from the shooting. The cook then committed suicide in his jail cell.[569] In an interview, Rinehart explained the situation was "sad, not dramatic."[570]

In 1947, Rinehart, who had had breast cancer, openly discussed the ordeal in an interview, "I Had Cancer," which was published in the *Ladies' Home*

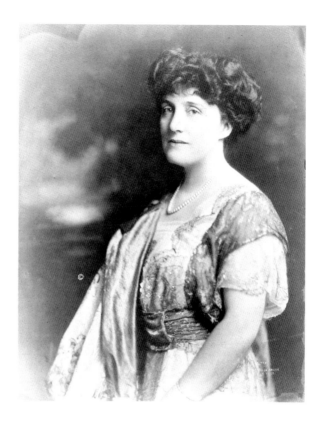

Mary Roberts Rinehart
(1914). Theodore
C. Marceau. *Library
of Congress Prints &
Photographs Division.*

Journal. During a period when discussing such topics was taboo, Rinehart encouraged women to have breast examinations.[571]

In 1953, her final work, *The Frightened Wife and Other Murder Stories*, was published. The next year, she received a special Edgar Award for lifetime achievement.[572]

On September 22, 1958, Mary Roberts Rinehart died at her apartment in New York City. She was eighty-two.[573]

THE GRAVE

Mary Roberts Rinehart and her husband, Stanley Marshall Rinehart, are buried in section 3 in Arlington National Cemetery and have a personalized die on base headstone. On the back of the marker, the family name Rinehart is listed. The front of the marker reads: "Stanley Marshall Rinehart/Major/United States Army/1867–1932/His Wife/Mary Roberts Rinehart/1876–1958."

Mary Roberts Rinehart's grave in Arlington National Cemetery. *Author's collection.*

HER WRITING

The phrase "The butler did it" is credited to her novel *The Door* (1930), although the exact phrase does not appear in the story. The Rinehart formula includes an initial crime that leads to a series of other crimes and an inner story that is gradually revealed.[574] Another popular formula she used became known as the "had I but known" school of mystery writing, which involves female protagonists and narrators who foreshadow impending danger by reflecting on what they might have done differently.[575]

Mary Roberts Rinehart's books and plays have been made into major motion pictures, and her works are still available in print today. *The Bat* has been made into a film twice, including a 1926 silent film starring Jack Pickford and Louise Fazenda and the 1959 version starring Vincent Price and Agnes Moorehead. Mary Robert Rinehart's papers are held at the Special Collections Department at the University of Pittsburgh.[576]

NOT TO MISS

The first recorded burial on the grounds that would become Arlington National Cemetery was of Mary Randolph, the cousin of George Washington Parke Custis, the step-grandson of George Washington and the one who built Arlington House. Randolph was an author of *The Virginia House-Wife* (1824), an influential housekeeping and cookbook that popularized many native vegetables. She is buried in Section 2, Grave S-6.[577]

JUDITH PAGE WALKER RIVES

(1802–1882)
Rives-Troubetzkoy Cemetery, Albemarle County
Small family plot

Judith Page Walker Rives was the author of *Souvenirs of a Residence in Europe* (1842) and *Home and the World* (1857). Published under "A Lady from Virginia," the author was an elite member of society. Her family connections intertwine with American founding fathers including Thomas Jefferson and George Washington.[578]

Her Story

Judith Page Walker was born in Albemarle in 1802 to Colonel Francis Walker and Jane Byrd Nelson Walker. She was the granddaughter of Thomas Walker, who was a close acquaintance to Peter Jefferson, Thomas Jefferson's father, and Mildred Meriwether Walker, whose first cousin was George Washington.[579]

Her parents passed away when she was a young girl, and she inherited Castle Hill, the family home that was established in 1764 on 1,500 acres.[580]

When she was sixteen, she married William Cabell Rives, who had studied law under Thomas Jefferson. Judith Page Walker Rives accompanied her husband to Washington as he served in the House of Representatives representing Virginia from 1823 to 1829.[581] In 1826, their

The grave of Judith Page Walker Rives. *Author's collection.*

first son, William Cabell Rives, was born. In 1828, their daughter Grace was born in Massachusetts; the family moved to France, where William Cabell Rives served as a minister. While there, their second son, Alfred Landon Rives, was born in Paris in 1830. Their daughter Amelia Louise Rives was born in France in 1832. And their youngest daughter, Ella Rives, was born in 1835 in Virginia.[582]

In 1842, after returning home, Judith Page Walker Rives's *Souvenirs of a Residence in Europe* was published, although it did not include her name—attributed simply as "by a Lady of Virginia"—since women of her means did not typically write and publish books during that era. The Riveses continued to live at Castle Hill in Albemarle until William Cabell Rives was called again to work in Paris as an American minister. When they returned home, her second book, *Home and the World*, was published in 1857.[583]

In 1868, William Cabell Rives died. Judith Page Walker Rives remained at Castle Hill until her death in 1882. The Riveses are buried on the family estate.[584]

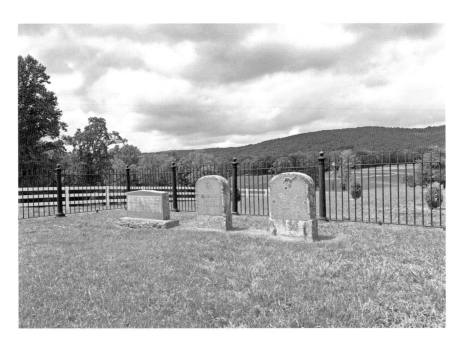

Above: Rives-Troubetzkoy
Cemetery. *Author's collection.*

Right: Castle Hill historic
sign. *Author's collection.*

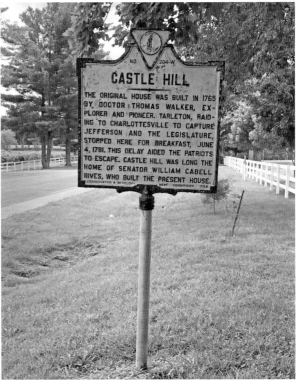

THE GRAVE

The marker is a die on base with the epitaph: "Judith Page Rives/1802–1882/ My Peace Give Unto You." The marker has lichen, a slow-growing plant that forms a crusty growth on stone and trees, making it somewhat challenging to read.

HER WRITING

Judith Walker Rives's writing includes her life at Castle Hill as fictitious "Avonmore" in *Home and the World* (1857).

Truth is often more marvelous than fiction.[585]

Her writing offers a glimpse into the life of wealthy southerners during the nineteenth century. Both of the publications by Judith Page Walker Rives can be read online for free through the California Digital Archive.[586]

NOT TO MISS

The apple variety now known as the Albemarle Pippin was first planted at Castle Hill. Established in 2010, Castle Hill Cider shares six hundred acres of the original estate with the historic home and gardens. Visitors can now experience the cider in the tasting room and tour the property, which includes over 6,500 trees, including Albemarle Pippin.[587]

RUBY THELMA ALTIZER ROBERTS

(1907–2004)
Sunset Cemetery, Christiansburg
Section R, near road between sections R and H

Ruby Thelma Altizer Roberts was a writer and poet. In 1950, she was the first woman writer to be named poet laureate of the Commonwealth of Virginia. For twenty-five years, she owned, published and edited a magazine of poetry, *The Lyric*. She was also the author of the children's book *The Story of Buzzy Bee* (1982).[588]

HER STORY

Ruby Thelma Altizer was born in Alum Ridge in 1907 to Waddie William Altizer and Dana L. Cummings Altizer. Her ancestors were associated with colonial Virginia and were soldiers in the American Revolutionary War.[589] She was proud of her lineage, which dated back to General Charles Cornwallis at Yorktown in 1781.[590]

In 1927, Ruby Altizer married Laurence Roberts. The couple had one daughter, Heidi Anne Roberts.[591] They lived in Christiansburg.

In 1937, her first writing endeavor included a genealogical history cowritten with her cousin Rosa Altizer Bray.[592] In 1938, as a young housewife, she began writing "pretty awful" poetry.[593] Over the next decade, she contributed articles and reviews to periodicals and published her poetry

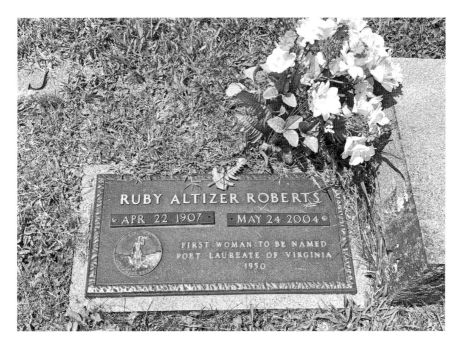

The plaque for Ruby Altizer Roberts for being the "First Woman to Be Named Poet Laureate of Virginia." *Author's collection.*

in over seventy newspapers and magazines in America and England.[594] She published two collections of poetry, including *Forever Is Too Long* (1946) and *Command the Stars* (1948).

In 1950, she was named Virginia poet laureate—the first woman to receive such an honor.[595] In 1952, she became the owner, publisher and editor of *The Lyric,* the oldest magazine in North America in continuous publication devoted to traditional poetry, when Virginia Kent Cummins died and left the magazine to her.[596] Roberts edited the magazine for the next twenty-five years.[597]

In 1966, her husband of thirty-nine years passed away after a long illness. In 1979, Roberts wrote a memoir, *The Way It Was.* In 1982, Roberts published *The Story of Buzzy Bee,* a children's book, illustrated by her niece Jeanne Altizer Barley.[598] In 1994, she wrote a second memoir, *The Way It Is.* That same year, she also wrote a memoir of her friendship with artist, architect and sculptor Walter Russell, *Look Down at the Stars.*[599]

Roberts once told a newspaper reporter:

> *I'm not really into poetry but I'm into life. I only write it when it knocks on my door. I never knock on its door.*[600]

The Roberts family grave marker in Sunset Cemetery. *Author's collection*.

Ruby Roberts died on May 24, 2004, in Christiansburg. She was ninety-seven. She was buried in Sunset Cemetery in Christiansburg.

THE GRAVE

Ruby Thelma Altizer Roberts has a die on base marker with the family name inscribed, "In Loving Memory of Roberts/The Lord is My Shepherd" on the back. A large bush covers the entire front of the grave. Beside the family gravestone, the author has a small plaque, which reads: "Ruby Altizer Roberts/April 22, 1907 May 24, 2004/First Woman to Be Named Poet Laureate of Virginia/1950."

HER WRITING

Ruby Thelma Altizer Roberts became a regular contributor to newspapers and magazines in America and England. In 1950, she was the first woman writer to be named poet laureate of the Commonwealth of Virginia. Today, Roberts's writing can be purchased through booksellers who specialize in used books.

Sunset Cemetery. *Author's collection.*

The front of the gravestone is obstructed by a bush. *Author's collection.*

NOT TO MISS

The most notorious person interred in Sunset Cemetery is Virginia Wardlaw, a woman who ran the Montgomery Female Academy in Christiansburg and was one of the notorious "Black Sisters." Known as a peculiar family, the sisters wore all black clothing and covered their faces with black veils. In 1910, Virginia Wardlaw, along with her sisters Caroline and Mary, was accused of murdering family members for insurance money.[601] In order not to be convicted, Virginia Wardlaw starved herself to death before the judge in the case could rule against her.[602] Wardlaw is buried in an unmarked grave in Sunset Cemetery.[603] Just a few blocks away from the cemetery is the Montgomery Museum of Art & History. In 2018, the New River Stage performance of *Three Sisters Dressed in Black* was introduced by a museum docent who offered the true story of the Wardlaw sisters. They also offer the Historic Christiansburg Walking Tour, which includes the location of the former Montgomery Female Academy, which closed in 1908, after the sisters were suspected of having been involved with the death of family members.[604]

SALLY BERKELEY NELSON ROBINS

(1855–1925)
Ware Episcopal Church Cemetery, Gloucester
Section W, Lot 124B

Sally Berkeley Nelson Robins was an author, genealogist, historian, suffragist and a great-granddaughter of Thomas Nelson, signer of the Declaration of Independence. She wrote *Gloucester: One of the First Chapters of the Commonwealth of Virginia* (1893), *Scuffles* (1912), *A Man's Reach* (1916) and *Love Stories of Famous Virginians* (1923).

HER STORY

Sally Berkeley Nelson was born on March 18, 1855, at Timberneck in Gloucester to Dr. William Wilmer Nelson and Sally Berkley Catlett Nelson. Nelson attended the Eclectic Institute in Baltimore, Maryland.[605]

On May 23, 1878, she married William Todd Robins, a Civil War Confederate colonel of the Twenty-Fourth Virginia Cavalry who was a widower with one daughter. In the 1890s, the family moved to Richmond from Gloucester. Robins worked as a secretary of the Virginia Historical Society for several years and made contributions to the recording of local history.[606]

In 1893, she published *Gloucester: One of the First Chapters of the Commonwealth of Virginia*. Robins was a genealogical editor for the *Richmond Times-Dispatch*. She wrote a weekly column of family histories in response to reader queries.

Right: The grave of Sally Nelson Robins. *Author's collection.*

Below: Ware Episcopal Church Cemetery. *Author's collection.*

She served as secretary and vice president of the Association for the Preservation of Virginia Antiquities.[607]

On October 26, 1906, her husband, William Todd Robins, passed away. After his death, she began writing fiction and, in 1912, published *Scuffles*, which was somewhat autobiographical. In 1916, she published *A Man's Reach*. During this time, she served as the vice president of the Equal Suffrage League's Richmond chapter. She was a contributing editor to the *Virginia Suffrage News* published in 1914.[608] In 1921, Robins helped the Virginia League of Women Voters publish the *Virginia Cookery Book: Traditional Recipes* as a fundraiser.[609]

In 1923, she published *Love Stories of Famous Virginians*. With the income from her publishing, Robins traveled. She spent time in California and took a trip to Europe during the summer before her death.[610]

On February 4, 1925, Robins died at Stuart Circle Hospital in Richmond.[611] She is buried at the Ware Episcopal Church Cemetery in Gloucester.

THE GRAVE

Sally Nelson Robins's grave is a large cross resting on a base that includes her epitaph: "Sally Nelson Robins/1855–1925/As Poor Yet Making Many Rich."[612]

HER WRITING

As Sally Nelson Robins was a historian and genealogist, much of her early writing focuses on history, with a fictional novel published after her husband's death. Today, her books have been digitized and can be accessed for free on the internet.[613]

NOT TO MISS

Murray Leinster was the pen name of science fiction writer William Fitzgerald Jenkins, who is buried in Ware Episcopal Church Cemetery. Leinster published more than 1,500 short stories and articles, 14 movie scripts and hundreds of radio scripts and television plays. In 1956, he received a Hugo Award for Best Novelette for "Exploration Team."[614] In 1996, he was honored with a Retro-Hugo for Best Novelette for "First Contact."[615]

ANNE SPENCER

(1882–1975)
Forest Hill Burial Park, Lynchburg
First traffic circle on left from entrance

Anne Spencer was an American poet and a civil rights activist. She was an important figure of the Black literary and cultural movement during the Harlem Renaissance period. Her home in Lynchburg became an intellectual salon for guests including Langston Hughes, George Washington Carver, Thurgood Marshall, Martin Luther King Jr. and W.E.B. Du Bois.[616] She was the second African American author to be included in the *Norton Anthology of Modern Poetry*.[617]

HER STORY

Annie Bethel Bannister was born on February 6, 1882, to Joel Cephus Bannister and Sarah Louise Scales in Henry County.[618] In 1893, at the age of eleven, Bannister was sent to Lynchburg to attend the Virginia Seminary, where she would later deliver the valedictory address at her graduation in 1899. While attending school, she met her future husband, Charles Edward Spencer. The couple married on May 15, 1901, and resided in Lynchburg, where they would raise three children: Bethel, Alroy and Chauncey Spencer.[619]

While raising her children, Spencer helped found the Lynchburg chapter of the National Association for the Advancement of Colored People

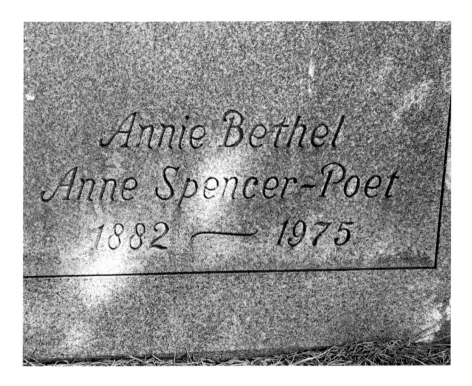

Above: The epitaph of Anne Spencer.
Author's collection.

Right: Anne Bethel Spencer in her
wedding dress, 1900. Unknown
photographer. *Beinecke Rare Book &
Manuscript Library, Yale University.*

(NAACP) in 1918. The Spencers frequently hosted Black travelers during a time of Jim Crow segregation, as they were barred from staying at local hotels. Their home became a salon for prominent guests such as W.E.B. Du Bois, Langston Hughes, Paul Robeson and Thurgood Marshall.[620]

Spencer's home garden included a "one-room retreat" that was a converted garage. This is where Spencer did much of her writing.[621] The retreat was called Edankraal, derived from their names, Edward and Anne, and *kraal*, the Afrikaans word for "enclosure" or "corral."[622] There is a decorative fountain in the garden with water lilies. A cast-iron head named "Prince Ebo" was a gift from W.E.B. Du Bois.[623]

She worked at Paul Laurence Dunbar High School as a librarian from 1923 to 1945.[624] Because the collection was small, Spencer frequently brought in books from her personal collection.[625]

Spencer published over thirty poems during her lifetime that were included in various anthologies, including *The Book of American Negro Poetry* (1922) and *Caroling Dusk* (1927). Spencer wrote prolifically even though only a small portion was published while she was alive. She was the first African American female poet to be included in the *Norton Anthology of Modern Poetry* (1973).[626]

Spencer died on July 27, 1975; she was ninety-three years old. The author is buried in Forest Hill Cemetery in Lynchburg.

Posthumously, her writing was published in *Time's Unfading Garden: Anne Spencer's Life and Poetry*.[627] Books have been written about her life and work, including *Lessons Learned from a Poet's Garden* (2011) by Jane Baber White.

The Grave

Anne Spencer and Edward Alexander share a slant marker. The inscription reads: Spencer. On the left, "Edward Alexander/'Ed' 1876–1964." On the right side, "Annie Bethel/Anne Spencer–Poet/1882–1975." The slant marker is part of a family plot located in the first traffic circle. As you enter the cemetery and reach the traffic circle, the family plot includes a small decorative wall surrounding the family graves that can be seen to the left of the circle. The family plot includes Anne and Ed Spencer's children. There is a military marker for their son Chauncey Edward Spencer, who was one of the aviators who helped pave the way for the Tuskegee Airmen, a group of African American military fighter pilots who fought in World War II.[628]

The grave marker of Anne Spencer and her husband. *Author's collection.*

The Spencer family plot. *Author's collection.*

Her Writing

Anne Spencer's writing has gained popularity since her death, with much of her poetry published posthumously. Today, her writing can be found online and in various anthologies. Her papers can be found at the Albert and Shirley Small Special Collections Library at the University of Virginia.[629]

Not to Miss

Approximately three miles from the cemetery is the Anne Spencer House & Garden Museum, which is included on the National Register of Historic Places and is designated a Virginia Historic Landmark, a Friends of the Library USA Literary Landmark and a Historic Landmark by the Association for the Study of African American Life and History.[630]

MARY NEWTON STANARD

(1865–1929)
Hollywood Cemetery, Richmond
Section 5-19

Mary Newton Stanard was a historian and author of *The Story of Bacon's Rebellion* (1907)[631] and several biographies, including *The Dreamer: A Romantic Rendering of the Life-Story of Edgar Allan Poe* (1909),[632] *John Marshall* (1913)[633] and a biography of her father titled *John Brockenbrough Newton* (1924). Stanard wrote social histories of Virginia and edited a collection of letters from Edgar Allan Poe. She was one of the members of the executive committee of the Edgar Allan Poe Shrine.[634]

HER STORY

Mary Mann Page Newton was born in Westmoreland County in 1865 to John Brockenbrough Newton and Roberta Page Newton. She attended ordinary schools and attended Leache-Wood School in Norfolk.[635]

In 1900, she married William Glover Stanard of Richmond.[636] The couple collaborated on *The Colonial Virginia Register* (1902). In 1907, she published *Bacon's Rebellion*, which was considered "a remarkable success."[637] Critics noted that while the work was "an accurate historical account," it also was entertaining.[638]

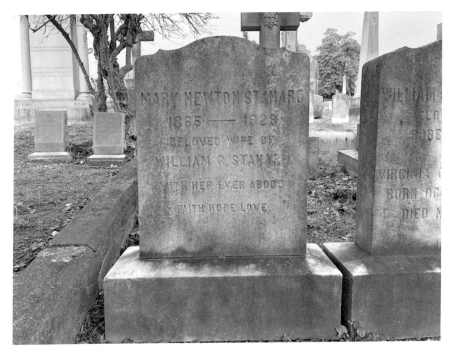

The grave of Mary Newton Stanard. *Author's collection.*

In 1923, *Richmond, Its People and Its Story* was published.[639] While writing, she also served as a historian of the Association for the Preservation of Virginia Antiquities. She also served on the Virginia War History Commission.[640]

In 1925, she edited *Edgar Allan Poe Letters Till Now Unpublished in the Valentine Museum, Richmond, Va.*[641] She served on the executive committee of the Edgar Allan Poe Shrine.[642] In December 1925, she presented an etching by the artist A.G. Learned to the Poe Shrine.[643]

Her last book, *The Story of Virginia's First Century*, was published in 1928. Stanard died the next year on June 5, 1929.[644] She is buried in Hollywood Cemetery.[645]

THE GRAVE

Mary Newton Stanard's gravestone is a die in socket. The epitaph reads: "Mary Newton Stanard/1865–1929/Beloved wife of/William R. Stanard/ With her Ever Abode/Faith. Hope. Love."

HER WRITING

Today, Stanard's writing can be accessed for free online. Her papers are held in the Special Collections at the University of Virginia Library in Charlottesville.[646]

NOT TO MISS

Directly behind the grave of Mary Newton Stanard is a large cross with what appears to look like a dollar sign. This symbol includes the letters *IHS* overlaid on one another and is an abbreviation of the phrase *in hoc signo*, Latin for "by this sign we conquer," referring to the cross.[647]

AMÉLIE LOUISE RIVES CHANLER TROUBETZKOY

(1863–1945)
Rives-Troubetzkoy Cemetery, Albemarle County
Small family plot

Princess Amélie Louise Rives Chanler Troubetzkoy was an author, poet and playwright. Her first novel, *The Quick or the Dead?* (1888), sold 300,000 copies and created a bit of a scandal.[648] Her novel *World's End* (1914) became a best-seller. In 1896, she married Prince Pierre Troubetzkoy of the Russian royal family.[649]

HER STORY

Amélie Louise Rives was born on August 23, 1863, in Richmond to Alfred Landon Rives and Sarah Catherine MacMurdo Rives. Her paternal grandmother was author Judith Page Walker Rives, and her grandfather was Senator William Cabell Rives, minister plenipotentiary to France. She was the goddaughter of Robert E. Lee. Rives spent much of her early life at Castle Hill in Albemarle County. She was educated at home with a governess and had access to her grandfather's extensive library.[650] Described as "morbidly sensitive," Rives is said to have had many peculiarities.[651]

Rives's piece "A Brother to Dragons" appeared in the *Atlantic Monthly* in 1886. Her first novel, *The Quick or the Dead?*, was published in 1888. The

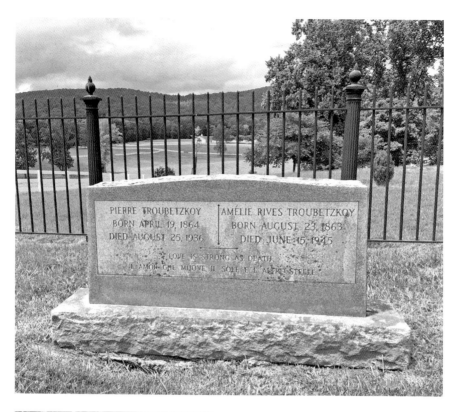

Above: The grave of Amélie Rives Troubetzkoy at Castle Hill. *Author's collection.*

Left: Countess Troubetskoy and Fang the wolf. *Library of Congress, Prints & Photographs Division.*

novel was a sensation, as it suggested that women had sexual feelings. The novel was reviled by critics but went on to sell 300,000 copies. That year, Rives married John Armstrong Chanler, an heir to the Astor fortune.[652]

From 1890 to 1891, the couple spent their time residing in Europe; in Paris, Amélie Chanler studied art. During their seven-year marriage, the relationship was scandalous with reported flirting and affairs. She drew a nude self-portrait on the day Lord George Curzon visited Castle Hill—her husband was in New York.[653]

Amélie was friends with other female authors, including Ellen Glasgow and Julia Magruder, who was a frequent guest at Castle Hill.[654]

In 1894, Oscar Wilde introduced her to the émigré Russian prince Pierre Troubetzkoy while in London.[655] The Chanlers lived apart for most of the marriage, and by the end of 1895, the couple had divorced. In February 1896, she married Troubetzkoy, which made her a princess.[656] For a decade, Princess Amélie Troubetzkoy did not write. She would later go on to publish other works of fiction, poetry and plays. She published over twenty-five novels, including *The Ghost Garden* (1918), *Seléné* (1905), *A Damsel Errant* (1908), *The Golden Rose: The Romance of a Strange Soul* (1908), *Trix and Over-the-Moon* (1909), *Pan's Mountain* (1910), *As the Wind Blew* (1920), *The Sea-Woman's Cloak and November Eve* (1923), *The Queerness of Celia* (1926) and *Firedamp* (1930).

The last years of her life were said to be unhappy.[657] In August 1936, Pierre Troubetzkoy passed away. By the 1940s, she was recognized as one of Virginia's first women writers. She lived at Castle Hill until her death on June 15, 1945, and is buried at Rives-Troubetzkoy Cemetery on the property of Castle Hill with her husband. In 1947, the property was sold out of the family.[658]

THE GRAVE

Amélie Troubetzkoy's grave is a die on base headstone that she shares with her husband, Pierre Troubetzkoy. The inscription reads: (left) "Pierre Troubetzkoy/Born April 19, 1864/Died August 25, 1936," (right) "Amélie Rives Troubetzkoy/Born August 23, 1863/Died June 15, 1945." Under their inscriptions reads: "Love is Strong as Death/L'Amor Che Muove Il Sole E L'Altre Stelle."

The Rives-Troubetzkoy Cemetery. *Author's collection.*

HER WRITING

Amélie Rives Troubetzkoy wrote popular romantic fiction that received positive praise from critics.[659] Many of her novels are digitized and can be read online for free.[660] Amélie Troubetzkoy's papers are held at the Albert and Shirley Small Special Collections Library at the University of Virginia.[661]

NOT TO MISS

Approximately sixteen miles from the cemetery is the Albert and Shirley Small Special Collections Library at the University of Virginia, which specializes in American history and literature and the history of Virginia.[662]

EDNA HENRY LEE TURPIN

(1867–1952)
Hollywood Cemetery, Richmond
Section 26, Plot 82 K

Edna Henry Turpin was a prolific writer of children's literature, history textbooks, manuals for teachers and stories, including *A Short History of the American People* (1911), *Happy Acres* (1913) and *Echo Hill* (1933). Her last book during her life was *The Story of Virginia* (1949). Her book, *This Is Our Land: The Story of Water, Soil, and Other Natural Resources* was submitted to publishers before her death and was published in 1954.

HER STORY

Edna Henry Turpin was born on July 26, 1867, at Echo Hill in Mecklenburg County to Edward Henry Turpin and Petronella Lee Turpin.[663] Her father died of tuberculosis on March 1, before she was born. She grew up on the family farm with her mother and brother until her mother remarried in 1871 to William Cary Johnson. Their family farm, Echo Hill, was sold and the family moved to Johnson's home.[664]

Turpin began writing stories in her youth; her first short story was accepted for publication in 1882 when she was fifteen years old. She attended and graduated from Hollins College in 1887.[665] When she returned home, she purchased Echo Hill and kept the home for several years.[666] On the 1900

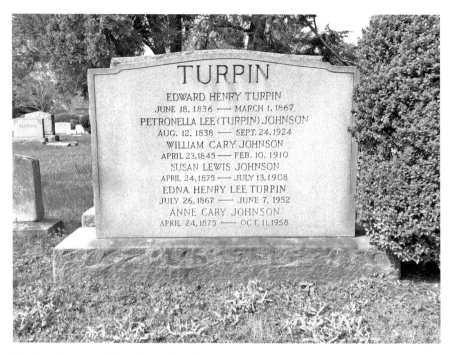

The family grave of Edna Henry Lee Turpin. *Author's collection.*

U.S. Census, she was listed as an authoress. Turpin edited a number of collections, including a collection of *Grimm's Fairy Tales* for primary grade readers along with *The Gold Bug* by Edgar Allan Poe.[667] On the 1910 U.S. Census, Turpin lists both author and farmer for occupations. She published her first book, *A Short History of the American People*, in 1911.[668] By the 1920 census, her occupation is listed solely as author.[669]

In 1925, Turpin was commissioned by the Mecklenburg County Board of Supervisors to attend the Virginia Historical Commission conference in Richmond to work on documenting the soldiers who served in World War I who were from Mecklenburg County.[670]

Turpin wrote several school textbooks, manuals for teachers and stories, including *A Short History of the American People* (1911), *Happy Acres* (1913), *Peggy of Roundabout Lane* (1917), *Three Circus Days* (1935), *Littling of Gaywood* (1939) and *Echo Hill* (1933).[671] Her last book during her life was *The Story of Virginia* (1949). She submitted a manuscript, *This Is Our Land*, before her death, and the book was published in 1954.[672]

Turpin kept a summer home at the Mountain Lake Biological Station, a field research and teaching station of the Biology Department at the

University of Virginia originally established in 1930. There, she wrote and contributed to the artist community.[673]

She died on June 8, 1952, and was buried in Hollywood Cemetery in Richmond.

THE GRAVE

Edna Henry Lee Turpin shares a die on base headstone with family members, including her father, mother, stepfather and half siblings. The grave includes the family name Turpin with each family member's full name and birth and death dates.

HER WRITING

Turpin's writing is available online for free in eBook form. Many of her publications can also be purchased in printed books.

NOT TO MISS

There are many unique symbols found on graves throughout the cemetery. To Girl Scouts, the trefoil symbol is a familiar one. Visitors can find the trefoil on the grave of Isabel Matthes, the second executive director of the Richmond, Virginia Girl Scouts. Matthes contracted tuberculosis and died only two months after taking on the position. Her mother requested special permission to use the Girl Scout trefoil on her daughter's tombstone.[674] Her grave can be found in section 16 in plot 80.

MARIE TERESA
"TERE" RÍOS VERSACE

(1917–1999)
Arlington National Cemetery, Arlington
Section 13 Lot 494-2

Marie Teresa Ríos Versace was a writer who used the penname Tere Ríos. She wrote *The Fifteenth Pelican* (1966), which was the basis for *The Flying Nun* television sitcom in the 1960s.

HER STORY

Marie Teresa Ríos was born on November 9, 1917, to Rafael Ríos and Marie Teresa Dowd in Brooklyn, New York. She began writing at a young age. She was a devout Catholic and proud of her Puerto Rican heritage. Her childhood was spent in Puerto Rico as one of six children.[675]

In 1935, Ríos met her future husband, who had just graduated from West Point. On October 8, 1936, she married Humbert Joseph Versace.[676] The couple traveled around the world to army bases before World War II began. He was stationed in Hawaii, where their first of five children, Humbert Roque, was born in 1937. During World War I, she drove army trucks. During the war, she also wrote and edited newspapers, including *Armed Forces Star & Stripes* and *Gannett*.[677] In December 1941, after the attack on Pearl

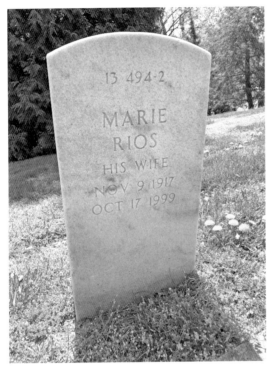

Left: The epitaph of Marie Ríos. *Author's collection.*

Below: Arlington National Cemetery. *Author's collection.*

Harbor, her husband was sent to the Pacific theater and she remained in Savannah, Georgia, with her children. There, she learned to fly as a student pilot in the Civil Air Patrol.[678]

Ríos taught creative writing at the University of Pittsburgh and was on the staff of the Rhinelander Writers Conference.[679]

In 1957, under the penname of Tere Ríos, she published her first book, *An Angel Grows Up*. Ríos joked that it took her longer to type the story than to write it, which only took two weeks to write.[680]

> *I started off with the truth and then embroidered around it to fit the patterns of fiction.*[681]

She was named Wisconsin Writer of the Year in 1958.[682] The same year, Ríos worked on translations of Puerto Rican stories. Her short story "Lapina" was published in *Today* magazine.[683]

In 1963, she published *Brother Angel*. That same year, her oldest son, Humbert, who had his own military career and attained the rank of captain, was captured on October 29, 1963, along with two other Americans, by the Viet Cong during Humbert's second tour in Vietnam. Captain Versace was executed on September 26, 1965.[684] Her grief over learning of her son's death can be read in her poetry during this time.

Ríos's third book, *The Fifteenth Pelican*, was published in 1966. The television series *The Flying Nun* was based on this book. In 1967, she also published several Vatican council documents for high school students.[685]

On June 12, 1972, Ríos's husband, Humbert Joseph Versace, died.

In 1990, Ríos moved to Fajardo, Puerto Rico, to retire. When she was diagnosed with lung cancer in 1999, she returned to Florida and was hospitalized in Sarasota. She passed away on October 17, 1999. Her ashes were sent to Arlington National Cemetery to be interred with her husband.[686]

THE GRAVE

Marie Ríos's name is inscribed on the back of her husband's military grave in Arlington National Cemetery, along with "His Wife/Nov 9, 1917/Oct 17, 1999." The grave number is 13 494-2.

HER WRITING

Tere Ríos's writing included fiction and nonfiction pieces connected to her military career. *The Fifteenth Pelican* can still be purchased today through used booksellers.

NOT TO MISS

Near Marie Teresa Ríos Versace's grave in section 13 is the Space Shuttle Challenger Memorial. In 1986, the space shuttle Challenger exploded just after takeoff, killing all seven crew members, which included high school teacher Christa McAuliffe, who had been selected as the first teacher in space. The cremated remains of the seven Challenger astronauts were buried in Section 46, Grave 1129.[687]

43

SUSAN ARCHER TALLEY WEISS

(1822–1917)
Riverview Cemetery, Richmond
Section C-18

Susan Archer Talley Weiss was a poet and author who contributed to *Harper's*, *Scribner's*, the *Southern Literary Messenger* and the *Magnolia Weekly*. Her poetry received positive attention from "the prince of critics," Edgar Allan Poe.[688] A collection of her poems, titled *Poems*, was published by Rudd & Carleton of New York in September 1859.[689] In 1907, her biography of Poe, called *The Home Life of Poe*, was published by Broadway Publishing Company of New York.[690]

HER STORY

Susan Archer Talley was born on February 14, 1822, in Hanover. Her father studied law but due to health reasons did not practice his profession and retired to the Richmond area. Her mother was the daughter of Captain Archer of Norfolk.[691] In childhood, she "delighted in all sights and sounds of beauty, and would sit for hours watching the sky in storm and sunshine, or listening to the wind among the trees."[692] At the age of nine, Talley, who had been ill with scarlet fever, lost her hearing.[693] Her parents removed her from school, and Talley began to learn at home, where "her natural love of study deepened into a passion."[694] In an article in December 1859, Talley's

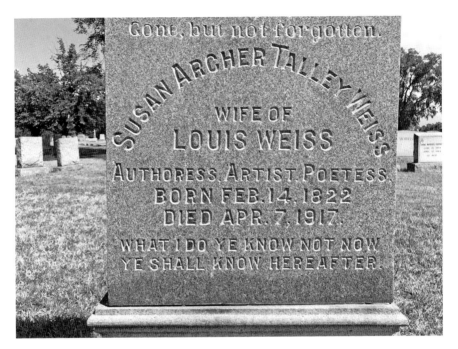

The epitaph of Susan Archer Talley Weiss. *Author's collection.*

deafness is described: "A look, a sign, on their part, or a half-spelled sentence upon the fingers, is instantly caught and interpreted."[695] She was not able to read lips and communicated through written English. Various sources contradict one another in their descriptions of Talley's ability to speak; some state that she continued to speak after becoming deaf, others note that it was difficult for her to speak, and in an 1864 letter it is noted "she was forced to write, for she could not talk."[696]

Talley's deafness is particularly interesting due to her role in the American Civil War. Talley was a Confederate spy who carried messages in the braids of her hair.[697] In an article in July 1862, the Norfolk correspondent for the *New York Herald* wrote:

> *Miss Susan Archer Talley, the Southern authoress, who was arrested in April…on suspicion of being a spy, arrived in this city on Thursday from Fort McHenry, where she was resided for the past two months. She is deaf and dumb, but a quick and graceful writer, and seems to have enough faculties left to do us harm whenever she is able.[698]*

The portrait of Susan Archer Talley Weiss in *The Century Illustrated Monthly Magazine*, 67, Century Company, 1904, 910.

A later article expanded on some of Talley's aid to the Confederate troops, noting she attempted to transport a coffin full of percussion primers through the enemy lines and stated her brother's body was in the coffin. When the coffin was opened, Talley was taken under arrest.[699] While imprisoned at Fort McHenry, Talley met and secretly married a Union solider, Lieutenant Louis Von Weiss, on May 13, 1862.[700] Weiss obtained a discharge and returned to his home in Germany. Talley and Weiss remained out of contact for three years. When they finally reunited, a difference in opinion led to Talley Weiss filing for a divorce and suing for custody of their only child, Stuart Archer Weiss.[701]

Susan Archer Talley Weiss refused alimony and supported herself and her son by writing. She contributed to various newspapers and magazines, *Harper's* and *Scribner's*. In 1907, she published her biography of Edgar Allan Poe, *The Home Life of Poe*. Later in her life, she developed an eye affliction and was unable to continue writing. She lived with her son in Richmond.[702] On April 7, 1917, she died at her home in Richmond.[703] She was ninety-five years old and was buried at Riverview Cemetery.

THE GRAVE

The monument for Susan Archer Talley Weiss is a die, base and cap headstone. The Weiss grave marker includes Susan Archer Talley Weiss along with her son, Stuart Archer Weiss. The back of the grave includes an epitaph for the author's mother, Eliza Francis Archer, and the author's brother, Robert Archer Talley.

HER WRITING

Susan Talley Weiss's biography of Poe along with several articles are still referenced by Poe scholars. Readers can find the works of Talley Weiss on Project Gutenberg and throughout the internet.

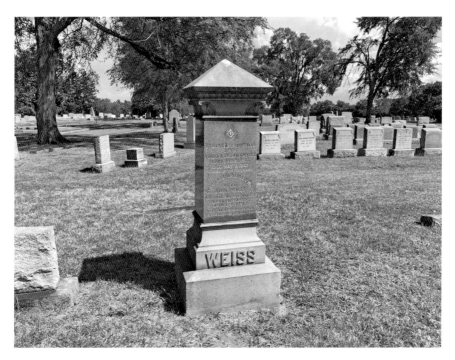

The family grave of Susan Archer Talley Weiss. *Author's collection.*

NOT TO MISS

After visiting the grave of Susan Archer Talley Weiss, head toward the James River. As you look down the hill, you will see a large elk statue for the Elks Rest Richmond Lodge No. 45 monument. Founded in 1868, the Elks were a fraternal organization. The Richmond Lodge 45 was established in 1886.[704]

ANNIE STEGER WINSTON

(1862–1927)
Hollywood Cemetery, Richmond
Section M-26

Annie Steger Winston was a novelist and a short story writer who contributed to *The Century*, *Scribner's*, *Atlantic*, *McBride's Magazine* and *Harper's Magazine*. Her novels include *Memoirs of a Child* (1903)[705] and *The Deeper Voice* (1923).

HER STORY

Annie Steger Winston was born in Richmond on September 20, 1862, to Charles H. Winston and Nannie Steger Winston.[706] She was one of eight children. Her father was the president of the Richmond Female Institute until 1873, when he was named professor of physics and astronomy at Richmond College. She attended Richmond public schools and explained that she "developed a fatal facility for mental abstraction from its irksome routine," although she did love to read and started writing at an early age.[707] After public school, she studied under Richmond sculptor Edward Virginius Valentine. Her first publication was a poem accepted by *The Century* and a short story by *Harper's Magazine*, which encouraged her "to adopt literature as a profession."[708]

Her first novel, *Memoirs of a Child*, published in 1903, originated in *Lippincott's Magazine* in two shorter pieces, "Fantastic Terrors of Childhood" and "The Book Which Most Benefited Me." The book was used as a reference text by

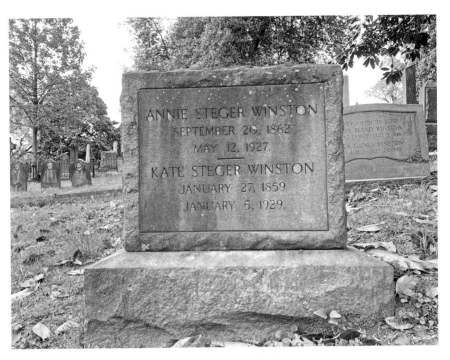

The family grave of Annie Steger Winston. *Author's collection.*

postgraduate students at Clarke University in Worcester, Massachusetts.[709] Winston continued to publish short stories and was a prominent member of the Virginia Writers' Club. She wrote one-act plays, gave readings and published her second novel, *The Deeper Voice*, in 1923.[710] She also attended the Virginia Writers' Club appreciation dinner along with other notable women writers, including Kate Langley Bosher, Ellen Glasgow, Mary Johnston, Margaret Prescott Montague and Edna Turpin.[711]

On May 12, 1927, after a brief illness, Annie Steger Winston died at her home on Hanover Avenue at the age of sixty-four and was buried in Hollywood Cemetery.[712]

THE GRAVE

Annie Steger Winston shares a grave with her sister Kate Steger Winston. It is a vertical upright marker. The design is rustic with a smooth surface for the epitaph. The marker reads: "Annie Steger Winston/September 20, 1862/ May 12, 1927."

Her Writing

Annie Steger Winston's work, both her short stories and her novels, can be read online for free through Google Books and can be purchased as facsimile reprints.

Not to Miss

Throughout the cemetery you will find treestone markers or tree stump tombstones, popular from 1885 until 1905 as part of the rustic movement of the mid-nineteenth century. The gravestones are purposefully designed to look like trees that had been cut and left in the cemetery, and they are filled with symbolism. Treestones could be ordered from the Sears and Roebuck catalogue.[713]

NOTES

Introduction

1. James Curl, *The Victorian Celebration of Death* (Gloucestershire, UK: Sutton, 2001), 47.
2. Loran Rhoads, *199 Cemeteries to See Before You Die* (New York: Black Dog & Leventhal, 2017), 1.
3. Linda B. Glaser, "When Last Comes First: The Gender Bias of Names," *Cornell Chronicle,* July 2, 2018, https://news.cornell.edu/stories/2018/07/when-last-comes-first-gender-bias-names.
4. "Blandford Cemetery," *Encyclopedia of Virginia*, Virginia Foundation for the Humanities, retrieved August 8, 2020, https://encyclopediavirginia.org/2990hpr-98ebb609681a271/.
5. "National Register Information System," National Register of Historic Places, National Park Service, October 15, 1992.
6. Veronica A. Davis, *Here I Lay My Burdens Down: A History of Black Cemeteries of Richmond, Virginia* (Richmond, VA: Dietz Press, 2003), 34.
7. Ibid.
8. Ibid.
9. "About," The Friends of East End Cemetery, retrieved October 24, 2020, https://friendsofeastend.com/about/.
10. "Historic Evergreen Cemetery," Enrichmond, retrieved October 24, 2020, https://enrichmond.org/evergreen-cemetery/.

11. "Lynchburg Burial Grounds," Old City Cemetery Lynchburg Burial Grounds, accessed June 2, 2021, https://www.gravegarden.org/lynchburg-burial-grounds/.

12. "Forest Lawn Cemetery," City of Norfolk, https://www.norfolk.gov/Facilities/Facility/Details/Forest-Lawn-Cemetery-48.

13. Forest Lawn Cemetery, https://www.burialplanning.com/cemeteries/forest-lawn-cemetery-richmond.

14. Fredericksburg City Cemetery, https://fredericksburgcitycemetery.org/.

15. NPSFSP historian, "Forgotten in Plain Sight: The City Cemetery at the Head of Amelia Street," Mysteries and Conundrums: Exploring the Civil War-era Landscape in the Fredericksburg & Spotsylvania Region, July 1, 2015. https://npsfrsp.wordpress.com/2015/07/01/forgotten-in-plain-sight-the-city-cemetery-at-the-head-of-amelia-street/.

16. "Hollywood Cemetery," The Cultural Landscape Foundation, accessed June 20, 2021, https://tclf.org/landscapes/hollywood-cemetery.

17. The two other cemeteries with two U.S. presidents include Arlington National Cemetery, where John F. Kennedy and William Howard Taft are buried, and United First Parish in Quincy, Massachusetts, where John Adams and John Quincy Adams are buried.

18. "Our History," Ivy Hill Cemetery, https://ivyhillcemetery.net/visitors/.

19. "Cemetery History," Town of Bedford, https://www.bedfordva.gov/149/Cemetery-History.

20. "Maplewood Cemetery," CVillePedia, https://www.cvillepedia.org/Maplewood_Cemetery.

21. "National Register Information System."

22. Mount Hebron Cemetery, https://mthebroncemetery.org/.

23. "Lexington City Council Votes to Rename Stonewall Jackson Memorial Cemetery," WFXR Newsroom, retrieved December 20, 2020, https://www.wfxrtv.com/news/local-news/lexington-city-council-votes-to-rename-stonewall-jackson-memorial-cemetery/.

24. Old City Cemetery, https://www.gravegarden.org/.

25. Personal correspondence, October 12, 2020. The cemetery receptionist stated the cemetery was established in 1920, although public records show burials beginning in the mid-1800s.

26. "Our Story: The Estate," Castle Hill Cider, www.castlehillcider.com/the-estate.

27. T. Tyler Potterfield, *Nonesuch Place: A History of the Richmond Landscape* (Charleston, SC: The History Press, 2009), 88.

28. St. John's Tappahannock, VA, https://stjohnstappahannock.org/.
29. Alyson L. Taylor-White, *Shockoe Hill Cemetery: A Richmond Landmark History* (Charleston, SC: The History Press, 2017), 12.
30. Ibid., 13.
31. "About Us," Friends of Shockoe Hill Cemetery: Commemorating the Past, https://shockoehillcemetery.org.
32. "Town of Christiansburg Sunset Cemetery Master Plan," New River Valley Regional Commission, 2014, https://www.christiansburg.org/166/Cemetery.
33. Ibid.
34. "Our Story," Ware Episcopal Church, https://warechurch.org/our-history.
35. Woodland Cemetery, https://thewoodlandcemetery.net/.

Cleo Virginia Andrews, "V.C. Andrews"

36. E.D. Huntley, *V.C. Andrews: A Critical Companion* (Westport, CT: Greenwood Press, 1996), 7.
37. "V.C. Andrews," Simon & Schuster, accessed September 12, 2020. https://www.simonandschuster.com/authors/V-C-Andrews/4466.
38. Huntley, *V.C. Andrews*, 1.
39. Ibid., 4.
40. "A Message to Readers," in *Gods of Green Mountain*, by V.C. Andrews (New York: Simon & Schuster, 2004).
41. Huntley, *V.C. Andrews*, 4.
42. Ibid.
43. Dolly Langdon, "Have You Read A Best-Selling Gothic Lately? Chances Are It Was by a Recluse Named V.C. Andrews," *People*, October 1980.
44. Huntley, *V.C. Andrews*, 6.
45. "Remembering V.C. through Her Personal Letters and Prized Possessions," letter to Mother from Virginia Andrews, August 23, 1983, Simon & Schuster Publishing, http://www.simonandschusterpublishing.com/vcandrews/index.html.
46. Huntley, *V.C. Andrews*, 6.
47. Ibid.
48. Ibid.

49. Bill Cresenzo, "Millions from the 'Attic': V.C. Andrews, Long-Dead Portsmouth Author, Continues to Make a Fortune," *Inside Business*, August 13, 2010, https://www.pilotonline.com/inside-business/article_e1d335df-7d8c-56dc-87ca-5affb79349c2.html.

50. Simon & Schuster Publishing, https://www.simonandschuster.com.

51. Anna Strock, "These 14 Real Life Witches Show the 'Wicked' Side of Virginia's History," *Only In Virginia*, OnlyInYourState, December 13, 2015, https://www.onlyinyourstate.com/virginia/witches-va/.

52. Ibid.

Jane Briggs Howison Beale

53. Laura Ng, "Theater of War: Capturing Battle in Film and Fiction: An Interview with Ron Maxwell and Jeff Shaara," *Civil War Book Review* 4, no. 3 (2002): 2.

54. "Jane Howison Beale," *History of American Women*, November 2006, https://www.womenhistoryblog.com/2006/11/jane-howison-beale.html.

55. Jane Howison Beale, *The Journal of Jane Howison Beale* diary entry, October 18, 1850.

56. 1860 United States Federal Census, *Fredericksburg, Spotsylvania, Virginia*, page 92, line 11.

57. Beale, *Journal*, diary entries, September 27, 1850, April 28 and April 29, 1862.

58. Jane Beale is listed as "keeper of boarding house" on the 1870 census.

59. 1880 United States Federal Census, *Fredericksburg, Spotsylvania, Virginia*, page 24, line 16.

60. Ng, "Theater of War," 2.

61. Beale, *Journal*, diary entry, December 16, 1862.

Helen Gordon Beale

62. Mary Tardy, *The Living Female Writers of the South* (Philadelphia: Claxton, Remsen & Haffelfinger, 1872), 421.

63. Beale, diary entry, September 4, 1850.

64. Beale, diary entry, November 7, 1850.

65. 1860 United States Federal Census, *Fredericksburg, Spotsylvania, Virginia*, page 92, line 12.

66. Ibid., page 86, line 11.
67. Tardy, *Living Female Writers*, 421.
68. "Southern Society for 1868," *Weekly Panola (MS) Star*, August 1, 1868.
69. 1880 United States Federal Census, *Fredericksburg, Spotsylvania, Virginia*, page 24, line 17.
70. Susan B. Riley, "The Southern Literary Magazine of the Mid-Nineteenth Century," *Tennessee Historical Quarterly* 23, no. 3 (September 1964): 235.
71. Tardy, *Living Female Writers*, 422.
72. "Southern Society for 1868."
73. "Christiana Campbell's Tavern," Colonial Williamsburg, https://www.colonialwilliamsburg.org/locations/christiana-campbells-tavern/.

Kate Lee Langley Bosher

74. "Bosher Estate Is Estimated at over $165,000," *Richmond (VA) Times-Dispatch*, August 3, 1932.
75. Ibid.
76. Joseph M. Flora and Ambel Vogel, eds., *Southern Writers: A New Biographical Dictionary* (Baton Rouge: Louisiana State University Press, 2006), 36.
77. "Society," *Times-Democrat* (New Orleans, LA), June 9, 1912.
78. "Mrs. Kate Langley Bosher Elected President of League," *Baltimore (MD) Sun*, September 25, 1919.
79. Flora and Vogel, *Southern Writers*, 36.
80. "Bosher Estate Is Estimated at Over $165,000."
81. Charles Gideon Bosher died on October 10, 1931.
82. Flora and Vogel, *Southern Writers*, 36.
83. Personal correspondence with Katherine Alden, October 7, 2020.

Rosa Dixon Bowser

84. Veronica Alease Davis and the Dictionary of Virginia Biography, "Bowser, Rosa L. Dixon (1855–1931)." *Encyclopedia Virginia*, February 28, 2020, https://encyclopediavirginia.org/entries/bowser-rosa-l-dixon-1855-1931/.
85. Davis and the Dictionary of Virginia Biography, "Bowser, Rosa L. Dixon (1855–1931)."

86. Ibid.

87. Ibid.

88. Ibid.

89. Rosa D. Bowser, "Virginia," *Women's Era* 2, no. 1 (1895).

90. Daniel Wallace Culp, ed., *Twentieth Century Negro Literature* (Naperville, IL: J.L. Nichols, 1902), 176–82.

91. Irving Garland Penn and John Wesley Edward Bowen, eds., *The United Negro: His Problems and His Progress*, (Atlanta: D.E. Luther Publishing Company, 1902), 446–48.

92. Davis and the Dictionary of Virginia Biography, "Bowser, Rosa L. Dixon (1855–1931)."

93. Ibid.

94. Rosa D. Bowser, "The Mother's Duty to Her Adolescent Sons and Daughters," in *The United Negro*, 447.

95. Davis and the Dictionary of Virginia Biography, "Bowser, Rosa L. Dixon (1855–1931)."

96. "Obituaries," *Times Dispatch* (Richmond, VA), February 9, 1931.

97. Brian Palmer and Erin Hollaway, "Place," *East End Cemetery Project*, Dumbarton Oaks Research Library and Collection, January 21, 2019, https://eastendcemeteryrva.com/place/.

98. Personal correspondence with Friends of East End Cemetery, July 24, 2020, https://www.facebook.com/eastendcemeteryproject.

99. Ibid.

100. "Emory Women Writers Project," Emory University, http://womenwriters.digitalscholarship.emory.edu/.

101. "Maggie Walker, National Historic Site, Virginia," National Parks Service, https://www.nps.gov/mawa/index.htm.

Estelle Aubrey Brown

102. Max Binheim and Charles A. Elvin, *Women of the West; A Series of Biographical Sketches of Living Eminent Women in the Eleven Western States of the United States of America* (Los Angeles: Publishers Press, 1928), 6.

103. Estelle Aubrey Brown, *Stubborn Fool* (Caldwell, ID: Caxton Printers, 1952), 15.

104. 1897 marriage index, Gibson William Cunningham, Bangor, New York.

105. Brown, *Stubborn Fool*, 43.

106. Ibid., 64–68.

107. Ibid., 77.

108. Patricia Carter, "'Completely Discouraged': Women Teachers' Resistance in the Bureau of Indian Affairs Schools, 1900–1910," *Frontiers: A Journal of Women Studies* 15, no. 3 (1995): 66.

109. Ibid.

110. Ibid.

111. Ibid.

112. "League of Pen Women Honors Mrs. E.A. Brown," *Evening Star* (Washington, D.C.), November 9, 1924, 13.

113. "Pen Women Here Set an Example," *Arizona Republican* (Phoenix, AZ), November 20, 1928.

114. "Writes Novels: Estelle Aubrey Brown," *Arizona Republican* (Phoenix, AZ), April 6, 1930.

115. "Arizona's Authors," *Arizona Republic* (Phoenix, AZ), December 11, 1938.

116. "Woman's Club Notes," *Sunday News* (Ridgewood, NJ), April 2, 1939.

117. Brown, *Stubborn Fool*.

118. "Between Book Ends," *Arizona Daily Star* (Tucson, AZ), January 25, 1958.

119. "Local Author Estelle Brown Dies at 81," *Arizona Daily Star* (Tucson, AZ), January 25, 1958.

120. "Nurses Memorial," Arlington National Cemetery, https://www.arlingtoncemetery.mil/Explore/Monuments-and-Memorials/Nurses-Memorial.

Ella Howard Bryan, "Clinton Dangerfield"

121. Correspondence, May 6, 1895, from Ella Howard Bryan to Joseph Bryan, Virginia Historical Society, Mss3 M4638a FA2 folder 121a.

122. "Clinton Dangerfield," *New York Times*, October 25, 1902.

123. Correspondence, July 5, 1902, from Ella Howard Bryan to Joseph Bryan, Virginia Historical Society, Mss3 M4638a FA2 folder 121a.

124. "A Savannah Girl's Success," *Atlanta Constitution*, September 14, 1902.

125. "Clinton Dangerfield."

126. Bryan references Emanuel Swedenborg, the theologian and philosopher.

127. Correspondence, July 5, 1902, from Ella Howard Bryan to Joseph Bryan.

128. Ibid.

129. Letter from Theodore Roosevelt to Ella Howard Bryan, Theodore Roosevelt Papers, Library of Congress Manuscript Division, Theodore Roosevelt Digital Library, Dickinson State University, https://www.theodorerooseveltcenter.org/Research/Digital-Library/Record?libID=o180590.

130. *Savannah (GA) Morning News*, January 7, 1902.

131. "Clinton Dangerfield." The article mentions Bryan is the direct descendent of the Revolutionary Patriot Jonathan Bryan and the great-niece of the southern author Caroline Gilman.

132. Item 1, Clinton Dangerfield papers, MS 1059, Georgia Historical Society, Savannah, Georgia.

133. *Chattanooga (TN) Daily Times*, April 9, 1910; November 27, 1912; May 29, 1914; June 30, 1925.

134. "Miss Bryan's Play Shown," *Chattanooga (TN) Daily Times*, June 19, 1915.

135. The MacGowan sisters, Grace MacGowan Cooke and Alice MacGowan, received popular success with their short stories, novels and poems beginning in 1888. For more details about the sisters and their works, see Kay Baker Gaston, "The MacGowan Girls," *California History* 59, no. 2 (July 1980): 116–25.

136. "Miss Bryan's Play Shown."

137. "Clinton Dangerfield Now Writing in New York," *Chattanooga (TN) News*, March 23, 1917.

138. "Mrs. Caroline Morrison, Beloved Woman, Dies," *Chattanooga (TN) News*, May 11, 1918.

139. Georgia State Board of Health Death Certificate.

140. "Society Page," *Chattanooga (TN) Daily Times*, June 30, 1925.

141. "Looking Backward," *Chattanooga (TN) Daily Times*, May 14, 1944.

142. Email and phone conversation with Carlene Mitchell Bass on June 18, 2020.

143. "Deaths," *Times Dispatch* (Richmond, VA), February 14, 1954.

144. Woodland Cemetery Tour, Saturday, April 25, 2015, 4:30 p.m., the Ashland Museum, tour guide Susan Tucker.

145. In Virginia, cemetery companies may contact the next of kin to purchase any unused burial plots.

146. Clinton Dangerfield papers, MS 1059, Georgia Historical Society, Savannah, Georgia.

147. "Appendix C History, Comprehensive Plan 2011," Town of Ashland, 2011, http://ashlandva.gov/.

148. Woodland Cemetery Tour.

Letitia "Lettie" McCreery Burwell

149. Virginia Is for Lovers, https://www.virginia.org/listings/
HistoricSites/Avenel/.
150. Jessie Pounds, "'Ghost' of Poe Appears at Historic Haunt Avenel,"
News & Advance, February 18, 2013, https://newsadvance.com/news/
local/ghost-of-poe-appears-at-historic-haunt-avenel/article_54dee6dd-
c123-5c2a-8431-f9bfbb1a54b1.html.
151. Carrie Sidener, "History and Mystery Surround Antebellum Bedford
Mansion," *News & Advance*, May 29, 2020.
152. Letitia M. Burwell, *A Girl's Life in Virginia before the War* (New York:
Frederick A. Stokes Company, 1895), 1.
153. Sidener, "History and Mystery."
154. Ibid.
155. Ibid.
156. Burwell, *Girl's Life in Virginia*, 195.
157. Sidener, "History and Mystery."
158. Historic Avenel, https://www.historicavenel.com.
159. Ibid.
160. Colonial Ghosts, "Historic Avenel, Bedford, Virginia," https://
colonialghosts.com/historic-avenel-and-the-weems-botts-museum/.
161. "Historic Avenel," *Living in the Heart of Virginia-LHOV,* June 16, 2020,
television show. During the segment, Irene Catlin, Historic Avenel
facility director, discusses the history and the possibility of ghosts.
162. Sir Walter Scott, *The Monastery: A Romance. By the Author of "Waverley"
Sir Walter Scott* (Edinburgh: Longman, Hurst, Rees, Orme and Brown,
1820).

Nancy Larrick Crosby

163. "Nancy Larrick (1910–2004) Biography," JRank Articles, https://
biography.jrank.org/pages/1210/Larrick-Nancy-1910-2004.
html#ixzz6hw68jzK3.
164. Ibid.
165. Ibid.
166. Certificate of Marriage, Commonwealth of Virginia.
167. *News Herald* (Perkasie, PA), February 6, 1980; *Chula Vista (CA) Star-
News*, August 14, 1980.

168. "Nancy Larrick (1910–2004) Biography."

169. Ibid.

170. Nancy Larrick, "The All-White World of Children's Books," *Saturday Review*, September 11, 1965.

171. *Morning Call* (Allentown, Pennsylvania), November 24, 1991.

172. "Nancy Larrick (1910–2004) Biography."

173. Ibid.

174. Nancy Larrick, "Nancy Larrick Tells of Early Years at IRA," *History of Reading News* 19, no. 2 (Spring 1996).

175. Jennifer Bayot, "Nancy Larrick, Author of a Guide to Children's Reading, Dies at 93," *New York Times*, November 21, 2004.

176. "New Neighborhood Park Named in Honor of Local Business Owner," Winchester, Virginia, February 12, 2020, https://www.winchesterva.gov/new-neighborhood-park-named-honor-local-business-owner.

177. Brian Brehm, "New Winchester Park a Celebration of Racial Harmony," *Daily News-Record*, October 18, 2020, https://www.dnronline.com/news/new-winchester-park-a-celebration-of-racial-harmony/article_870cd00d-eabb-5ae6-8f13-ecbca40c65eb.html.

Elizabeth "Lizzie" Petit Cutler

178. Tardy, *Living Female Writers*, 430.

179. Edwin Anderson Alderman and Joel Chandler Harris, eds., *Library of Southern Literature: Biographical Dictionary of Authors* (Atlanta: Martin and Hoyt Company, 1910).

180. "New Book by Author of Light and Darkness," *Richmond (VA) Enquirer*, August 19, 1856.

181. "Spirit-Mates" in Tardy, *Living Female Writers*, 432.

182. Tardy, *Living Female Writers*, 430.

183. "From Washington," *Wheeling (WV) Daily Intelligencer*, March 25, 1858, 2.

184. "Miss Lizzie Petit," *Richmond (VA) Enquirer*, March 30, 1858, 2.

185. "Philomathean Society," *New York Daily Herald*, April 20, 1860, 3.

186. Tardy, *Living Female Writers*, 431.

187. *New York Daily Herald*, April 9, 1860, 1.

188. *New-York Tribune*, May 2, 1860, 2.

189. New York marriage records, November 5, 1861, married by Reverend Robert L. Shaw in Cold Spring, New York.

190. "Mrs. Lizzie Petit Cutler," *St. Louis (MO) Republican*, April 18, 1875.

191. "A Lady in Want," *Richmond (VA) Dispatch*, October 28, 1900.

192. "Mrs. Cutler Returns Her Thanks," *Richmond (VA) Dispatch*, November 11, 1900.

193. "The New York Era," *Brooklyn (NY) Daily Eagle*, March 9, 1867.

194. *The Sun* (New York, NY), June 20, 1897.

195. "Mrs. Lizzie Petit Cutler," *St. Louis (MO) Republican*, April 18, 1875.

196. "Suicide," *Times Union* (Brooklyn, NY), April 21, 1869.

197. *Hartford (CT) Courant*, April 22, 1869.

198. "Virginia Literati in a Book," *Richmond (VA) Dispatch*, December 1, 1869.

199. "Society Page," *Birmingham (UK) Daily Post*, January 24, 1873.

200. "Married Flirts," *New York Times*, March 27, 1874.

201. *Cincinnati (OH) Daily Star*, April 16, 1877.

202. "New Words to Auld Lang Syne," *Brooklyn (NY) Citizen*, June 19, 1887.

203. "Interesting Facts about Richmond's Citizens and Other Matters," *The Times* (Richmond, VA), April 4, 1893.

204. *Richmond (VA) Dispatch*, October 28, 1900.

205. Dr. McGuire established hospitals that later became part of the Medical College of Virginia (MCV) in Richmond, Virginia, including St. Luke's Hospital and Training School for Nurses, which was founded in 1893.

206. "A Lady in Want," *Richmond (VA) Dispatch*, October 28, 1900.

207. "Mrs. Cutler Returns Her Thanks," *Richmond (VA) Dispatch*, November 11, 1900.

208. "Funeral Notice," *Richmond (VA) Dispatch*, January 17, 1902.

209. Personal correspondence with Riverview Cemetery, January 19, 2021.

210. "Lee Camp Meeting," *The Times* (Richmond, VA), January 18, 1902. Although the newspaper article reads, "The request had been granted by the Ladies' Auxiliary and the devoted woman was laid to rest in the cemetery of her choice," Cutler is not buried in Hollywood Cemetery. This is incorrectly noted in Mary H. Mitchell's *Hollywood Cemetery: The History of a Southern Shrine* (Richmond: Library of Virginia, 1999).

211. Personal correspondence with Riverview Cemetery, January 19, 2021. Riverview Cemetery confirmed its records with plot book 1, page 273.

212. Jeremy M. Lazarus, "Confederate Flag Replaced at Riverview Cemetery," *Richmond (VA) Free Press*, March 13, 2018.

213. Richard Guy Wilson, *Buildings of Virginia: Tidewater and Piedmont* (New York: Oxford University Press, 2002), 267–68.

214. Maymont, https://maymont.org/.

Virginia Emeline Butts Davidson

215. Tardy, *Living Female Writers*, 403.
216. Ibid.
217. Ibid., 402.
218. Richard Gardiner and Daniel Bellware, *The Genesis of the Memorial Day Holiday in America* (Columbus, GA: Columbus State University, 2014), 144.
219. Tardy, *Living Female Writers*, 402.
220. Ibid.
221. Ibid.
222. 1910 United States Federal Census, *Petersburg, Virginia*, page 88B, line 60.
223. 1870 United States Federal Census, *Petersburg, Virginia*, page 23, line 5; 1880 United States Federal Census, *Petersburg, Virginia*, page 31, line 30; 1900 United States Federal Census, *Petersburg, Virginia*, page 19B, line 55; 1910 United States Federal Census, *Petersburg, Virginia*, page 88B, line 60.
224. Grave interment information, City of Petersburg, ID 10915, Ward A, Grave 2, OLD.
225. *The Southern Opinion* (Richmond, VA: H. Rives Pollard, 1867–69), https://lccn.loc.gov/sn84024683.
226. Goth Gardener, "A Behind the Scenes, Hard Hat Tour of Poplar Grove Cemetery," *Goth Gardening*, September 4, 2016, https://goth-gardening.blogspot.com/2016/09/a-behind-scenes-hard-hat-tour-of-poplar.html.

Varina Anne "Winnie" Davis

227. Heath Hardage Lee, *Winnie Davis: Daughter of the Lost Cause* (Lincoln: University of Nebraska Press, Potomac Books, 2014), Kindle, chapter 5.
228. Ibid., chapter 6.
229. "Miss Winnie Davis Dead," *New York Times*, September 19, 1898.
230. Varina Anne Davis, *An Irish Knight of the 19th Century: Sketch of the Life of Robert Emmet* (New York: John W. Lovell Company, 1888).
231. Lee, *Winnie Davis*, chapter 17.
232. *New York Times*, September 19, 1898.
233. Lee, *Winnie Davis*, chapter 17.
234. Ibid., preface.
235. "Miss Davis' Story," *Galveston (TX) Daily News*, August 3, 1895.
236. *Philadelphia (PA) Inquirer*, July 20, 1895.

237. *Baltimore (MD) Sun*, August 10, 1898.
238. Clayton McClure Brooks, "Mary-Cooke Branch Munford (1865–1938)," *Encyclopedia Virginia*, Virginia Humanities, January 26, 2016, https://encyclopediavirginia.org/entries/munford-mary-cooke-branch-1865-1938/.

Varina Anne Banks Howell Davis

239. Bertram Wyatt-Brown, *The House of Percy: Honor, Melancholy and Imagination in a Southern Family* (New York: Oxford University Press, 1994), 124.
240. Ibid.
241. Frances Clarke, "Review of Cashin, *First Lady of the Confederacy*," *Australasian Journal of American Studies* 27, no. 2 (December 2008): 145–47.
242. Ibid., 146.
243. "Varina Howell Davis (1826–1906)," *Encyclopedia Virginia*, Virginia Humanities, June 2, 2014, https://encyclopediavirginia.org/entries/davis-varina-1826-1906/.
244. Ibid.
245. Ibid.
246. Ibid.
247. Joan E. Cashin, *First Lady of the Confederacy: Varina Davis's Civil War* (Cambridge, MA: Harvard University Press, 2006), 6.
248. "Varina Howell Davis (1826–1906)."
249. Cashin, *First Lady of the Confederacy*, 295–98.
250. Ibid., 6.

Judith L.C. Garnett

251. New York State Census, City of Brooklyn, June 1865, 29.
252. Ibid.
253. John Hastings Gwathmey, *Twelve Virginia Counties: Where the Western Migration Began* (Richmond, VA: Dietz Press, 1937), 169.
254. 1880 United States Federal Census, Staunton, Virginia, line 7.
255. Edmund D. Potter, *A Guide to Historic Staunton, Virginia* (Charleston, SC: The History Press, 2008).
256. 1900 United States Federal Census, Essex, Virginia, 19, line 32.
257. 1910 United States Federal Census, Essex, Virginia, 16, line 93.

258. 1920 United States Federal Census, Essex, Virginia, 14, line 76.

259. Ibid.

260. "Henrico Police Not to Probe Kish Case," *Times Dispatch* (Richmond, VA), February 27, 1930.

261. "To Open Memorial Campaign in Ohio," *Chattanooga (TN) Daily Times*, January 17, 1926.

262. "19 Named Here in 'Who's Who' of U.S. Women," *Times Dispatch* (Richmond, VA), July 7, 1935.

263. "Richmond Women Listed in Book," *Times Dispatch* (Richmond, VA), June 26, 1937.

264. Certificate of Death, Commonwealth of Virginia, Henrico, registered no. 1397.

265. "Miss Judith Garnett to Be Buried Today," *Times Dispatch* (Richmond, VA), June 27, 1938.

266. "Famous Memorials in Forest Lawn Cemetery and Mausoleum," Find a Grave, https://www.findagrave.com/cemetery/154652/famous-memorials.

267. "Latest Books on the Market," *Spokane (WA) Chronicle*, March 17, 1922.

268. "Eloquent Poetry by Miss Garnett," *Times Dispatch* (Richmond, VA), December 31,1922.

269. Papers, 1902, Judith Garnett Papers, Special Collections Research Center, accessed July 31, 2020, https://scrcguides.libraries.wm.edu/repositories/2/archival_objects/246866.

270. Kessinger Publishing's Rare Reprints, https://www.kessingerpublishing.com/.

271. Selden Richardson, "The Diamond Peters' Mausoleum, Forest Lawn Cemetery, Richmond, VA," *Shockoe Examiner*, August 24, 2010. https://theshockoeexaminer.blogspot.com/2010/08/diamond-peters-mausoleum-forest-lawn.html.

272. Ibid.

Ellen Glasgow

273. Harry G. Lang and Bonnie Meath-Lang, "Ellen Glasgow," in *Deaf Persons in the Arts and Sciences: A Biographical Dictionary* (Westport, CT: Greenwood Press, 1995), 145.

274. Ibid., 143.

275. Susan Goodman, *Ellen Glasgow: A Biography* (Baltimore, MD: Johns Hopkins University Press, 1998).

276. Lang and Meath-Lang, "Ellen Glasgow," 144.

277. Ibid., 145.

278. Catherine G. Costantino, "'Fellow-Craftsmen': A Study of the Personal and Professional Relationship between Mary Johnston and Ellen Glasgow" (master's thesis, University of Richmond, 1998).

279. Lang and Meath-Lang, "Ellen Glasgow," 143.

280. Dorothy M. Scura, "A Knowledge in the Heart: Ellen Glasgow, the Women's Movement, and 'Virginia,'" *American Literary Realism, 1870–1910* 22, no. 2 (1990): 32.

281. Ibid., 32.

282. "Ellen Glasgow," *Virginia Changemakers*, accessed May 25, 2021, https://edu.lva.virginia.gov/changemakers/items/show/93.

283. John T. Kneebone et al., eds., *Dictionary of Virginia Biography* (Richmond; Library of Virginia, 1998–), 1:136–37.

284. Ellen Glasgow, *The Woman Within* (Charlottesville: University Press of Virginia, 1954), 284.

285. Larry Hall, "Richmond Novelist Glasgow Was Advocate for Animals." *Richmond (VA) Times-Dispatch*, December 19, 2007.

286. James E. DuPriest, *Hollywood Cemetery: A Tour* (Richmond, VA: Richmond Discoveries Inc., 1985), 6.

287. "Ellen Glasgow," *Virginia Changemakers*.

288. Papers of Ellen Glasgow, Accession #5060, Special Collections, University of Virginia Library, Charlottesville, Virginia.

289. DuPriest, *Hollywood Cemetery*, 10.

290. Jonathan Spiers, "11,000-Square-Foot Ellen Glasgow House Hits Market after 34 Years for $3.5M," Richmond BizSense, September 21, 2020, https://richmondbizsense.com/2020/09/18/11000-square-foot-ellen-glasgow-house-hits-market-after-34-years-for-3-5m/#.

Lizzie Chambers Hall

291. Commonwealth of Virginia, Certificate of Death, 152.

292. 1900 United States Census, Lynchburg, VA, lines 37–44.

293. Virginia, U.S., Select Marriages, 1785–1940 [database online], https://www.ancestry.com/search/collections/60214/.

294. "The Pulpit at the First Bapt. Church," *Richmond (VA) Planet*, October 10, 1896.

295. "From Petersburg," *Richmond (VA) Planet*, January 8, 1898, 4.

296. "The High Street Baptist Church," *Richmond (VA) Planet*, March 30, 1901, 1.

297. *Richmond (VA) Planet*, April 5, 1902, 1.

298. *Richmond (VA) Planet*, April 4, 1908, 1.

299. Lizzie Chambers Hall Papers #4145-z, Southern Historical Collection, Wilson Library, University of North Carolina at Chapel Hill.

300. "Baptist Women Hold Successful State Convention," *Richmond (VA) Planet*, June 29, 1918.

301. "In Memoriam," *The Bee* (Danville, VA), July 1, 1927.

302. 1930 United States Census, Lynchburg, VA, lines 63–67.

303. "Colored Ministers Meet," *The Bee* (Danville, VA), May 5, 1936.

304. "Mrs. Chambers Hall," *Daily Press* (Newport News, VA), February 7, 1965.

305. Commonwealth of Virginia, Certificate of Death, 152.

306. Old City Cemetery burial records, ID Number: T06137.

307. "In Memoriam."

308. Lizzie Chambers Hall Papers #4145-z.

309. Old City Cemetery, https://www.gravegarden.org/.

Constance Fairfax Cary Harrison

310. Adrienne Dunning Rea, "Mrs. Burton Harrison (1843–1920)," *Encyclopedia Virginia*, Virginia Humanities, February 16, 2017, https://encyclopediavirginia.org/entries/harrison-burton-mrs-1843-1920/.

311. Ibid.

312. Tardy, *Living Female Writers*, 398.

313. Rea, "Mrs. Burton Harrison."

314. Gaillyn Bowman, "Constance Cary Harrison, Refugitta of Richmond: A Nineteenth-Century Southern Woman Writer's Critically Intriguing Antislavery Narrative Strategy," ProQuest Dissertations Publishing, 2003.

315. Rea, "Mrs. Burton Harrison."

316. *The Magnolia Weekly* was "a home journal of literature & general news" published by Haines & Smith out of Richmond, Virginia, from 1863 to 1865; Tardy, *Living Female Writers*, 398.

317. Tardy, *Living Female Writers*, 398.

318. "Burton Harrison Dead," *Brooklyn (NY) Times Union*, March 30, 1904.

319. "Married," *Charleston (SC) Daily News*, December 13, 1867.

320. Rea, "Mrs. Burton Harrison."

321. "Burton Harrison Dead."

322. Rea, "Mrs. Burton Harrison."

323. "Noted Southern Author Succumbs to Illness," *Evening Star* (Washington, D.C.), November 22, 1920.

324. Bowman, "Constance Cary Harrison," 16.

325. The self-guided tour and map can be found here: https://www. alexandriava.gov/uploadedfiles/dchs/info/womentourwebsite.pdf.

Lucy Norvell Harrison

326. Norvell Harrison, "Another William Tell," in *Werner's Readings and Recitations* (New York: Edgar S. Werner & Company, 1915), 95–100.

327. "Deaths in Virginia," *Times Dispatch* (Richmond, VA), August 18, 1917.

328. Norvell Harrison, "Celibacy of Man," *Frank Leslie's Popular Monthly*, August 1901.

329. *Times-Democrat* (New Orleans, LA), March 30, 1902.

330. Norvell Harrison, "De Profundis," *Frank Leslie's Popular Monthly*, August 1902.

331. "The Magazines for February," *Times Dispatch* (Richmond, VA), January 29, 1905.

332. "Miss Harrison's Story," *Times Dispatch* (Richmond, VA), August 26, 1905.

333. "Society in Richmond," *Washington Post* (Washington, D.C.), August 27, 1905, 7.

334. "The Travelers," *Brooklyn Life* (Brooklyn, NY), February 23, 1907, 20.

335. 1910 United States Federal Census, Charleston Ward 8, Kanawha, West Virginia, T624_1684, page 5A, Enumeration District.

336. Henry Harrison and Norvell Harrison, "Having a Man," *Adventure*, May 1911.

337. Norvell Harrison, "The Boarding-House Graphophone," *Woman's Home Companion*, December 1911.

338. "Society," *Times Dispatch* (Richmond, VA), June 29, 1913.

339. "Warm Sulphur Springs," *Times Dispatch* (Richmond, VA), July 26, 1914.

340. "At the Warm," *Times Dispatch* (Richmond, VA), August 11, 1914.

341. Biography provided by Jeffry Burden, Friends of Shockoe Hill Cemetery.

342. 1920 United States Federal Census, Manhattan Assembly District 13, New York, New York, Page 8B.

343. "Women Picket Church Edifices to Protest War," *Daily News* (New York), December 26, 1921.

344. 1925 New York State Census, Manhattan Assembly District 21, New York, New York, page 9.

345. "Press Comments," *Tennessean Sun* (Nashville, TN), July 20, 1930.

346. "Man Is Midway in Evolution, Speaker States," *Times Dispatch* (Richmond, VA), March 14, 1929.

347. Ibid.

348. *The Tennessean* (Nashville, TN), July 20, 1930).

349. "Society," *Evening Star* (Washington, D.C.), September 23, 1931.

350. "Miss Norvell Harrison Dies in Columbia, S.C.," *Richmond (VA) Times Dispatch*, October 13, 1955.

351. "Smart Set," *Standard Union* (Brooklyn, NY), February 19, 1905.

352. "Miss Harrison's Story," *Times Dispatch* (Richmond, VA), August 26, 1905.

353. *A Guide to Shockoe Hill Cemetery*, Friends of Shockoe Hill brochure, 24.

Mary Jane Haw

354. *Magnolia Weekly* was "a home journal of literature & general news" published by Haines & Smith out of Richmond, Virginia, from 1863 to 1865.

355. Tardy, *Living Female Writers*, 399.

356. M.J. Haw, "My Visits to Grandmother." *Christian Observer*, May 18, 1910.

357. Haw genealogical records.

358. "Springfield Plantation Historical Marker," Richmond National Battlefield Park, National Parks Service.

359. Haw genealogical records.

360. "Christmas-Day A.D. 1861," *Richmond (VA) Dispatch*, January 2, 1898.

361. Tardy, *Living Female Writers*, 399.

362. *Times and News* (Eufaula, AL), March 25, 1886.

363. *The Times* (Philadelphia, PA), October 5, 1889.

364. Documenting the American South, UNC-CH digitization project, University of North Carolina at Chapel Hill, https://docsouth.unc.edu.

365. "Arboretum," Hollywood Cemetery, https://www.hollywoodcemetery. org/about/arboretum.

Mary Anna Morrison Jackson

366. Chalmers G. Davidson, "Jackson, Mary Anna Morrison," *NCpedia*, from *Dictionary of North Carolina Biography*, 6 volumes, edited by William S. Powell, accessed June 12, 2021, https://www.ncpedia.org/biography/jackson-mary.

367. Ibid.

368. William S. Powell, ed., *Dictionary of North Carolina Biography* (Chapel Hill: University of North Carolina Press, 1979).

369. Davidson, "Jackson, Mary Anna Morrison."

370. Mary Anna Jackson, *Julia Jackson Christian* (Charlotte, NC: Stone & Barringer Co., 1910).

371. Wallace Hettle, "Mary Johnston and 'Stonewall' Jackson: A Virginia Feminist and the Politics of Historical Fiction," *Journal of Historical Biography* (Spring 2008): 3.

372. James Robertson, *Stonewall Jackson: The Man, The Soldier, The Legend* (New York: MacMillan Publishing, 1997), 44.

Mary Johnston

373. Clayton McClure Brooks, Samuel P. Menefee and Brendan Wolfe, "Mary Johnston (1870–1936)," *Encyclopedia Virginia*, Virginia Humanities, March 20, 2014, https://encyclopediavirginia.org/entries/johnston-mary-1870-1936/.

374. *Audrey*, directed by Robert G. Vignola (Jacksonville, FL: Famous Players Film Company, 1916), film.

375. Hettle, "Mary Johnston and 'Stonewall' Jackson," 3.

376. E.T. James, J.W. James and P.S. Boyer, eds., "Mary Johnston," *Notable American Women, 1607–1950: A Biographical Dictionary* (Cambridge, MA: Belknap Press of Harvard University Press, 1971), 2:282–83.

377. Ibid.

378. George Longest, *Three Virginia Writers; Mary Johnston, Thomas Nelson Page, and Amelie Rives Troubetskoy: A Reference Guide* (Boston: G.K. Hall, 1978), 23–25.

379. *To Have and to Hold* (New York: Grosset & Dunlap, 1899), 160.

380. Marjorie Spruill Wheeler, "Mary Johnston, Suffragist," *Virginia Magazine of History and Biography*, January 1992.

381. Brooks, Menefee and Wolfe, "Mary Johnston (1870–1936)."

382. Ibid.
383. "Mary Johnston," *Notable American Women*.
384. Rex Springston, "A River of Knowledge: 14 Cool Things to Know about the James River," *Richmond Times-Dispatch*, August 14, 2017.
385. "Belle Isle Resort (U.S. National Park Service)," National Parks Service, U.S. Department of the Interior, https://www.nps.gov.

Cornelia Jane Matthews Jordan

386. Mary Simmerson Cunningham Logan, *The Part Taken by Women in American History* (Wilmington, DE: Perry-Nalle Publishing Company, 1912). p. 819; Tardy, *Living Female Writers*, 425.
387. Tardy, *Living Female Writers*, 425.
388. Ibid.
389. Tardy, *Living Female Writers*, 424.
390. Ibid.
391. Presbyterian Cemetery burial records.
392. T.W. White, "Notice of New Works," *Southern Literary Messenger*, March 1861.
393. Presbyterian Cemetery burial records.
394. Ibid.
395. Tardy, *Living Female Writers*, 425.
396. "A Christmas Poem, for Children," *Richmond (VA) Dispatch*, December 23, 1865.
397. Frances Elizabeth Willard and Mary Ashton Rice Livermore, *A Woman of the Century: Fourteen Hundred-Seventy Biographical Sketches Accompanied by Portraits of Leading American Women in All Walks of Life.* (Buffalo, NY: Moulton, 1893), 426.
398. *Norfolk (VA) Landmark*, October 6, 1888.
399. "'Hope Dare' Dead," *Alexandria (VA) Gazette*, January 27, 1898.
400. Presbyterian Cemetery burial records.
401. Personal correspondence with the great-great-great-grandson's wife, Julia Wallace Chipley.
402. Lynchburg Museum, https://www.lynchburgmuseum.org.
403. Presbyterian Cemetery, https://presbyteriancemeteryva.com/.

Mary Greenhow Lee

404. Linda Wheeler, "The 'She-Devils' of the Shenandoah Valley Held Their Own," *Washington Post*, March 2, 2012.
405. "Site of Civil War Diarist's Home to Get State Marker," *Winchester (VA) Star*, November 4, 2014.
406. Sheila R. Phipps, *American National Biography*. (New York: Oxford University Press, 1999), 179.
407. Ibid.
408. Sheila R. Phipps, *Genteel Rebel: The Life of Mary Greenhow Lee* (Baton Rouge: Louisiana State University Press, 2004), 138.
409. Wheeler, "The 'She Devils' of the Shenandoah."
410. Ibid.
411. Phipps, *American National Biography*, 179.

Mary Tucker Magill

412. Mary Bayliss, "Magill, Mary Tucker (1830–1899)," *Encyclopedia Virginia*, Virginia Humanities, accessed February 12, 2021, https://encyclopediavirginia.org/entries/magill-mary-tucker-1830-1899/.
413. Ibid.
414. Ibid.
415. Ibid.
416. Magill was an early advocate of exercise for women.
417. Bayliss, "Magill, Mary Tucker (1830–1899)."
418. *Alexandria (VA) Gazette*, February 1, 1881; *Norfolk (VA) Weekly Landmark*, October 23, 1884.
419. *The Free Lance* (Fredericksburg, VA), May 2, 1899.
420. "Obituary," *The Free Lance* (Fredericksburg, VA), May 2, 1899.
421. Bayliss, "Magill, Mary Tucker (1830–1899)."
422. Brian Brehem, "Scholars Treated to Tour of Willa Cather's Childhood Home," *Winchester (VA) Star*, June 18, 2019.

Julia Magruder

423. "Literary Notes," *Daily American* (Nashville, TN), June 9, 1887.

424. Carrie O'Brien, "Magruder, Julia (1854–1907)," *Encyclopedia Virginia*, Virginia Humanities, accessed February 12, 2021, https://encyclopediavirginia.org/entries/magruder-julia-1854-1907/.

425. Ibid.

426. "Julia Magruder Dead," *New York Times*, June 10, 1907.

427. "Julia Magruder Is Dead," *Leavenworth (KS) Post*, June 10, 1907.

428. "Julia Magruder," *Sabetha (KS) Republican-Herald*, October 13, 1893; "Julia Magruder Is Dead," *St. Joseph (MO) News-Press/Gazette*, June 10, 1907.

429. "Disciple of True Pleasure Passes," *Star Press* (Muncie, IN), June 24, 1907.

430. Ibid.

431. "Death of Miss Julia Magruder," *Concord (NC) Times*, June 11, 1907.

432. O'Brien, "Magruder, Julia (1854–1907)."

433. File No. 85, Magruder, Julia M, 1925, Box: MSS 88-3, Box 50, The Law Office Papers of William F. Long and R. Watson Sadler, Arthur J. Morris Law Library Special Collections, https://archives.lib.virginia.edu/repositories/4/archival_objects/67151.

434. Monticello Wine Trail, https://monticellowinetrail.com/.

435. "Oakencroft Vineyard & Winery," Southern Foodways Alliance, April 17, 2020, https://www.southernfoodways.org/interview/oakencroft-vineyard-winery/.

Katherine Boyce Tupper Marshall

436. Katherine Tupper Marshall papers, George C. Marshall Research Foundation, accession 23.

437. Ibid.

438. Ibid.

439. "Louis Berman Taken to Jail Under Guard," *Evening Sun* (Baltimore, MD), June 5, 1928.

440. "Best Man Pershing Stole Show When Marshalls Were Married," *Boston Globe*, January 9, 1947.

441. Ibid.

442. Katherine Tupper Marshall papers.

443. Ibid.

444. *Miami (FL) Herald*, December 20, 1978.

445. Marylou Tousignant, "A New Era for the Old Guard," *Washington Post*, March 23, 1996.



446. "Frequently Asked Questions," Society of the Honor Guard, Tomb of the Unknown Soldier, https://tombguard.org/society/faq/.

Frances McEntee Martin

447. 1910 United States Census, Newark, New Jersey, 20.
448. 1925 Marriage License, Brooklyn, New York, April 24, 1925.
449. 1930 United States Federal Census, Norfolk, Virginia, 10B.
450. "Norfolk Writers Honored at Annual Party Here," *Richmond (VA) Times-Dispatch*, May 11, 1953.
451. F. Leypoldt, "Shop Talk," *Publishers Weekly*, August 1, 1953.
452. "Norfolk Writers Honored at Annual Party Here."
453. Ibid.
454. *Daily Press* (Newport News, VA), September 28, 1957.
455. Commonwealth of Virginia Death Certificate, 205.
456. Forest Lawn Cemetery burial records.
457. For more details on the Women in Norfolk Historic Cemetery Tour and other tours offered at the cemetery, visit https://www.nsccva.org/.

Mabel Wood Martin

458. *Montclair (NJ) Times*, April 13, 1927.
459. Ibid.
460. *Everybody's Magazine*, 1909.
461. *Scribner's Magazine*, 1914.
462. 1930 United States Federal Census, El Paso, Texas, 22B.
463. 1940 United States Federal Census, District of Columbia, 539.
464. Arlington National Cemetery interment record.
465. "School Teaching in the Philippines," *New York Herald*, October 31, 1920.
466. More information about Memorial Trees can be found on Arlington National Cemetery's website: https://www.arlingtoncemetery.mil/Explore/Memorial-Arboretum-and-Horticulture/Trees/Memorial-Trees.

Judith Brockenbrough McGuire

467. Judith Brockenbrough McGuire, *General Robert E. Lee, the Christian Soldier* (Philadelphia: Claxton, Remsen & Haffelfinger, 1873).

468. Janet E. Kaufman, "Judith Brockenbrough McGuire," *American Women Writers: A Critical Reference Guide from Colonial Times to the Present*, https://www.encyclopedia.com/arts/news-wires-white-papers-and-books/mcguire-judith-whitebrockenbrough.

469. Judith Brockenbrough McGuire, *Diary of a Southern Refugee*, January 20, 1862 entry.

470. "White House of the Confederacy," National Historic Landmark summary listing, National Park Service.

471. Judith Robinson, "Judith Brockenbrough McGuire," WikiTree, September 16, 2016, https://www.wikitree.com/wiki/Brockenbrough-51.

472. McGuire, *Diary.*

473. Kaufman, "Judith Brockenbrough McGuire."

474. "U.D.C. Chapter Gathers for February Meeting," *Gaffney (SC) Ledger*, February 21, 1992.

475. Historical Walking Tour of Tappahannock, Essex County, Virginia: http://www.tappahannock.us/

476. *Baltimore (MD) Sun*, March 23, 1897.

477. *Alexandria (VA) Gazette*, March 23, 1897.

478. St. John's Episcopal Church, Tappahannock, Virginia, https://stjohnstappahannock.org/about-and-history/.

479. "Essex County Cemetery Tour," Essex County Museum and Historical Society, Tappahannock, Virginia, https://sms5.org/cemetery/index.htm.

480. Their website also includes a virtual cemetery tour: https://sms5.org/cemetery/index.htm.

Margaret Prescott Montague

481. "Prize Fiction in the Sunday Star," *Kansas City Star*, August 29, 1920; Debra K. Sullivan, "Margaret Prescott Montague." e-WV: The West Virginia Encyclopedia, November 29, 2016, https://www.wvencyclopedia.org/articles/2026.

482. The films include *Seeds of Vengeance* (1920), *Uncle Sam of Freedom Ridge* (1920), *Calvert's Valley* (1922) and *Linda* (1929).

483. A&M 1110, Margaret Prescott Montague, Author, Papers, West Virginia and Regional History Center, West Virginia University Libraries, https://archives.lib.wvu.edu/repositories/2/resources/4354.

484. Margaret Prescott Montague, *The Poet Miss Kate and I* (New York: Baker & Taylor Co., 1905).

485. Margaret Prescott Montague, *The Sowing of Alderson Cree* (New York: Baker & Taylor Co., 1907).

486. Margaret Prescott Montague, *In Calvert's Valley* (New York: Baker & Taylor Co., 1908).

487. Margaret Prescott Montague, *Linda* (New York: Houghton Mifflin Company, 1912).

488. Margaret Prescott Montague, *Of Water and the Spirit* (New York: E.P. Dutton & Company, 1916).

489. Margaret Prescott Montague, *Up Eel River* (New York: Macmillan Company, 1928).

490. Margaret Prescott Montague, *Twenty Minutes of Reality: An Experience* (New York: E.P. Dutton & Company, 1917).

491. "The Lucky Lady," *Richmond (VA) Times Dispatch*, May 2, 1943, 20.

492. E.A.F., "Tabular Statement of American Schools for the Deaf, November 10, 1910," *American Annals of the Deaf* 56, no. 1 (January 1911): 19.

493. "Questions and Answers," *Richmond (VA) Times Dispatch*, December 28, 1942.

494. "Margaret Prescott Montague Has Written a Novel of Graceful Charm in 'Linda,'" *Boston Globe*, November 9, 1912, 13.

495. A&M 1110, Margaret Prescott Montague, Author, Papers, West Virginia and Regional History Center, West Virginia University Libraries, https://archives.lib.wvu.edu/repositories/2/resources/4354.

496. "Deaf Children Miss Her," *Boston Globe*, February 1, 1913.

497. "The Deaf and Blind," *Boston Globe*, December 11, 1915.

498. "Author Gives Life to Wilson Ideals," *Richmond (VA) Times Dispatch*, September 14, 1924.

499. Margaret Prescott Montague, *Uncle Sam of Freedom Ridge* (New York: Doubleday, Page & Company, 1920).

500. "Author Gives Life to Wilson Ideals."

501. *Seeds of Vengeance* (1920), *Calvert's Valley* (1922), *Linda* (1929).

502. "Author Gives Life to Wilson Ideals."

503. Margaret Prescott Montague, *Deep Channel* (Boston: The Atlantic Monthly Press, 1923).

504. A&M 1110, Margaret Prescott Montague, Author, Papers, West Virginia and Regional History Center, West Virginia University Libraries, https://archives.lib.wvu.edu/repositories/2/resources/4354.

505. "Miss Montague to Be Buried Here Today," *Richmond (VA) Times Dispatch*, September 27, 1955.

506. Margaret Prescott Montague, *The Lucky Lady* (New York: Houghton Mifflin Company, 1933).

507. "On the Fringe of Silence; a Plea for the Hard of Hearing," *Des Moines (IA) Register*, October 6, 1934.

508. "This Clubs Begs for Reading of the Minutes," *Richmond (VA) Times Dispatch*, December 9, 1923.

LaSalle "Sallie" Corbell Pickett

509. L.J. Gordon, "LaSalle Corbell Pickett (1843–1931)," *Encyclopedia Virginia*, October 17, 2015, http://www.EncyclopediaVirginia.org/Pickett_LaSalle_Corbell_1843-1931.

510. Ibid.

511. Willard and Livermore, *Woman of the Century*, 570–71.

512. Ibid.

513. Gordon, "LaSalle Corbell Pickett (1843–1931)."

514. Ibid.

515. Ibid.

516. Willard and Livermore, *Woman of the Century*, 570–71.

517. Fredrick Kunkle, "Giving Up Its Ghosts," *Washington Post*, January 27, 2001.

518. Peter Y. Hong, "Vandalism in Va. Mausoleum Said to Indicate Satanism," *Washington Post*, June 23, 1994.

519. Nancy Scannell, "In the Market for a Mausoleum?" *Washington Post*, August 2, 1984.

520. "Confederate Couple Unite in Cemetery," *San Bernardino County (CA) Sun*, March 22, 1998.

521. Ibid.

522. Gordon, "LaSalle Corbell Pickett (1843–1931)."

523. Mary Mitchell, *Hollywood Cemetery: The History of a Southern Shrine* (Richmond: Library of Virginia, 1999), 73.

524. Ibid., 67.

Margaret Junkin Preston

525. *Knoxville (TN) Tribune*, March 29, 1897.

526. "Margaret J. Preston," *Knoxville (TN) Tribune*, March 29, 1897.

527. Tardy, *Living Female Writers*, 379.

528. *Evening News* (Harrisburg, PA), March 19, 1924.

529. Tardy, *Living Female Writers*, 379.

530. *Evening News* (Harrisburg, PA), March 19, 1924.

531. *Evening Star* (Washington, D.C.), March 14, 1857.

532. *Evening News* (Harrisburg, PA), March 19, 1924.

533. Tardy, *Living Female Writers*, 380.

534. *Evening News* (Harrisburg, PA), March 19, 1924.

535. *Knoxville (TN) Tribune*, March 29, 1897.

536. *Evening News* (Harrisburg, PA), March 19, 1924.

537. University of North Carolina in The Southern Historical Collection at the Louis Round Wilson Special Collections Library, Collection Number: 01543, Collection Title: Margaret Junkin Preston Papers, 1812–1892, 1938, 1997, https://finding-aids.lib.unc.edu/01543/.

538. Ruth Anderson McCulloch, *Mrs. McCulloch's Stories of Ole Lexington* (Lexington, VA: McClure Press, 1972).

Eudora Woolfolk Ramsay Richardson

539. Andrea Ledesma, "Eudora Ramsay Richardson (1891–1973)," Dictionary of Virginia Biography, Library of Virginia, accessed January 23, 2021, https://www.lva.virginia.gov/public/dvb/bio.php?b=Richardson_Eudora_Ramsay.

540. "Richmond Women Cited," *Richmond (VA) Times-Dispatch*, August 24, 1951.

541. Ledesma, "Eudora Ramsay Richardson (1891–1973)."

542. Ibid.

543. Ibid.

544. "Society," *Columbia (TN) Herald*, December 7, 1917.

545. Ledesma, "Eudora Ramsay Richardson (1891–1973)."

546. Terence E. Hanley, "Eudora Ramsay Richardson (1891–1973)," *Tellers of Weird Tales: Artists and Writers in The Unique Magazine*, May 23, 2012, tellersofweirdtales.blogspot.com/2012/05/eudora-ramsay-richardson-1891-1973.html.

547. "Mrs. Eudora Ramsay Richardson," *Leader-Call* (Laurel, MS), March 13, 1935; "Chairman Named for Club Year by Mrs. Richardson," *Richmond (VA) Times-Dispatch*, April 26, 1936.

548. "Is Author of New Book," *Greenville (SC) News*, March 20, 1932.

549. "Geline Bowman Urges Women to Study Art of Public Speaking," *Richmond (VA) Times-Dispatch*, January 26, 1936.

550. Hanley, "Eudora Ramsay Richardson (1891–1973)."

551. "Richmond Feminist Proves Women Can Do Man's Work," *Richmond (VA) Times-Dispatch*, August 25, 1950.

552. "Richmond Women Cited," *Richmond (VA) Times-Dispatch*, August 24, 1951.

553. "Henricopolis Chapter Will Sponsor Benefit Tea," *Richmond (VA) Times-Dispatch*, April 3, 1941.

554. "First Unitarian Church," *Richmond (VA) Times-Dispatch*, May 22, 1953; *Richmond (VA) Times-Dispatch*, October 15, 1960.

555. "Club Calendar for Today," *Richmond (VA) Times-Dispatch*, April 19, 1961.

556. "Arthritis Foundation Elects Attorney Here," *Richmond (VA) Times-Dispatch*, October 30, 1963.

557. Commonwealth of Virginia Death Certificate, filed October 10, 1973, #143, 649.

558. Papers of Eudora Ramsay Richardson, 1925–1960, Accession #9766, Special Collections, University of Virginia Library, Charlottesville.

559. Ledesma, "Eudora Ramsay Richardson (1891–1973)."

560. "Wall of Honor," Virginia Women's Monument Commission, accessed June 20, 2021, http://womensmonumentcom.virginia.gov/wallofhonornames.html.

Mary Roberts Rinehart

561. "Mary Roberts Rinehart Passes at 82," *Napa Valley (CA) Register*, September 23, 1958.

562. Mary Roberts Rinehart Papers, ULS Archives & Special Collections, University of Pittsburgh, SC.1958.03.

563. Ibid.

564. "Mary Roberts Rinehart Had Her Own Mystery," *Boston Globe*, September 28, 1958.

565. Ibid.

566. Charlotte MacLeod, *Had She But Known: A Biography of Mary Roberts Rinehart* (New York: Mysterious Press, 1994).

567. "Mary Roberts Rinehart, Author, Dies at 82," *Detroit (MI) Free Press*, September 23, 1958, 1.

568. Timothy D. Murray and Theodora Mills, "Cosmopolitan Book Corporation," in *American Literary Publishing Houses, 1900–1980. Trade and Paperback*, ed. Peter Dzwonkoski (Detroit, MI: Gale Research Co., 1986), 91–92.

569. "Mary Roberts Rinehart Had Her Own Mystery."

570. Ibid.

571. Gretta Palmer, "I Had Cancer," *Ladies' Home Journal* 64, no. 7 (July 1947): 143–48.

572. Mystery Writers of America, the Edgars, http://theedgars.com/awards/.

573. "Mary Roberts Rinehart Passes at 82."

574. "Mary Roberts Rinehart Had Her Own Mystery."

575. Ibid.

576. Mary Roberts Rinehart Papers 1831–1970, SC.1958.03, Special Collections Department, University of Pittsburgh. Identifier, US-PPiU-sc195803.

577. More information about Prominent Women can be found on Arlington National Cemetery's website.

Judith Page Walker Rives

578. Tardy, *Living Female Writers*, 437.

579. Ibid.

580. Erin Parkhurst, "The Literary Life," *Virginia Living*, February 2014, www.virginialiving.com/house-and-garden/literary-life/.

581. Tardy, *Living Female Writers*, 437.

582. Ibid.

583. Ibid.

584. Ibid.

585. Judith Page Walker Rives, *Home and the World* (New York: D. Appleton and Company, 1857), 7.

586. A Lady of Virginia, *Tales and Souvenirs of a Residence in Europe* (Philadelphia: Lea & Blanchard, 1842), Internet Archive, archive.org/details/talesandsouvenir00riveiala; Rives, *Home and the World*, archive.org/details/homeandworld00riverich.

587. "Orchard," Castle Hill Cider, www.castlehillcider.com/orchard.

Ruby Thelma Altizer Roberts

588. M.L. Crawford, "Ruby Altizer Roberts (1907–2004)," *Encyclopedia Virginia*, January 5, 2014, http://www.EncyclopediaVirginia.org/Roberts_Ruby_Altizer_1907-2004.
589. "Virginia Writers," *Richmond (VA) Times-Dispatch*, Sun, May 22, 1949.
590. Tonia Moxley, "'That's the Way She Was, Like a Bubbling Spring,'" *Roanoke Times*, May 30, 2004.
591. *Brown County Democrat* (Nashville, IN), July 23, 1959.
592. Crawford, "Ruby Altizer Roberts (1907–2004)."
593. "Poet Laureate Aids Youth," *Richmond (VA) Times-Dispatch*, October 15, 1950.
594. "Virginia Writers," *Richmond (VA) Times-Dispatch*, May 22, 1949.
595. Moxley, "'That's the Way She Was.'"
596. *The Lyric Magazine*, thelyricmagazine.com.
597. Crawford, "Ruby Altizer Roberts (1907–2004)."
598. Ibid.
599. Ibid.
600. Ibid.
601. "Sisters in Black Disclose Weird Crime," *Knoxville (TN) Journal*, April 21, 1946.
602. Anna Strock, "These 5 Stories of Serial Killers in Virginia Will Leave You Terrified," Only in Your State, April 1, 2015, www.onlyinyourstate.com/virginia/5-serial-killers-in-virginia/.
603. Personal correspondence with Kevin Poff, cemeterian, Town of Christiansburg, May 18, 2021.
604. "Exhibitions: Galleries at the Montgomery Museum," Montgomery Museum, montgomerymuseum.org/exhibitions.

Sally Berkeley Nelson Robins

605. "Final Rites Today for Noted Authoress," *Richmond (VA) Times-Dispatch*, February 5, 1925.
606. Ibid.
607. Frances S. Pollard, "Sally Berkeley Nelson Robins (1855–1925)," *Dictionary of Virginia Biography*, Library of Virginia, https://www.lva.virginia.gov/public/dvb/bio.php?b=Robins_Sally_Berkeley_Nelson.

608. *Virginia Suffrage News*, October 1914, via Virginia Chronicle: Digital Newspaper Archive, virginiachronicle.com.

609. Pollard, "Sally Berkeley Nelson Robins (1855–1925)."

610. Ibid.

611. Ibid.

612. The quote comes from 2 Corinthians 6:10 in the Bible.

613. "Sally Nelson Robins," Online Books, https://onlinebooks.library.upenn.edu/webbin/book/lookupname?key=Robins%2C%20Sally%20Nelson.

614. Thomas Barrett, "Jenkins, Will F. (1896–1975)," *Encyclopedia Virginia*, https://encyclopediavirginia.org/entries/jenkins-will-f-1896-1975.

615. The Hugo Awards, http://www.thehugoawards.org/hugo-history/1946-retro-hugo-awards/.

Anne Spencer

616. Mariana Brandman, "Anne Spencer Biography," National Women's History Museum, November 13, 2019, www.womenshistory.org/education-resources/biographies/anne-spencer.

617. "Anne Spencer House and Garden Museum," http://www.annespencermuseum.com/biography.php.

618. Brandman, "Anne Spencer Biography."

619. Ibid.

620. Ibid.

621. Goth Gardener, "A Poet's Sacred Space Transforms Me," *Goth Gardening*, July 18, 2015, goth-gardening.blogspot.com/2015/07/poets-sacred-space-transforms-me.html.

622. "Anne Spencer House and Garden Museum."

623. Ibid.

624. Erin Parkhurst, "Literary Luminary: Celebrating Poet Anne Spencer," *Virginia Living* 9, no. 2 (2011): 17.

625. "Anne Spencer House and Garden Museum."

626. Ibid.

627. Maureen Honey, *Shadowed Dreams: Women's Poetry of the Harlem Renaissance* (Brunswick, NJ: Rutgers University Press, 1989).

628. "Chauncey Spencer," *Pioneers of Flight*, Smithsonian National Air and Space Museum, accessed June 12, 2021, https://pioneersofflight.si.edu/content/chauncey-spencer.

629. MSS 16228, Anne Spencer Exhibit archival museum prints, undated, Small Special Collections Library at the University of Virginia, https://archives.lib.virginia.edu/repositories/3/resources/397.
630. "Anne Spencer House and Garden Museum."

Mary Newton Stanard

631. Mary Newton Stanard, *The Story of Bacon's Rebellion* (New York: Neale Publishing Company, 1907).
632. Mary Newton Stanard, *The Dreamer: A Romantic Rendering of the Life-Story of Edgar Allan Poe* (Richmond, VA: The Bell Book and Stationery Company, 1909).
633. Mary Newton Stanard, *John Marshall* (Richmond, VA: WM. Ellis Jones' Sons Inc., 1913).
634. Jennifer Scanlon and Shaaron Cosner, *American Women Historians, 1700s–1990s: A Biographical Dictionary.* (Westport, CT: Greenwood Publishing Group, 1996), 209.
635. Ibid.
636. "Noted Writer Dies; One Year's Illness," *Daily Press* (Newport News, VA), June 6, 1929.
637. "Mrs. Stanard's Success," *Times Dispatch* (Richmond, VA), August 11, 1907.
638. Ibid.
639. Scanlon and Cosner, *American Women Historians*, 209.
640. Ibid.
641. Ibid.
642. Ibid.
643. "Etching of E.A. Poe Presented to Shrine," *Richmond (VA) Times Dispatch*, December 4, 1925, 1.
644. Scanlon and Cosner, *American Women Historians*, 209.
645. "Prominent Richmond Authoress Is Buried," *Richmond (VA) Times Dispatch*, June 8, 1929.
646. Papers of Mary Mann Page Stanard, ca. 1916–23, Accession #6394, Special Collections, University of Virginia Library, University of Virginia, Charlottesville.
647. Douglas Keister, *Stories in Stone: A Field Guide to Cemetery Symbolism and Iconography* (Salt Lake City, UT: Gibbs Smith, Publisher, 2004), 146.

Amélie Louise Rives Chanler Troubetzkoy

648. Petrina Jackson, "Patron's Choice: Sex, Celebrity and Scandal in the Amélie Rives Chanler Troubetzkoy Papers," *Notes from Under Grounds*, August 23, 2013, smallnotes.library.virginia.edu/2013/08/23/sex-celebrity-and-scandal/.

649. Welford Dunaway Taylor, *Amelie Rives (Princess Troubetzkoy)* (New York: Twayne Publishers, 1973).

650. Ibid.

651. Mildred Lewis Rutherford, *American Authors: A Hand-Book of American Literature from Early Colonial to Living Writers* (Atlanta, GA: Franklin Printing and Publishing Company, 1894), 636.

652. Jackson, "Patron's Choice."

653. Ibid.

654. Robert W. Bolwell, "Julia Magruder," in *Dictionary of American Biography* (New York: American Council of Learned Societies, 1928–1936), 206.

655. Taylor, *Amelie Rives.*

656. Donna M. Lucey, *Archie and Amélie: Love and Madness in the Gilded Age* (New York: Harmony Books, 2006).

657. Taylor, *Amelie Rives*, 1973.

658. Castle Hill, U.S. National Register of Historic Places.

659. Leila Christenbury, "Amélie Louise Rives Chanler Troubetzkoy 1863–1945," *Dictionary of Virginia Biography*, Library of Virginia, published 2021, https://www.lva.virginia.gov/.

660. Amélie Rives, *The Ghost Garden; a Novel*, HathiTrust Digital Library, catalog.hathitrust.org/Record/100216889.

661. Albert and Shirley Small Special Collections Library at the University of Virginia, https://www.library.virginia.edu/special-collections/.

662. Ibid.

Edna Henry Lee Turpin

663. Certificate of Death, Commonwealth of Virginia, 1573.

664. John Caknipe Jr., *Southside Virginia Chronicles* (Charleston, SC: Arcadia Publishing, 2014), 128.

665. "Edna Henry Lee Turpin 1887," *Hollins Authors*, Hollins University, www.hollins.edu/authors/edna-henry-lee-turpin/.

666. Caknipe, *Southside Virginia Chronicles*, 128.

667. "Edna Henry Lee Turpin 1887."
668. "Richmond Author of Books for Children Dies," *Daily Press* (Newport News, VA), June 8, 1952.
669. 1920 United States Census, Henrico, 20.
670. Caknipe, *Southside Virginia Chronicles*, 100.
671. "Edna Henry Lee Turpin 1887."
672. "Richmond Author of Books for Children Dies."
673. Mountain Lake Lodge is recognizable to fans of the 1987 movie *Dirty Dancing* as Kellerman's Resort, although the film takes place during the summer of 1963, a decade after Edna Turpin's death.
674. "The Hollywood Trefoil—A Past Revisited," *A Gateway into History* 4, no. 1 (Spring 2013): 7–8.

Marie Theresa "Tere" Ríos Versace

675. "Mother of 5 Contends: 'A Book's Easy to Write,'" *Wisconsin State Journal* (Madison, WI), December 22, 1957.
676. New York City Municipal Archives, New York, New York, Borough: *Manhattan*, Volume Number: 10.
677. Michael Robert Patterson, "Marie Teresa Rios Versace, Military Spouse & Author," Arlington National Cemetery, May 22, 2002, www.arlingtoncemetery.net/mtrversace.htm.
678. "Mother of 5 Contends."
679. Ibid.
680. Ibid.
681. Ibid.
682. Patterson, "Marie Teresa Rios Versace."
683. "Journalist Mothers to Attend Ladies of the Press Breakfast," *Capital Times* (Madison, WI), April 23, 1958.
684. Arlington National Cemetery.
685. "'Flying Nun' Series Writer to be CDA Speaker Monday," *Capital Times* (Madison, WI), April 23, 1958.
686. Arlington National Cemetery.
687. "Space Shuttle Challenger Memorial," Arlington National Cemetery, www.arlingtoncemetery.mil/Explore/Monuments-and-Memorials/Space-Shuttle-Challenger.

Susan Archer Talley Weiss

688. Mary Forrest, *Women of the South: Distinguished in Literature* (New York: Charles B. Richardson, 1865), 312.

689. Ida Raymond, *Southland Writers: Biographical and Critical Sketches of the Living Female Writers of the South*, (Philadelphia: Claxton, Remsen & Haffelfinger, 1870), 751.

690. Susan Archer Weiss, *The Home Life of Poe* (New York: Broadway Publishing Company, 1907).

691. Rufus Wilmot Griswold, *The Female Poets of America* (Philadelphia: Carey and Hart, 1852), 311.

692. Forrest, *Women of the South*, 310.

693. Willard and Livermore, *Woman of the Century*, 756.

694. Raymond, *Southland Writers*, 751.

695. *Greensboro (NC) Times*, December 3, 1859.

696. John C. Oeffinger, ed., *A Soldier's General: The Civil War Letters of Major General Lafayette McLaws* (Chapel Hill: University of North Carolina Press, 2002), 235.

697. Raymond, *Southland Writers*, 752.

698. "Miss Susan Archer Talley," *Richmond (VA) Enquirer*, July 11, 1862.

699. *Austin (TX) State Gazette*, October 8, 1862.

700. *The Weekly Advertiser* (Montgomery, AL), March 18, 1863; Tardy, *Living Female Writers*, 392.

701. Raymond, *Southland Writers*, 763.

702. Willard and Livermore, *Women of the Century*, 756.

703. "Deaths in Virginia," *Times Dispatch* (Richmond, VA), April 10, 1917.

704. Selden Richardson, "Migratory Elk Observed on the Banks of the James," *Shockoe (VA) Examiner*, January 1, 2014.

Annie Steger Winston

705. Annie Steger Winston, *Memoirs of a Child* (New York: Longmans, Green and Co., 1903).

706. Certificate of Death, Commonwealth of Virginia, register no. 1045.

707. "Her Achieved Success by Very Hard Work," *Times Dispatch* (Richmond, VA), December 27, 1903.

708. Ibid.

709. Ibid.

710. "Miss Winston Dies After Brief Illness," *Richmond (VA) Times Dispatch*, May 13, 1927.

711. "Writers' Club Pays Tribute to Authors of Recent Books," *Richmond (VA) Times Dispatch*, December 28, 1923.

712. "Miss Winston, Writer, Is Dead." *Richmond (VA) Times Dispatch*, May 13, 1927, 1.

713. Douglas Keister, *Stories in Stone: A Field Guide to Cemetery Symbolism and Iconography* (Salt Lake City: Gibbs Smith, Publisher, 2004), 65.

SELECT BIBLIOGRAPHY

Alderman, Edwin Anderson, and Joel Chandler Harris, eds. *Library of Southern Literature: Biographical Dictionary of Authors*. Atlanta: Martin and Hoyt Company, 1910.

Binheim, Max and Charles A. Elvin. *Women of the West; a series of biographical sketches of living eminent women in the eleven western states of the United States of America*. Los Angeles: Publishers Press, 1928.

Curl, James. *The Victorian Celebration of Death*. Gloucestershire, UK: Sutton, 2001.

Davis, Veronica A. *Here I Lay My Burdens Down: A History of Black Cemeteries of Richmond, Virginia*. Richmond, Virginia: The Dietz Press, 2003.

Flora, Joseph M., and Ambel Vogel, eds. *Southern Writers: A New Biographical Dictionary*. Baton Rouge: Louisiana State University Press, 2006.

Keister, Douglas. *Stories in Stone: A Field Guide to Cemetery Symbolism and Iconography*. Salt Lake City: Gibbs Smith, Publisher, 2004.

Mitchell, Mary. *Hollywood Cemetery: The History of a Southern Shrine*. Richmond: Library of Virginia, 1999.

Rhoads, Loran. *199 Cemeteries to See Before You Die*. New York: Black Dog & Leventhal; Illustrated edition, 2017.

Rutherford, Mildred Lewis. *American Authors: A Hand-Book of American Literature from Early Colonial to Living Writers*. Hammond: The Franklin Printing and Publishing Company, 1894.

Scanlon, Jennifer and Shaaron Cosner. *American Women Historians, 1700s-1990s: A Biographical Dictionary.* Westport, CT: Greenwood Publishing Group, 1996.

Tardy, Mary. *The Living Female Writers of the South.* Philadelphia: Claxton, Remsen & Haffelfinger, 1872.

Taylor-White, Alyson L. *Shockoe Hill Cemetery: A Richmond Landmark History.* Charleston: The History Press, 2017.

Willard, Frances Elizabeth and Mary Ashton Rice Livermore. *A Woman of the Century: Fourteen Hundred-Seventy Biographical Sketches Accompanied by Portraits of Leading American Women in All Walks of Life.* Moulton, 1893.

ABOUT THE AUTHOR

 Sharon Pajka, PhD, is a professor of English at Gallaudet University. She is a graduate of Virginia Commonwealth University, Gallaudet University and the University of Virginia. She has a graduate certificate in public history from the University of Richmond. On the weekends, find her in the cemetery giving history tours or volunteering and running River City Cemetarians.

Visit us at
www.historypress.com